The Art
of Fantasy

Quarto

First published in 2023 by Frances Lincoln,
an imprint of The Quarto Group.
One Triptych Place,
London, SE1 9SH,
United Kingdom
T (0)20 7700 6700
www.Quarto.com

A catalogue record for this book is available from
the British Library.

ISBN 978-0-7112-7995-7
Ebook ISBN 978-0-7112-7996-4

10 9 8 7 6 5 4 3 2 1

Design by Masumi Briozzo

Printed in China

MIX
Paper | Supporting
responsible forestry
FSC® C016973
FSC
www.fsc.org

*For all those who sat alone at
school — but never lonely! Head in
the clouds and lost in the worlds
of fantastical stories while their
classmates laughed and played and
carried on — this book is for you.*

Front cover: The Love of Souls,
Jean Delville, 1900, oil on canvas.
© DACS 2023. Photo: The Stapleton
Collection/Bridgeman Images

Back cover: The Beautiful Crustacean,
Forest Rogers, 2016, mixed media,
Japanese air-dry clay with
mulberry paper.
© Forest Rogers

S. Elizabeth

The Art
of Fantasy

A Visual Sourcebook of All That is Unreal

FRANCES
LINCOLN

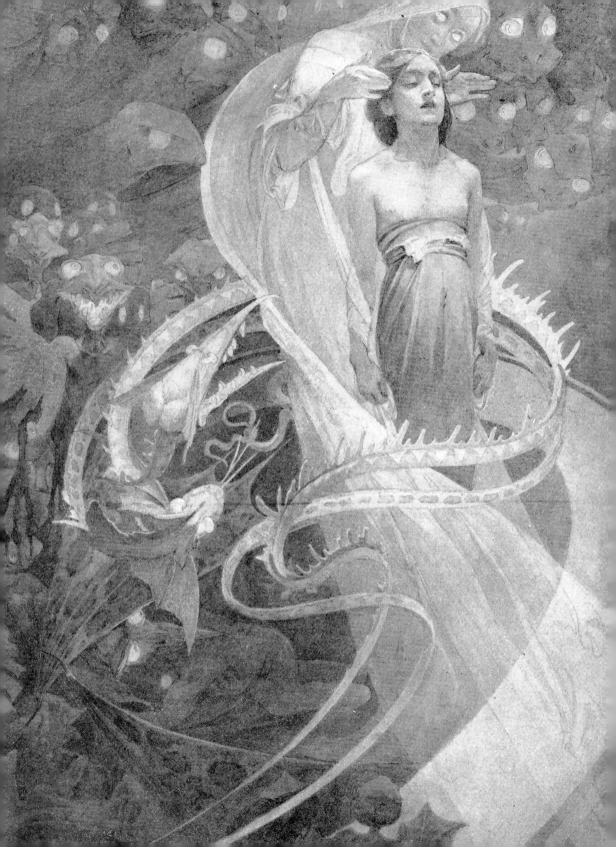

Introduction: The Irresistible Allure of the Unreal

Where is it that you disappear when you set reality aside, become entangled in a web of daydreams or lost in your own little world, and vanish into the fantastical landscape of your imagination? Are you a courageous hero fighting for glory and renown? The curious scholar, questing for knowledge and wisdom? Or are you the encroaching darkness, the monster slithering in the shadows, the dragon slumbering over its treasure hoard? Perhaps you are none of those things but rather plugged into a vast, expansive atmosphere of harmony and tranquillity, a crystalline kingdom in the clouds, a halcyon sanctuary and bastion of beauty at peace for a thousand years?

Our most madcap adventures and extraordinary flights of fancy – the impossible stuff of daydreams and reverie – this is the fabulous realm of fantasy. How are these stories portrayed in the canvas of your mind in these far-flung realms of all that is incredible and unreal?

There is something irresistible about the imaginary, the uncharted and the unknown, worlds full of magic and mythical creatures, epic journeys across otherworldly landscapes filled with secrets and treasures. Artists have explored imaginary worlds and fantastical creatures for centuries, expressing the mystical and mythical via various mediums. What draws the artistic mind to these immersive storied spheres, similar yet separate from reality, full of endless uncommon and astonishing possibilities?

Storytelling is older than any human language, and the existence of fantasy is as old as humankind. Every culture across the globe has its own fables and folklore to convey teachings and guidance or pass on pieces of their history, spun as fantastical

Opposite: The Great Red Dragon and the Woman Clothed with the Sun, William Blake, *c.* 1805, pen, ink and watercolour.

'Fantasy is hardly an escape from reality. It's a way of understanding it.'

— LLOYD ALEXANDER

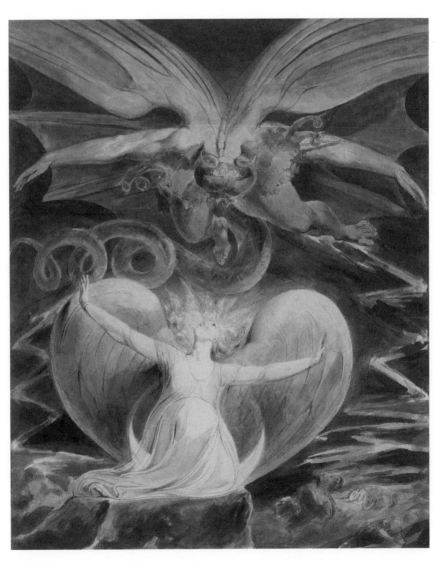

tales by ancestral storytellers to help us understand the universe around us and our existence. And, of course, the powerful urge to record and express our stories via markings on rock, pigments on paper or sculpted in stone is a vital part of our human experience as well. The creation of art has always been one of the most expressive and evocative ways to impart these figments and fragments of imagination, a way to interpret and reveal the exhaustive range of human fears and desires, hopes and dreams – from that of the renowned and beloved mythical and folkloric, to the artist's own innovative and inventive visions.

A sweeping though loosely defined art genre, with myriad styles and methods of expression, fantastic art is typically recognized as rooted in myth, lore and ancient belief. Often inspired by the fantastical in literature and not necessarily confined to a specific school of artists or historical period, art of this ilk is interwoven through the centuries in medieval, Mannerist, Magic Realist, Romantic, Symbolist and Surrealist imagery. Visual flights of fancy and imagination can be observed in religious works, from the horrors and hells and whimsical weirdness of Hieronymus Bosch to the otherworldly transcendence of William Blake's paintings to the shadowy drama of Gustave Doré's biblical illustrations. We see the fantastical writ large and lavish in the Victorian paintings of Arthurian legend by Pre-Raphaelites John William Waterhouse, Dante Gabriel Rossetti and Evelyn De Morgan.

Alice's Adventures in Wonderland, Lewis Carroll's children's book from 1865, satisfied childish longings with its illustrated pages of grinning cats and mad tea parties, and Frank Frazetta, with his sensational, action-packed renderings of the barbarian Tarzan, is considered one of the pioneers of modern fantasy illustration.

And indeed, artists have imagination enough and don't require an established literary canon or any recognizable myth or narrative to inspire their works; plumbing the depths and unrealities of their personal dreams and psyches, they expose their own unique visions of the world – fantastical symbols, motifs and archetypes that we can't connect to anything familiar or identifiable. Yet, it speaks to something deep within us nonetheless. If you've ever stood before the hallucinatory works of eccentric Surrealists Salvador Dalí or Leonora Carrington and thought, 'I don't know what on earth this is supposed to be but, wow, I sure can relate', then you know just what I am talking about.

The spectrum of fantastic art is an abundant, richly diverse wonderland to explore – and these artists, throughout history and within these pages, have offered us a key to glimpsing myriads and multitudes and multiverses of fantastical visions. These creations may occur in a time or place unfamiliar to us. Still, their imaginative revelations are built on universal themes; through them, we might unearth and experience the truths and triumphs shared by all of humanity. Through symbolism and allegory in themes and tales that have been passed on for thousands of years, these visual representations convey the vast swathe of hopes and dreams in our collected hearts.

Fantasy is not simply an escape from the dreariness of daily life; it is the irresistible impulse that reveals hope and wonder in us all. Through our dreams and imagination, we might draw forth – like a sword from a stone – what is needed to be the hero of our own reality. In experiencing through fantastical art the magic that is in the world around us and beyond, we can also connect with the magic deep in ourselves.

Right: *A Fairy Shepherd*, John Bauer, 1910, watercolour.

—

Beasts
&
Beings

"'Do you know, I always thought unicorns were fabulous monsters, too? I never saw one alive before!' "Well, now that we have seen each other," said the unicorn, "if you'll believe in me, I'll believe in you.'"

– LEWIS CARROLL, *THROUGH THE LOOKING GLASS*

Lumbering one-eyed giants with surly personalities and prodigious strength; diminutive, winged beings twinkling with magic both mischievous and malicious; luminous equine beasts with shimmering horns, elusive and rare. Mermaids and minotaurs, dragons and dwarves! Sphinxes, satyrs, swan maidens and even the Sandman – from the Cyclops' dusty cave to the mushroom-spotted faerie rings to the last unicorn hidden in a dark wood at the end of the world, there are clamouring, capering tales of fantastical creatures to be found in every nook and cranny of every culture.

Some of these creatures are astonishing and rather awe-inspiring, some so petrifying their gaze turns one to stone, some that are cuddly, fuzzy and even adorably endearing ones – and all of them are truly exceptional in their own unique ways. They are often suggestive of intriguing or fearsome creatures in our real world or inspired by beasts from myth. The mythologies and legends of ancient and modern cultures are overrun with throngs of monsters and imaginary beasts, and so many of these

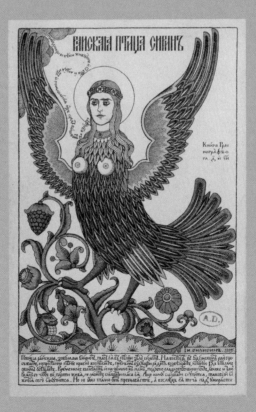

Right: Bird of Paradise Sirin, Ivan Bilibin, 1905, lithograph.

creatures have found their way into unforgettable and iconic fantasy settings, both in our treasured classics and in exciting contemporary storytelling. Whether that's a shapeshifting, befanged monster in a horror novel or an enchanted, winged sidekick in a fantasy series, the inclusion of extraordinary creatures and imaginary entities enriches a fantasy world, makes for an exciting story and enthralls an audience. Their presence brings a setting to life, inspiring questions of their origin, purpose and place in the story universe, and the themes, plots and character arcs that happen there – not to mention being marvellous vehicles for symbolism and allegory.

Monstrous creatures can help us by giving a material form to our secret fears, and these monsters made from our imagination have been around as long as the clever and inventive humans who created them. A great deal of exploration of the human soul can be considered with monster stories, and through examining the role of the monster in our various stories, fables and legends we can ferret out the similarities that connect them as well as decipher their underlying value and significance. Through the lens of a horrifying creature, we get insights into themes of identity and awareness, abandonment and alienation, vengeance and, sometimes, even love. They can represent deeply hidden aspects of ourselves, reminding us of our capacity for violence and ugliness, and the potential danger that comes from giving in to our own primal urges. Monsters can also be seen in opposition to the heroes that face them, helping to provide contrast between what is seen as acceptable, and what is objectionable. Another aspect of wondrous and monstrous creatures is that they can be beneficial, be they the guardians of precious things, the guides to enlightenment, the whisper that draws the daring adventurer ever forward in their quest.

But perhaps all imaginary beasts and beings are ultimately both monsters and wonders, and as we valiantly venture into their vibrant world, let's keep open hearts and minds and try to understand what they bring to our stories. Representing fascinating, frightening and illuminating archetypes and paradigms, they have always transcended the boundaries of human imagination – and even in our present-day lives, we persist in creating and sharing new stories about monsters, challenging and inspiring each new generation with tales of fabulous and inconceivable beasts.

Opposite: S.O.S., Evelyn De Morgan, 1914–16, oil on canvas.

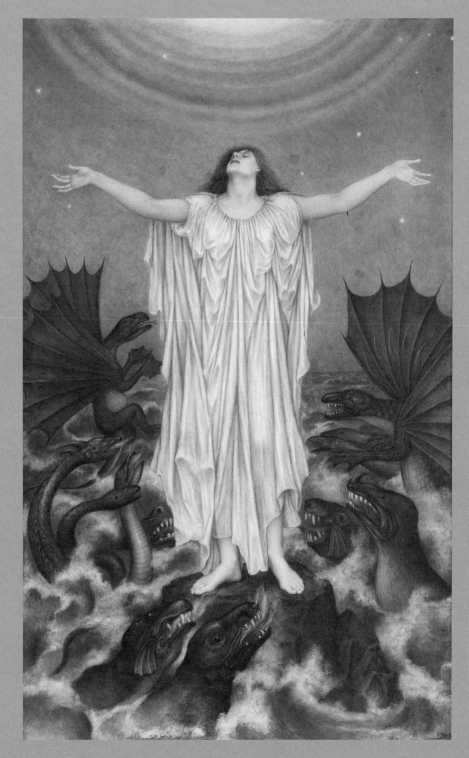

I

Creatures
Great & Small

'Every adventure requires a first step.'

– LEWIS CARROLL, *ALICE'S ADVENTURES IN WONDERLAND*

Cats with wings and talking rabbits. The great Aslan and the tiny Reepicheep. Flying monkeys! What was your first brush with the fantastical? No doubt for many, it was a naughty little rabbit in a blue jacket stealing Mr McGregor's veggies. For others, it may have been a maddening and enigmatic cat teasing a girl lost in Wonderland and who disappeared leaving only a grin. Or, for an unfortunate few, it may have been a terrifying squadron of soaring simians swooping down from the sky to snatch up unsuspecting little dogs, and haunting nightmares for many years to come.

Though our grown-up appetites for fantasy creatures have likely evolved beyond those of adorably floppy-eared childhood friends and expanded to include all manner of beasts with wings and horns, tails and scales, we can't deny that friendly or scary, naughty or nice, these creatures sparked our imaginations, populated our dreams and built the foundation for future stories and adventures. These small creatures were the gateway – or the guardians at the gate – to the unique animals and magical critters that populate the fantasy media we consume as adults.

Whether in novels, movies, video games, art or music, a panoply of fantasy creatures scurry, swarm and stampede across all cultures. Ancient civilizations on every continent speak of fantasy creatures, and mythical beasts and beings have not just a toehold, but claws sunk deeply into every corner of the globe. The Greeks had the wild and wise centaurs. Egyptians were riddled by the Sphinx. Today, we mostly agree that the unicorn is an imaginary beast – except maybe for some hard-core Renaissance faire enthusiasts! Roman naturalist Pliny the Elder (*c.* CE 23/24–79) detailed the unicorn in the eighth book of his encyclopedic *Natural History* in the following alarming description: ' . . . his bodie resembleth an horse, his head a stagge, his feet an Elephant, his taile a bore; he loweth after an hideous manner; one blacke horn he hath in the mids of his forehead. . . .' It's not quite the exquisite creature we envision today, is it? But hideous to espy or resplendent to behold, these fabulous, fanciful animals, though they may not exist in our reality, are more than just make-believe. They are a glimpse into how our ancestors once experienced and attempted to control a world that was staggeringly unknown and overwhelming, fuelling their fears and warning of danger when they heard strange noises in the night, but also filling their imaginations with surprise and delight and eons of entertainment.

Art history is a menagerie teeming with mythical and hybrid creatures. In the Middle Ages, artists often consulted beautiful bestiaries for real or imaginary specimens of the creatures that they then painted and carved, chiselled and cast. While biblical narratives contain relatively few instances of imaginary creatures, artists such as Hieronymus Bosch, Matthias Grünewald and Albrecht Dürer conceived of some of art's most unusual and unearthly creatures as metaphors for sin and wickedness and all the horrors of hell. Imaginary creatures, both benevolent and treacherous, were key components populating the worlds created by Surrealist artists, from the bird-like beasts that obsessed Max Ernst to Leonora Carrington's dream dimensions of divine horses and masked hyenas and the stylish elegance of Dorothea Tanning's mysterious monsters.

From part-human or animal hybrids to entirely fantastic beasts, imaginary creatures have captured the attention of artists since antiquity. Inspired by myths and legends, a diverse

Opposite: Jacket illustration for *Redwall* by Brian Jacques, Pete Lyon, 1986, acrylics over an underlying monochrome and coloured pencil sketch.

Right: Jacket illustration for *The Last Battle* by C.S. Lewis, Leo and Diane Dillon, *c.* 1993, acrylic on acetate mounted on Bristol board.

multitude of artists spanning continents and centuries have given these creatures their form. Mythical and fantasy creatures continue to occupy the hearts and fascinate the imaginations of today's artists, many of whom re-envision and reinvigorate these curious beasties through the lens of their own contemporary experiences, ideas and circumstances. Springing from our incredible human imagination, creatures such as unicorns and sphinxes – as well as malicious flying monkeys and mischievous bunny rabbits – appear in art everywhere, and these bestial marvels inhabit an archetypal realm embedded in our collective consciousness, which never seems to fade from popular awareness. Their shapes and sizes, meaning and purpose, may change over the centuries, but they will undoubtedly forever serve our desire for mystery and enchantment.

Above: Birds Fish Snake, Max Ernst, 1919, oil on canvas.

A leading pioneer of the Dada movement and Surrealism, German artist and poet Max Ernst (1891–1976) explored the mysteries of the human subconscious in his haunting paintings. Ernst developed a fascination with birds that manifested itself throughout his work after a rather dark incident he experienced as a child. By his account, his favourite pet bird died at the moment his younger sister was born. He subsequently started to view birds as omens of death, with the feathered creatures he depicts in his art emitting menace instead of optimism and recalling darkness instead of light.

Opposite: The Enchanted Domain, René Magritte, 1957, oil on canvas.

Widely celebrated Belgian painter René Magritte (1898–1967) revealed through his amusing, thought-provoking images the disturbing and strange hidden meaning behind the most ordinary familiar things. In 1953, Gustave Nellens commissioned René Magritte to create a giant mural for a seaside casino in Belgium. The result was *The Enchanted Domain*, a 360-degree continuous mural of monumental scale where Magritte brought together the dreamlike aesthetic and evocative symbols of some of his most important and iconic imagery.

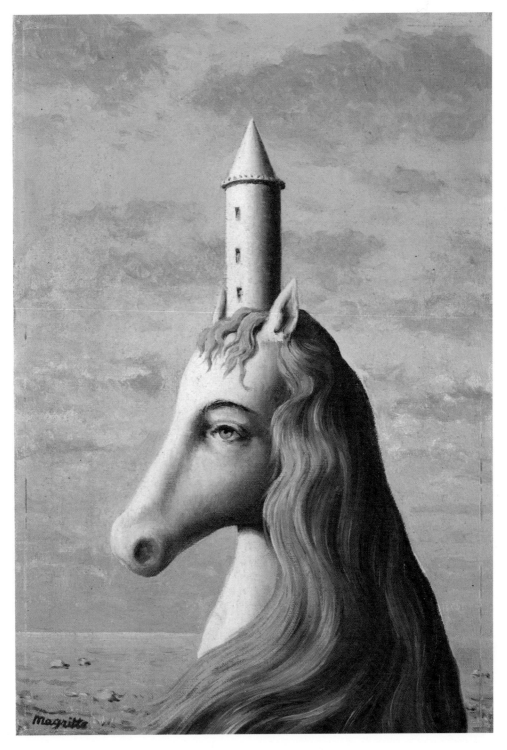

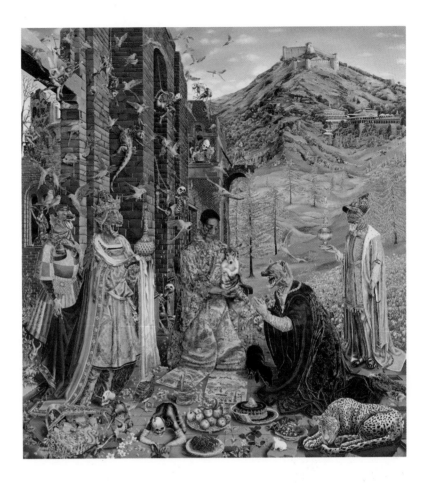

Opposite: Garden of Hope,
James Gurney, 1993, oil.

Above: The Adoration (after Jan Gossaert), Raqib Shaw, 2015–16, acrylic liner and enamel on birchwood.

Contemporary master of colour and light, James Gurney renders the impossible inevitable in his paintings of ancient and fantastic worlds, including his imaginative vision of the Earth populated by dinosaurs in his famous *Dinotopia* series of illustrated books. Gurney's childhood daydreams inspired an interest in archaeology and lost civilizations and though his heart's dream was to discover a lost city like Troy or Machu Picchu, he knew that he could always bring to life such an extraordinary place on the painter's canvas.

Raqib Shaw is an Indian-born, London-based artist known for his opulent and intricately detailed paintings of imagined paradises, inlaid with vibrantly coloured jewels and enamel. These fantastical worlds of splendour and opulence are resplendent with rich colour and intricate embellishment, and reveal an eclectic fusion of influences – from Persian carpets and Northern Renaissance painting to industrial materials and Japanese lacquerware – and are often developed in series from literary, art, historical and mystical sources.

Above: Unicorn's Dream, Irina Korsakova, 2003, oil on canvas.

Irina Korsakova paints with misty, expressive elegance portraits of serene princesses and sleepy unicorns, the stuff of memory and childhood fantasy. One of the most archetypal and traditionally well-known traits of the unicorn (though frankly creepy to modern sensibilities) is its fondness for virgin women. In legends where unicorns were characterized as either fierce and defiant or as incredibly evasive, only a sweet and gentle maiden has the power to tame the unicorn.

Opposite: The Unicorn Rests in a Garden (from *The Unicorn Tapestries*), 1495–1505, wool warp with wool, silk, silver and gilt wefts.

This iconic scene of the elusive, enchanting unicorn in the delicate sweep of a millefleur meadow is one of the most stunning works of art from the late Middle Ages to survive. Comprising seven massive allegorical tapestries, *The Unicorn Tapestries* (commonly known as *The Hunt of the Unicorn*) are ornately woven in sumptuous wool and silk with silver and gilt thread and are generally regarded to be among the greatest artworks in existence.

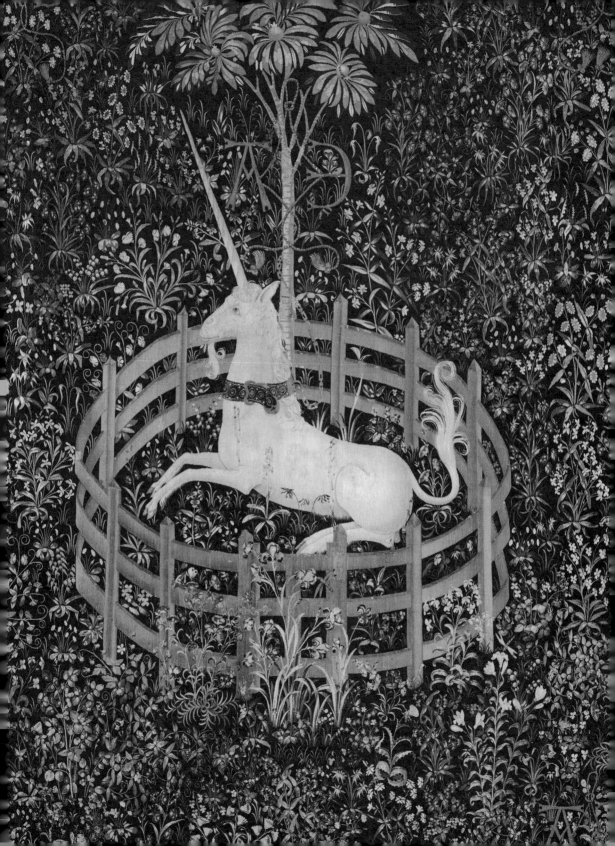

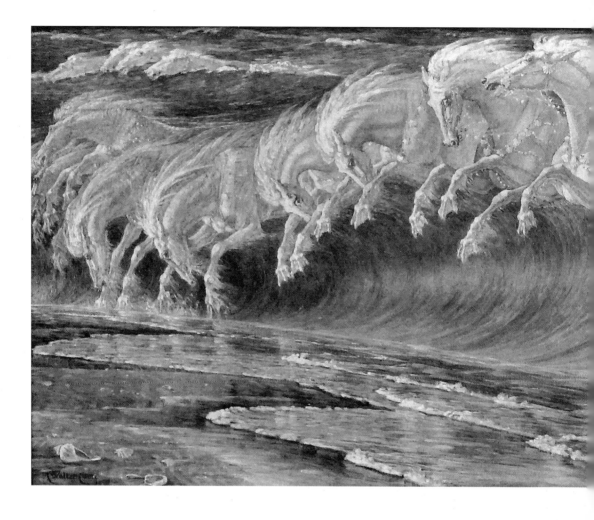

Above: Neptune's Horses, Walter Crane, 1910, lithograph.

English artist, author and illustrator of colourful, decorative children's books Walter Crane (1845-1915) was not influenced by visionary songstress Kate Bush, who sang of racing white horses on her album *The Ninth Wave*, but it's fun to imagine he might have been. No, Crane's depiction of Neptune harnessing the awesome might of the sea in the form of horses thundering in the crests of the waves, their manes streaming in the wind as they crash towards the shore, is drawn from classical mythology. As a god of the sea, Neptune could provoke or pacify the oceans, but he was also the god of horses and had a hand in their creation. This mythological aquatic equine energy can also be enjoyed in iconic scenes from beloved fantasy favourite films such as *The Lord of the Rings*, as well as *The Last Unicorn*.

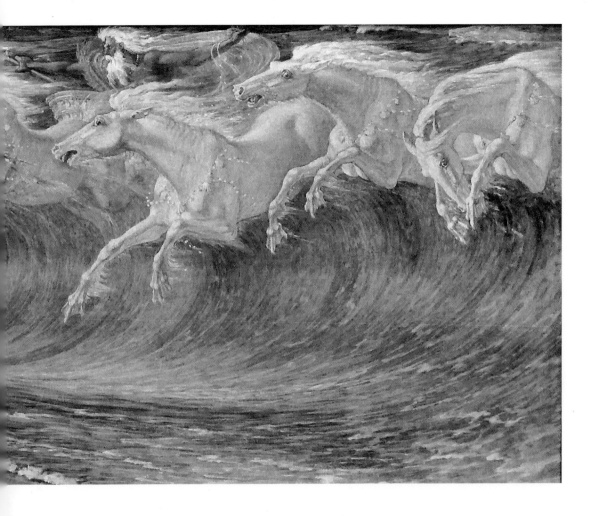

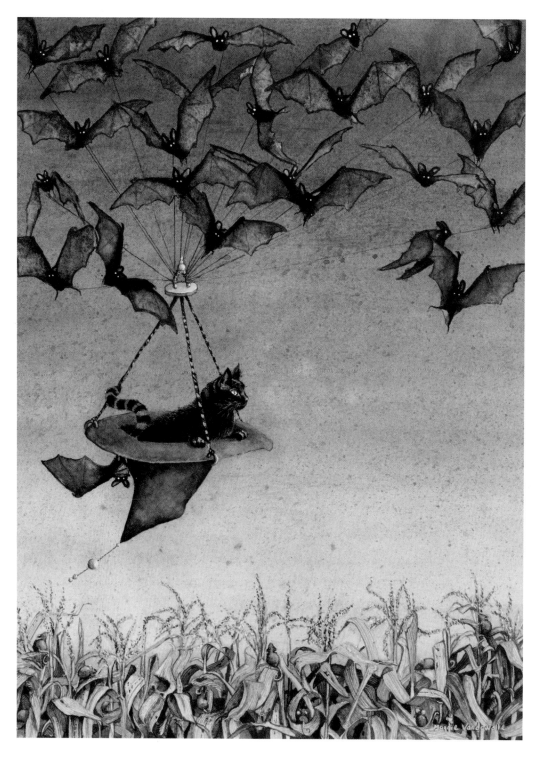

Opposite: Straight on Till Morning, Maggie Vandewalle, 2018, watercolour and graphite.

Contemporary artist Maggie Vandewalle blends fantasy and reality with watercolour and graphite to convey both her love of the organic world and that of a really good story. What story is unfolding in this enchanted vision of chiropteran twilight taxi service, wherein a shadowy cloud of bats whisks away a singularly-focused black cat, oblivious to the tiny stares of the mice-flocked cornfield below?

Above: Scowl, Annie Stegg Gerard, 2020, oils on wooden panel.

Annie Stegg Gerard has been painting whimsical illustrations from early childhood and her works encompass a wide variety of mediums, including both two- and three-dimensional forms. Specializing in character design and development as well as a masterful atmosphere of enchantment, Annie creates unique images populated with enigmatic figures and lively creatures. This transportive effect of emotion and imagination is undeniable, such as the dear little Scowl above, eyes gleaming sweetly, a tender paw adorably curled in mid-thought. A viewer can't help but coo in delight at the thought of those magical toe-beans!

Opposite: Excuses, Schmexcuses,
Femke Hiemstra, 2022,
acrylic on panel.

Dutch artist Femke Hiemstra uses acrylic paint and pencils to create the otherworldly folklore of her painted stories; meticulous surrealistic scenes that often include anthropomorphic flora and fauna imbued with a sense of mischief and mystery, wit and whimsy, roaming through a dark, fairy tale-like world.

Right: Shining Apples, Carisa Swenson, 2015, fabric, epoxy clay, acrylic paint, mohair, glass eyes.

Carisa Swenson creates curious critters who appear to have wandered gently out of a small child's fable of forest creatures, gleaming-eyed and grinning from beneath befanged overbites. Yet for all their grimacing, there is no sense of malice, no reason to take fright; look closer, and you will find something peculiar but profoundly endearing and strangely familiar about this oddball cast of creatures. Towering or tiny, and always with the underpinnings of the folkloric and fantastical serving as their very foundation, Carisa coaxes them forth from clay and wire, wood and glass. And though they seem semi-feral, fairy-tale beasts from a dark, wild wood, one gets the feeling from their earnest, even kindly expressions that these rascals, just like anyone, are yearning for a happy ever after.

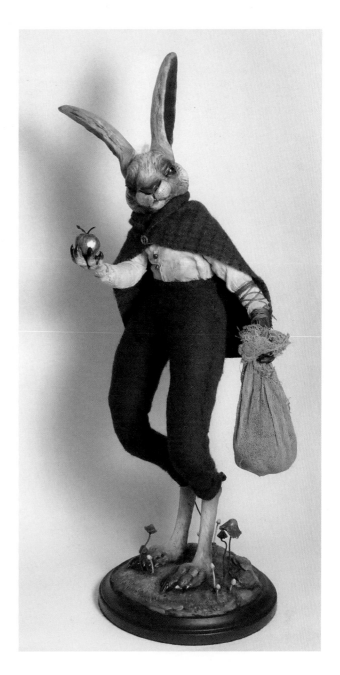

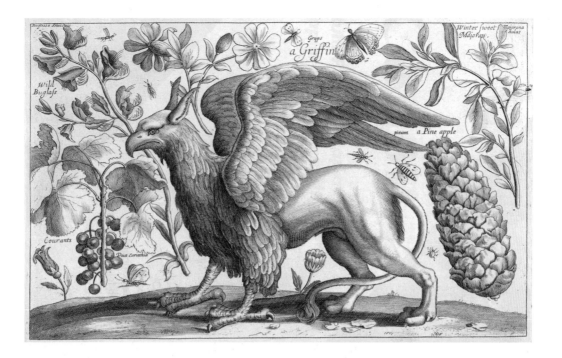

Opposite: Cats, Leonora Carrington, *c.* 1940, oil on panel.

It's always a bit disconcerting to see a cat intently staring at something that you can't see ... but to happen upon several dozen of them gazing steadily at an invisible spot feels quite ominous. Especially when you're not even certain that these creatures are, in fact, cats! Translated through the fantastical Surrealist lens of Leonora Carrington (1917-2011), these mundane creatures become magical, menacing, mythic.

Above: A Griffin, after Wenceslaus Hollar, 1662–63, etching.

Wenceslaus Hollar (1607-77), a skilful and prolific Bohemian graphic artist of the seventeenth century, was renowned for his engravings and etchings, and by his life's end, he had produced several thousand separate etchings - which is fairly remarkable given that he was nearly blind in one eye. In this etching a griffin poses placidly, surrounded by numerous plants, flowers and insects, and a pineapple. Plot twist! Several sources indicate that this work, previously attributed to Hollar, may instead just be after his style. Regardless of who created the etching, we can agree that the griffin is a mythical half-eagle, half-lion creature, which, in various cultures, guards the gold of the kings, as well as other priceless possessions.

Above: Little Wings and Heavy Hooves,
Eric Velhagen, 2009, oil on linen.

The work of contemporary artist Eric
Velhagen plays on paradox, and
captures both the subtle essence
of a scene and the raw energy of its
movements. Like many artists, Eric
began drawing at an early age; in his
early teens and after discovering the
literary works of J.R.R. Tolkien and the
powerful artwork of Frank Frazetta,
Eric realized that the realm of fantasy
art was his destiny.

Opposite: Sphinx pour David Barrett,
Leonor Fini, 1954, gouache
and tempera.

Surrealist Leonor Fini (1907-96)
created a complex menagerie of
both traditional and non-traditional
beasts in her art. With her meticulous
brushstrokes and lavish palette and
merging interests in psychoanalysis,
philosophy, mythology and sorcery,
Fini's focus on woman as a sensual
and sexual creature can be seen
in her lush, predatory sphinxes.

This mythical creature is emblematic
of Fini's simultaneous affinity for what
lurks in the border between artifice
and natural realities, and taking the
artistic fascination with the motif of
an animal/human hybrid somewhat
literally, she came to identify herself
with the ancient figure of a sphinx.

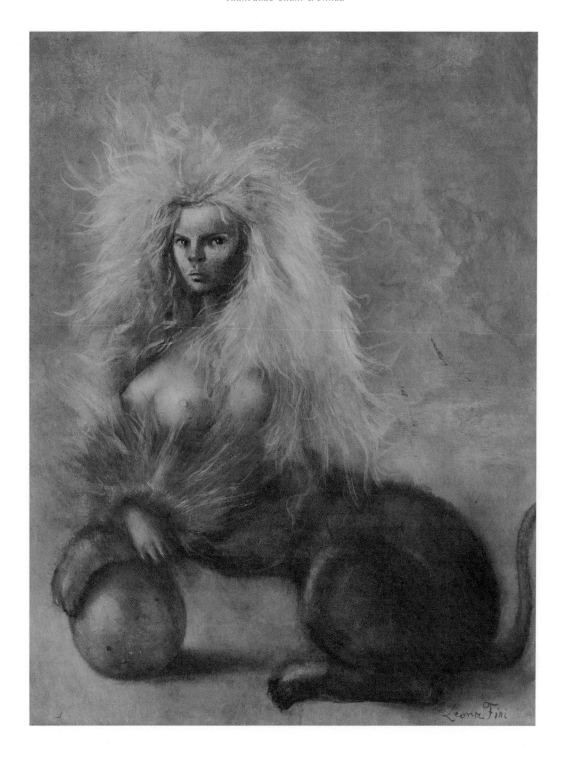

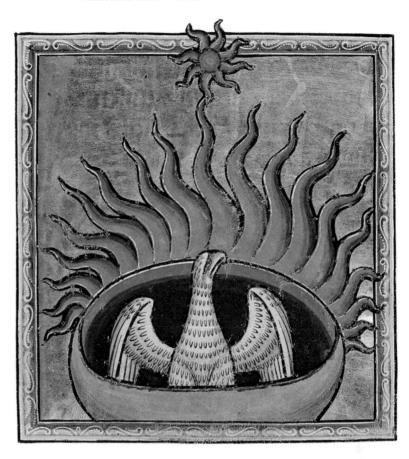

Opposite: Urweltwesen, Otto Dix, 1922, watercolour, pen and India ink on paper.

Urweltwesen is one of 16 rare watercolour illustrations by Otto Dix (1891-1969), a German painter and printmaker best known for anguished, exploited human figures representing the turmoil of his time. Interestingly, these spectacularly vibrant works collectively are part of *Bilderbuch für Muggeli* (A Picture-Book for Muggeli), which forms the first of five children's books that Dix would make during his lifetime. The poignant pages, full of whimsical adventure scenes from around the world, formed a picture book that he gave as an Easter gift to Martin Koch - the son of his friends Hans and Martha Koch.

Above: A phoenix as depicted in the *Aberdeen Bestiary*, twelfth century, illuminated manuscript.

This image from a medieval bestiary shows a phoenix, an ancient mythical creature symbolizing immortality, rising from flames. Bestiaries gathered together descriptions of animals, ranging from ordinary creatures such as goats and bees to fantastical beasts including griffins, mermaids and unicorns. In most bestiaries these animals are described in relation to ideas of Christian morality: the creatures themselves were not as important as the moral truths revealed in their explanation. This mythical bird's fiery death and miraculous rebirth have been inspiring readers for over 2,000 years. Living for upwards

of 500 years, when it observes that it has grown old, it forms a funeral pyre, intentionally fans the flames for itself and perishes in the fire. But on the ninth day, a new phoenix rises from the ashes of the old.

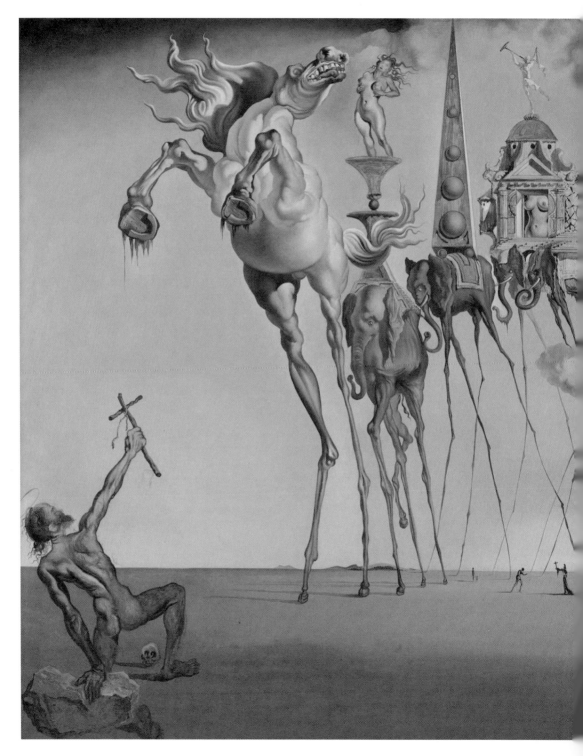

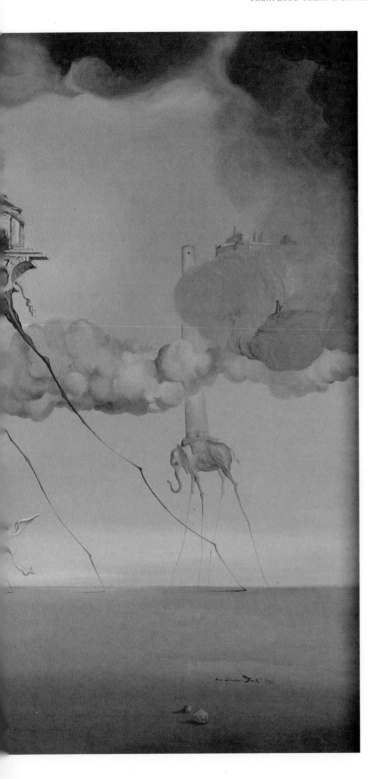

Left: The Temptation of St Anthony,
Salvador Dalí, 1946, oil on canvas.

A work of no small renown, the 1946
painting *The Temptation of St Anthony*
by Salvador Dalí (1904–89) serves as a
considerable example of the Surrealist
ideas and Christian iconography
often associated with this flamboyant
artist. Although Dalí's piece didn't
win the contest it was entered for
(the winner was, in fact, Max Ernst), it
went on to become one of the artist's
most famous and influential pieces.
An oft-revisited subject in art, the
story of the temptation of St Anthony
carries with it not only the freedom
to stylistically depict the demons of
temptations, but also the opportunity
to impart a moral message, which,
depending on the artist, may vary.
And, of course, if the artist can distract
us entirely with spindly-legged,
impossibly-skyscraper-tall fantasy
elephants, I suppose he can sneak in
whatever sort of message he wishes!

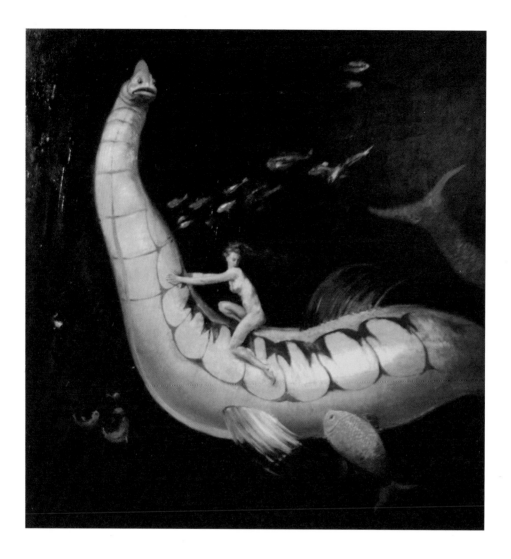

Above: Meerestiefe, Max Frey, *c.* 1926, oil on hardboard.

This work from German painter and graphic artist Max Frey (1874-1944) is not titled *Don't Talk To Me Or My Giant Sea Slug Ever Again*, but I sure wish it was because the subject's face is certainly giving that kind of energy. Frey's work includes a number of these glorious undersea marvels and was associated with the Symbolism and New Objectivity movements, and also contained imaginative and dreamlike elements of Magical Realism.

Above: The Temptation of St Anthony (detail), Matthias Grünewald, *c.* 1515, oil on panel.

Often thought of as one of the most consequential artists in the history of Northern Renaissance art, as well as one of the greatest of all German religious painters, Matthias Grünewald (*c.* 1470–1528) favoured the mystical, spiritual style of late medieval European art. His beautifully grotesque paintings were unusual in the way he used expressive colouring and feverish line to share a personal take on harrowing religious parables. Grünewald's depiction of the temptation of St Anthony focuses on a religious theme that has been repeated frequently in European art and these images are taken from just one panel of the 12 that make up the masterpiece for which Grünewald is most famous.

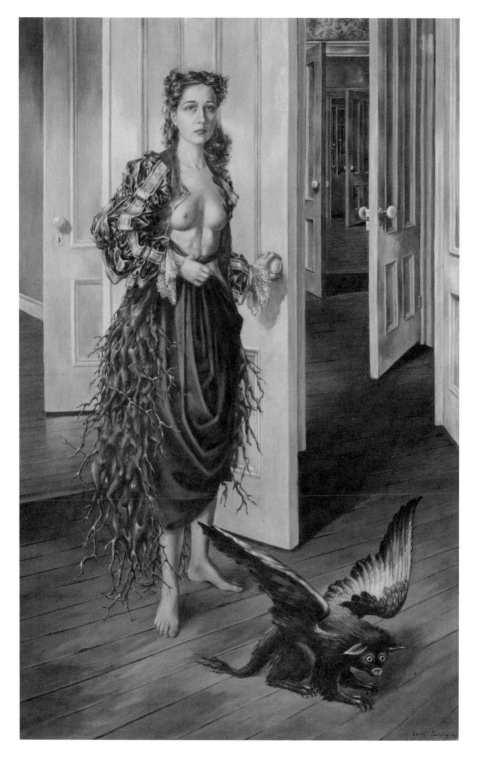

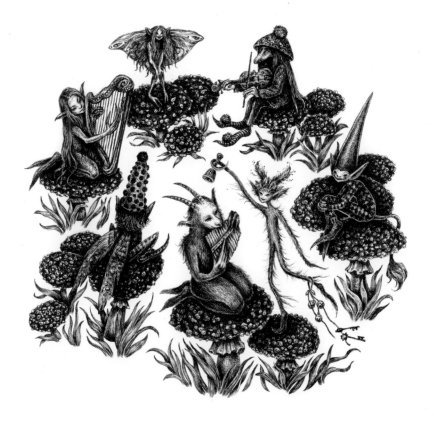

Opposite: Birthday, Dorothea Tanning, 1942, oil on canvas.

Above: Faerie Music, Brett Manning, 2021, ink.

Surrealist artist Dorothea Tanning (1910–2012) acts as a guide to imaginary realms in the self-portrait *Birthday,* widely considered a landmark work of the artist. A composition of cryptic symbolism, the artist's dispassionate gaze is neither inviting nor challenging as she stands at a threshold or a doorway, her hand poised to turn the knob, leading to an endless suite of other doors, an infinity of other places and boundless possibilities. Is she returning from within? Is she just headed out? Are we to accompany her? An anticipatory atmosphere crackles quietly through the dreamlike image while a small creature, fantastical in form, perches at her feet. Both figures appear expectant, on the verge of something. Let's not keep them waiting.

Fiddling, strumming and tootling through the twilight while lounging about on cosy toadstools, the faerie folk musicians by contemporary artist Brett Manning are a captivating blend of dainty and earthy, and seem envisioned from both ancient books of forest folklore and your favourite well-thumbed local woodland cryptid guide. A maker who wears many hats (probably woven by gnomes with spider silk and beetle wings), Manning's whimsical, magic creations take the form of illustrations as well as cavorting and capering all over the clothing that she designs.

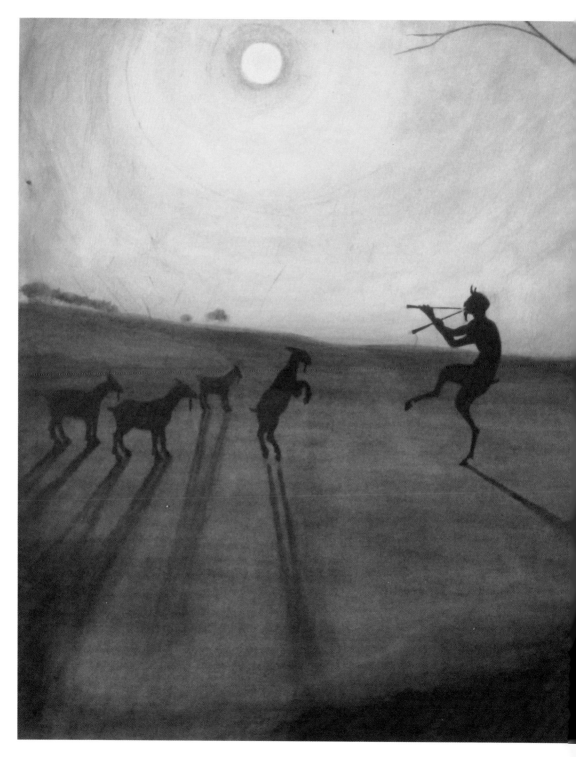

Left: Faun by Moonlight, Léon Spilliaert, 1900, Indian ink wash, brush, black chalk, coloured pencil on paper.

Almost entirely self-taught, prolific doodler Léon Spilliaert (1881–1946) was a painter of the *fin-de-siècle* Belgian avant-garde whose atmospheric works teemed with meditative mystery as well as an eerie sense of existential angst. This noted introvert and insomniac drew influence from Symbolist artist Odilon Redon, as well as master of nocturnes, James Abbott McNeill Whistler, in addition to writers Edgar Allan Poe and Friedrich Nietzsche – it is little wonder then that his canvases were the stuff of inscrutable psychology and uncanny reverie. Although his typical works include peculiar portraits and moody night-time street views and seascapes, in the otherworldly glooms of this haunting landscape, the fantastical figure of a faun is playing the pipes while leading a herd of goats across a darkened field, illuminated by the barest slivers of moonlight.

II

—

Almost
Human

'Do you believe in fairies? . . . If you believe clap your hands.'

— J.M. BARRIE, *PETER PAN*

In *Imaginary Animals: The Monstrous, the Wondrous and the Human* (2013), Boria Sax writes: 'There is some yeti in every ape, and a bit of Pegasus in every horse. Men and women are not only part angel and part demon, as the old cliché goes; they are also part centaur, part werewolf, part mandrake, and part sphinx.' The denizens of Innsmouth are fish people, the Narnian White Witch is part-giant, and Nanny Ogg has a trace of dwarven blood – from the ribald satyr of classic Greek mythology up to the latex-clad Lycan-dominant vampire hybrid of the gritty-goth contemporary *Underworld* franchise, many cultures and mythologies have stories to tell of part-human spirits, demons, creatures, monsters and other fauna of folklore.

A number of these mythical creatures are patchwork composites of different existing animals or of human beings and animals. They may have some of the same characteristics as a human, but their leathery wings, barbed tails or gasping gills offer just a tiny hint to the fact that they are definitely not 100 per cent just like you or me (like we're normal, right? I mean, who are we to judge?). Some of these entities may walk among us if their differences fly under the radar, unnoticed. Or they may live in alternative realities or even appear and disappear under specific circumstances. Some are easier to spot, such as John William Waterhouse's luminous mermaid with the upper body of a human woman and the bottom half of a fish – a creature which appears across Mediterranean legends, dating back to ancient Mesopotamia. A fascination with fairies, dainty damsels and garden spirits was a phenomenon of the Victorian age, and artists from Richard Dadd to Richard Doyle (along with the likes of pre-Victorian artists William Blake and Henry Fuseli, and, later, Arthur Rackham) shared a concrete idea of what the 'Faerie World' looked like, with tiny inhabitants whose dispositions ran the gamut from merry and mirthful to wicked and cruel.

It's difficult to say why or how these not-quite-human creatures emerged in minds and myths, but this compulsive human desire to label and delineate distinct categories for animals and people can be traced back to the Middle Ages. Our identities as 'human', our perceptions of our own uniqueness and dominance over the natural world, defined by our separation from the animal, lingers still – with philosophers and anthropologists long debating the meaning and importance of the human-adjacent creatures that appear in the history of

our stories. In some cultures, they represent various aspects of human nature or may have had an allegorical purpose, acting as cautionary tales. Sometimes they may have been products of overactive human imagination, longing to see someone incredible and picturing human forms on non-human objects or creatures.

These entities sometimes hold wondrous spiritual or magical powers; some are helpful creatures, or at the very least harmless, while others are mischievous or malicious or even meant as blatant representations of evil. Some are painted as protectors, benevolent and wise; others interpreted as tricksters, cunning and crafty, or reflected as rascals or roguish rapscallions. Some are worshipped or feared as gods and goddesses themselves. The trouble with hybrid human creatures – or anything different from us, really – is that they disturb our sense of the world, remind us of how small we are and how little we know. That we, too, essentially are animals, and animals are very much like

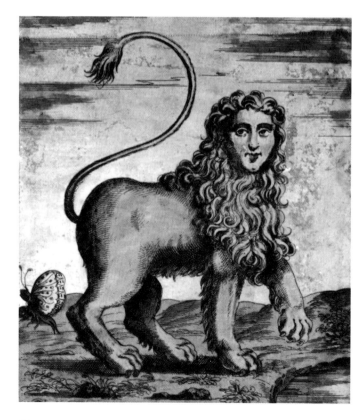

Left: A manticore in *Monstrorum Historia* by Ulisse Aldrovandi, original 1642 (since colourized), drawing.

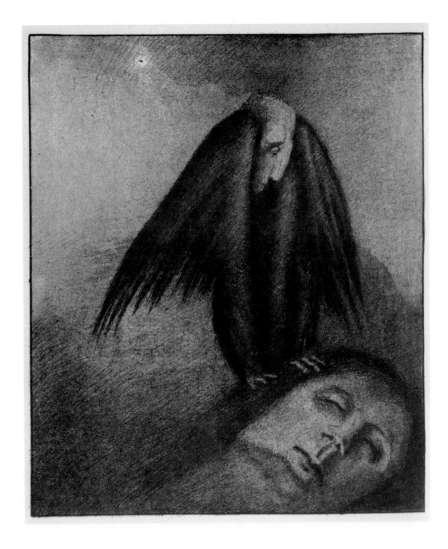

Above: The Vampire,
Alfred Kubin, *c.* 1900,
ink and wash on paper.

us – from the savage end of the spectrum to the wholly, purely innocent. This is the power of the hybrid creature. When we look into its human eyes, we see ourselves looking back from the animal body that we deny we inhabit.

However and whyever they were first invited into our mindscapes, a fantastic array of almost-human entities appear in our most beloved legends, stories, myths and even religions all across the globe, and no doubt these strange and wondrous characters will play a part in our stories and superstitions as long as we are here to dream them into being.

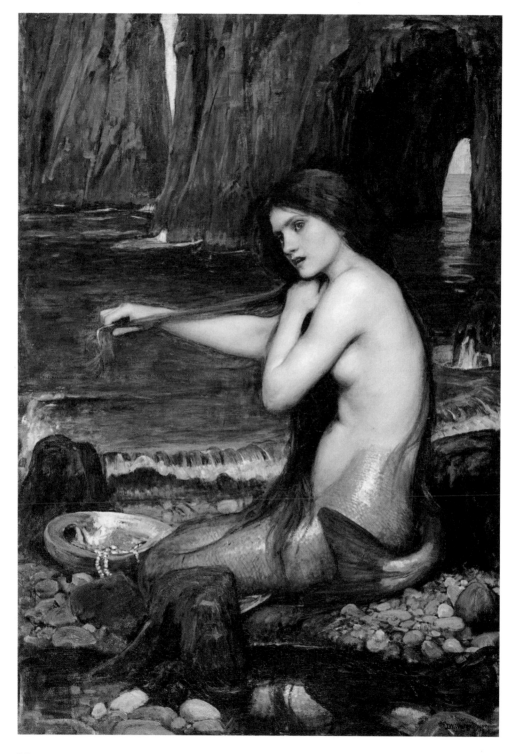

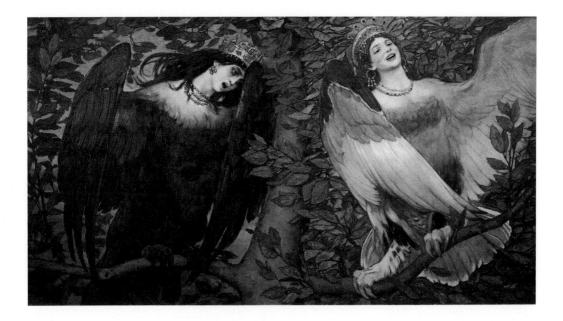

Opposite: A Mermaid, John William Waterhouse, 1901, oil on canvas.

In this captivating image of quiet vulnerability, a mermaid combs her lustrous abundance of hair as she rests on a sprawl of seaweed-strewn rocks in an isolated cove, the shimmering strength of her tail curled beneath her. An abalone shell scattered with pearls and the tears of dead sailors beside her, she wistfully gazes into the distance, unheeding of our eyes intruding upon her moment of reflection. Or do our eyes deceive us? Is this moment of enigmatic melancholia something else entirely? Perhaps a calculated move on the siren's part when, perceiving our gaze, she notes our hunger for magic and miracles, and in feigning unawareness of our presence, it is all the easier to lure us to our watery doom? John William Waterhouse's (1849-1917) fascination with the darker aspects of the mermaid's mythology as both a tragic figure and enchantress drives this work, and with it, he invites us to dive into the mystery and discover her intentions for ourselves.

Above: Sirin and Alkonost — Birds of Joy and Sorrow, Viktor Vasnetsov, 1896, watercolour.

For an artist who initially avoided mythological and historical subjects in favour of a realistic style of painting local people and contemporary life, Russian artist Viktor Mikhaylovich Vasnetsov (1848-1926) certainly revealed a fascination with the fantastically mythic in his later works. Widely thought of as the co-founder of Russian folklorist painting and a key figure in the Russian Revivalist movement, he was integral in moving Realism towards a more nationalist and historical style, believing that a true work of art conveys the past, present and maybe even the future. Vasnetsov's birds are animated and passionate. In this work, Sirin weeps with despair, while Alkonost appears to sing joyfully, gesturing broadly with her wings - they are two sides of a coin, and you cannot have one without the other. Neither of the two has arms, which makes them more bird than human, emphasizing their identity as mythical beasts.

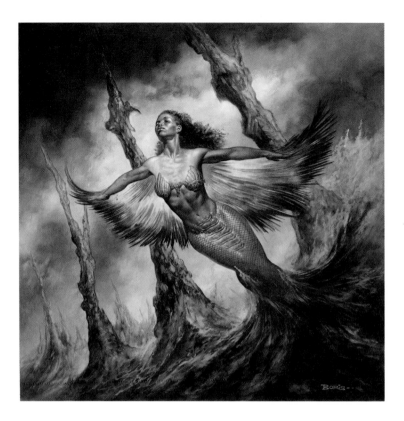

Above: Sunfish, Boris Vallejo, 2018, oil on artist's board.

Opposite: Hemera, Chie Yoshii, 2014, oil on wood panel.

Renowned Peruvian–American painter Boris Vallejo is universally considered to be one of the masters of modern fantasy illustration. His instantly recognizable, lavishly hyper-realistic-to-the-point-of-surreality paintings have appeared on the covers of numerous science fiction and fantasy fiction novels, trading cards and posters, with subjects encompassing heroes from myth and legend, fearsome prehistoric creatures and the cosmic serenity of ocean life. From epic sword-and-sorcery battles to the strange flora, fauna and denizens of extraterrestrial landscapes, Vallejo has painted boldly fantastical visions of almost every major fantasy figure that we know and love ... and showed us some stunning fantasies we'd never even dreamed up!

The lush, luminous oil paintings of Chie Yoshii explore timeless psychological themes through a mythical lens and aim to capture the ethereality of a moment and render it eternal. Her work, a masterful mix of techniques and styles, evokes the atmosphere of traditional Flemish portraiture embellished with meticulous jewellery and sumptuous fabrics, but the direct, commanding gaze of her subjects lends an air of contemporary sophistication and strength. The artist often features animal companions in her works, from the mundane and many-legged to the fantastical winged and scaled variety, and whose appearance suggests companionship and camaraderie rather than danger or menace, or, on the other end of the spectrum, mere pet ownership.

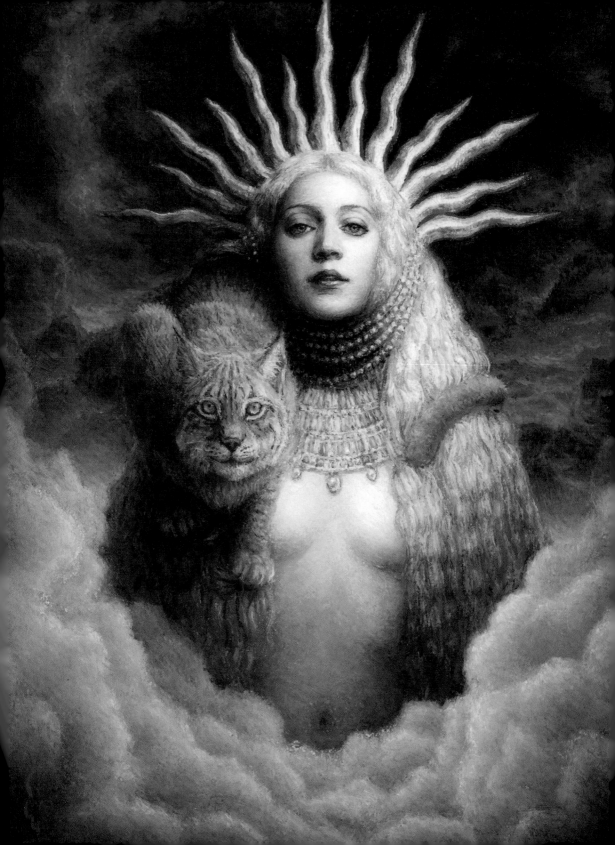

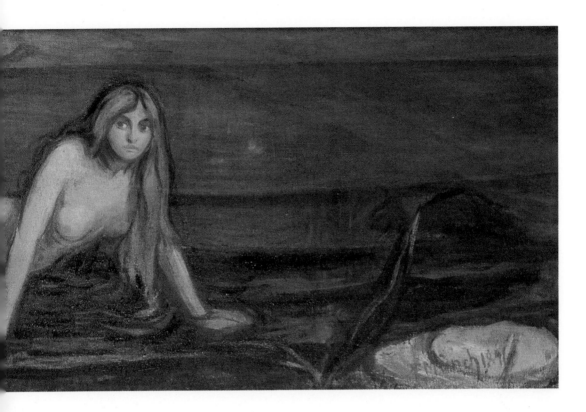

Above: Mermaid, Edvard Munch, 1896, oil on burlap.

Edvard Munch's (1863-1944) mermaid looks like she is desperately looking for an excuse not to show up for that thing she promised to attend, a month ago, when she was maybe feeling deceptively energetic and probably all hopped up on those tricksy endorphins after a vigorous ocean swim. Now she's having regrets because she's a midnight introvert and probably just wants to stay in her grotto, chill out and look at her collection of gadgets and gizmos aplenty. She definitely does not want to be where the people are. Or maybe she's a manifestation of Munch's preoccupation with loneliness and anxiety – in the form of a fish-woman painted by the artist as part of a commission from a Norwegian industrialist for a large-scale decorative work during an extended stay in Paris in 1896-97. Fantasy is only limited by our imaginations, and anxious people's (and anxious mermaids') imaginations no doubt work overtime!

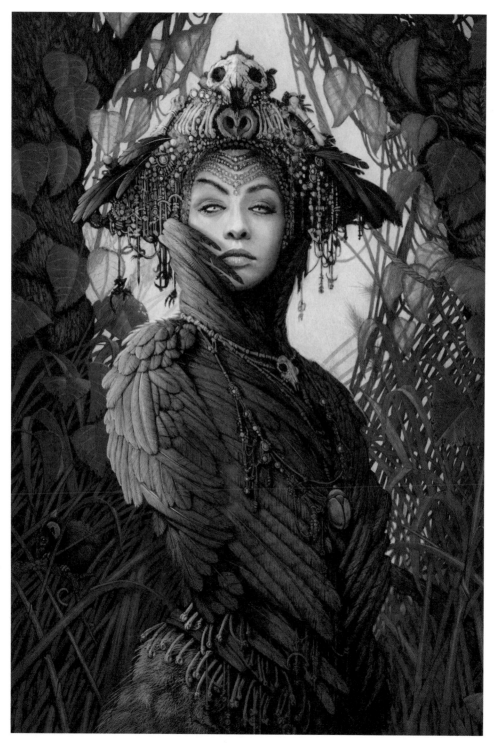

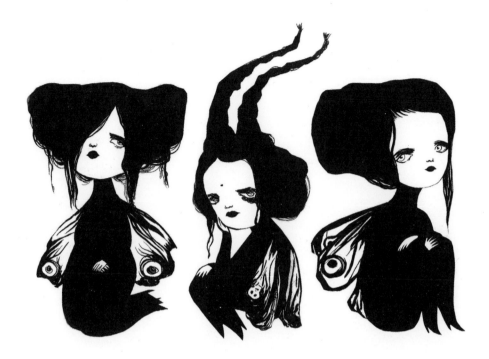

Opposite: Corvid Priestess, Ed Binkley, 2019, coloured pencil.

For three decades, artist Ed Binkley has brought to life traditional folklore through glimpses into imaginary worlds of woodland fantasy. Meticulously detailed faeries, mystical beings and other curious, improbable creatures inhabit these dreamlike realms, ascribed with human-related beauty and possibly imbued with human-like empathy and understanding. Perhaps these beings even seek our human company. In his professorial role at Madison College, Binkley pronounced to his students, 'If you can imagine it, you can create it', a promise fulfilled time and again in the viewing of his thrillingly imagined creations.

Above: Black Fairies, Luciana Lupe Vasconcelos, 2013, ink on paper.

Luciana Lupe Vasconcelos is a Brazilian artist whose work seeks to explore the realms of the mythical and mystical, and whose practice involves an interdisciplinary approach to art and magic. The resulting visions are striking and secretive, brimming with potent symbolism culled from the unconscious, and vibrant with feminine power. This shadowy trio of disaffected fairies look like they could be waiting in line for an event at Whitby Goth Weekend, and, yes, they are totally ignoring you.

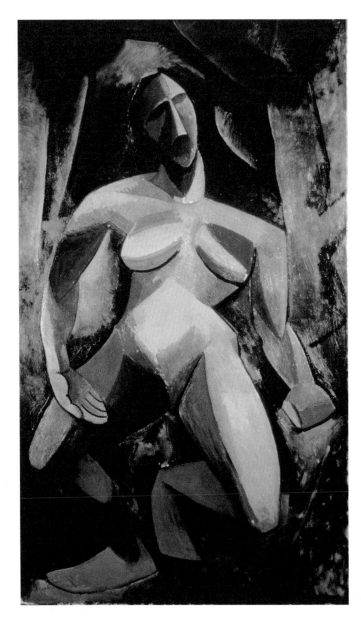

Left: Dryad, Pablo Picasso, 1908, oil on canvas.

Commonly thought of as one of the influential and innovative artists of the twentieth century, the idiosyncratic visionary Pablo Picasso (1881–1973) was a master painter, sculptor, printmaker, ceramics artist and more. Best known for pioneering Cubism, he also contributed to the rise of Surrealism and Expressionism. His cunning use of form and perspective profoundly impacted subsequent generations of painters and his adroitness in combining the variety of styles he worked in made him a legend in the art world, with prolific periods of artistic output that garnered his status as one of the most coveted artists of all time. *Dryad* or *Nude in the Forest* was created during the artist's African period. Dryads, in Greek mythology, were the nymphs of trees, groves, woodlands and mountain forests; in this painting, the forest deity, depicted in shadowed ochres and browns, appears to be emerging from a thicket and broods with hidden natural energies.

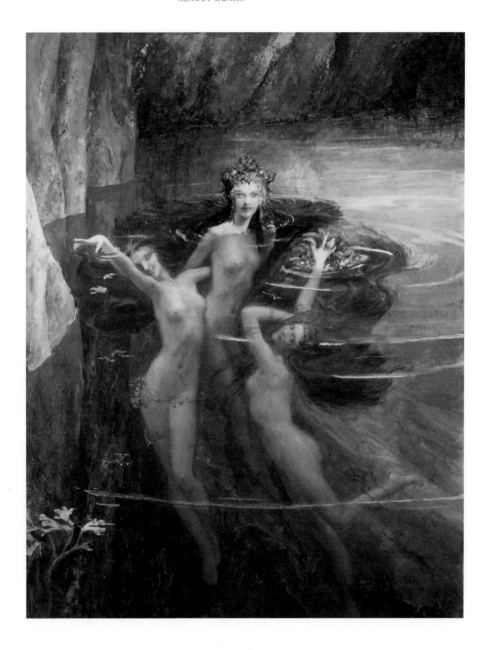

Above: Water Nymphs, Gaston Bussière, 1927, oil on canvas.

French painter and illustrator Gaston Bussière (1862-1928/29) studied at the Académie des Beaux-Arts in Lyon and both worked with and was greatly influenced by his contemporaries, Gustave Moreau and also the Czech painter Alphonse Mucha. His works were visual poems of Symbolist inspiration, glowing and full of vivid embellishments and often evoked the heroes and heroines of the epic mythology. He also painted many depictions of nymphs, nereids and fairies scantily dressed and showing a typical Art Nouveau ideal of beauty, such as this frolicking trio.

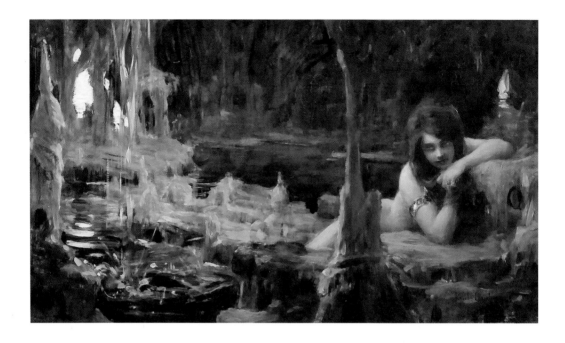

Above: Jeune Naiade, Paul Émile
Chabas, undated, oil on panel.

Opposite: The Court of Faerie, Thomas
Maybank, 1906, gouache on paper.

Celebrated French artist Paul Émile
Chabas (1869-1937) was a member
of the Académie des Beaux-Arts
and a painter of nudes, portraits and
seascapes. They loved him in Europe;
he first exhibited at the Paris Salon
in 1890, and received a number
of awards and accolades over the
next several decades. Sentiments
elsewhere, however, were not as
flattering, and reproductions of his
most (in)famous painting, depicting
a lakeside scene of an unclad young
woman protecting her bare skin
against a cool breeze in the autumn
morning sun, caused controversy and
scandal in the United States. A similar
painting in a literal sense – a watery
scene, its subject *au naturel* – Chabas'
darkly luminous glimpse of a naiad
idling in a crystalline cove leans more
into the fantastic, but the expression
on her face is pure, jaded realism.
'Calm down,' she seems to say, 'it's just
a bit of skin.'

Illustrator, cartoonist, painter and
'bachelor with a big brown beard',
Thomas Maybank (1869-1929) was
a regular Renaissance man, counting
singing baritone and playing the
piano and organ among his other
pastimes. Mostly, however, he was
known for his meticulous depictions of
fairies, pixies and magical landscapes,
works which were used on advertising
posters, prints and children's books
as well as contributions to *Punch* and
The Daily Sketch. Most likely inspired
by Richard Doyle, J. Noel Paton
and possibly George Cruikshank's
earlier fairy illustrations, his charming
and imaginative artworks were
compositions full of character
and movement, and can perhaps
be seen as a forerunner of Walt
Disney's creations.

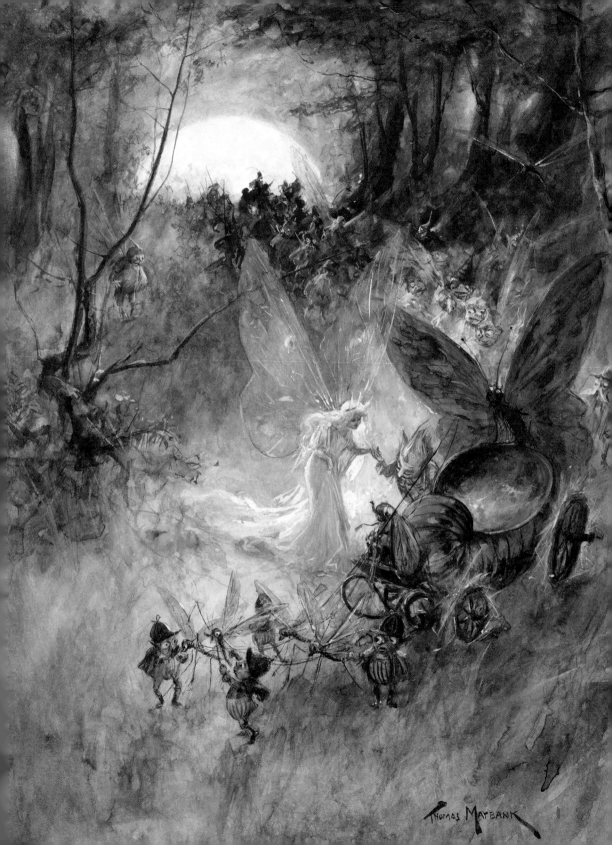

Right: Nøkken (The Water Sprite), Theodor Kittelsen, 1904, ink, watercolour, pencil, crayon, paper.

Theodor Severin Kittelsen (1857–1914) was a Norwegian artist, one of the most popular in Norway. Famous for his illustrations of fairy tales and legends, and eerie Nordic folklore, Kittelsen's dreamlike canvases, rendered in muted tones depicting mountaintop troll magic down to sea ghosts deep in the bogs, reveal his melancholic longing for his countryside. During a stay in Munich, the artist is noted to have opined, 'What appeals to me are the mysterious, romantic, and magnificent aspects of our scenery . . . it is becoming clearer and clearer to me what I have to do, and I have had more ideas – but I must, I must get home, otherwise it won't work.'

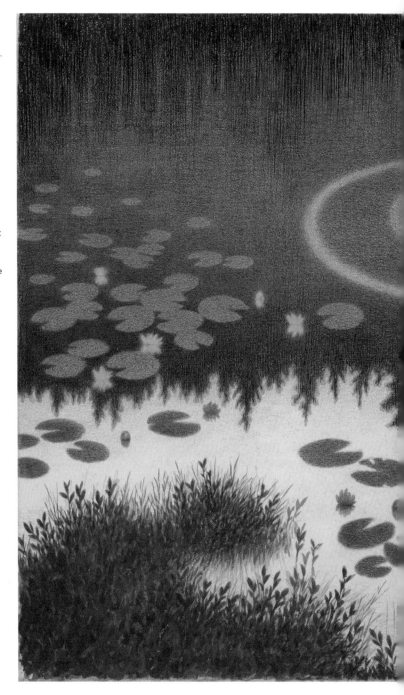

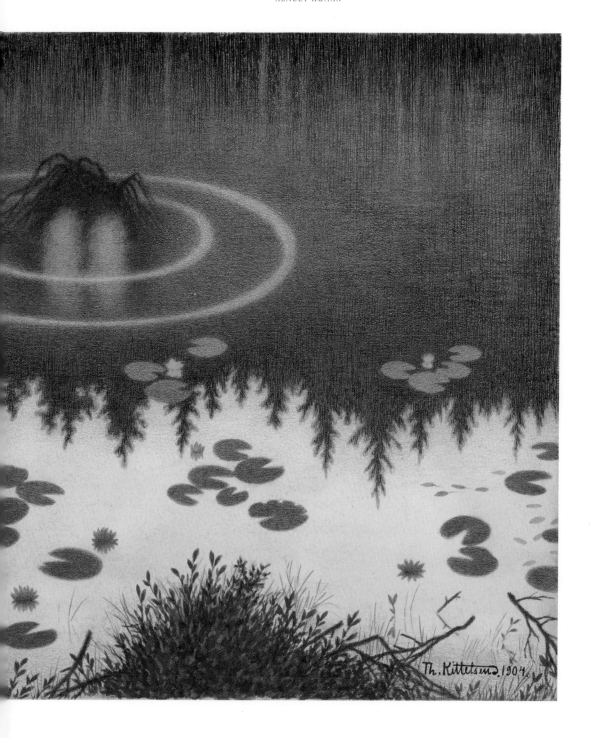

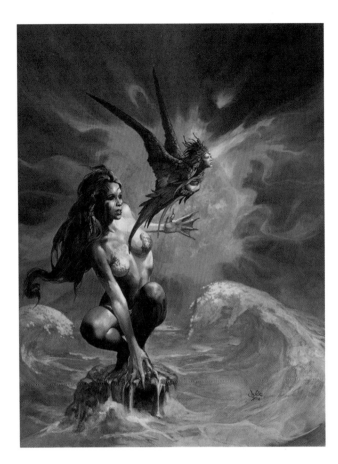

From strong, sculpted goddesses riding winged horses, to the marvel of airborne women soaring aloft on vibrantly coloured wings of their own, the lush, dramatic realism of master fantasy artist Julie Bell is instantly recognizable. A former nationally ranked competitive bodybuilder, her fascination with the body and knowledge of anatomy has allowed her to instil her figures of both humans and animals with grace and strength, and at the heart of this passion is found an intense curiosity and reverence, honour and respect for the vast and varied spectrum of emotions. Julie's work in the fantasy and science fiction field has appeared on hundreds of book covers, collectibles and comic books, where she became the first woman to illustrate *Conan the Barbarian* for Marvel Comics.

Opposite: Medusa II, Julie Dillon, 2022, digital.

The portfolio of Julie Dillon teems with gorgeous visions and glowing vibrance: seekers, saviours, gods and mortals – our eyes are drawn to all her striking, expressive characters equally and intently. Dillon notes: 'I love finding the magic in the world around me, and try to use bold colour and fantastical narratives to express that.' Without a doubt, magic and myth is a common thread that binds these visual tales, from acolytes making ancient, arcane discoveries to docile flying desert turtles and powerful deep-sea spell-working, to a grimly triumphant Medusa astride a man-made (as in made of men!) stone throne.

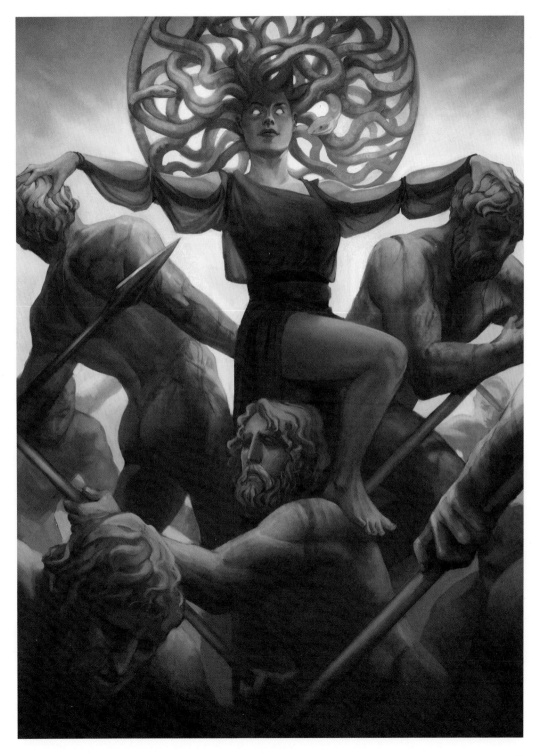

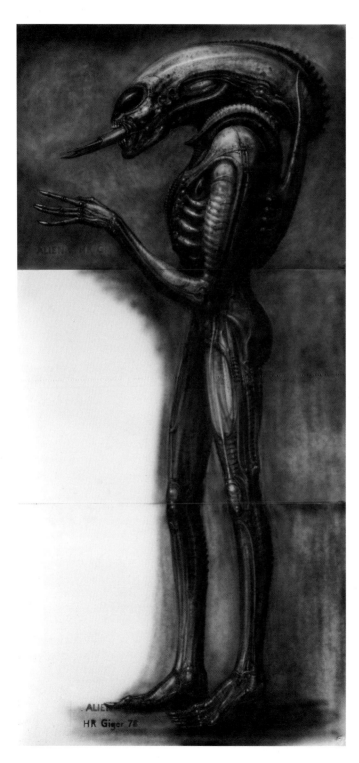

Left: Alien III, Side View II,
H.R. Giger, 1978, acrylic on paper.

The disturbing dreamscapes and unparalleled vision of Hans Ruedi Giger (1940–2014) span paintings, sculptures, film work and iconic album covers. His most famous design, both graceful and grotesque, the perfect embodiment of an otherworldly menace, terrorized Sigourney Weaver on screen in the 1979 film, *Alien*. Giger's work often features biomechanical forms, somewhat human in shape but void of humanity, mechanical in structure but organic in nature. The fantastically dark and surrealistic nature of these beings alarmed and aroused in equal measure, a style of artwork that has had an immense and far-reaching effect in the world of fantasy art.

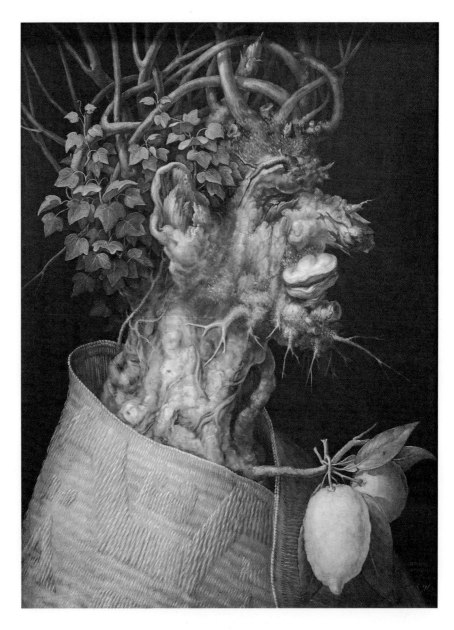

Above: Winter, Giuseppe Arcimboldo, 1573, oil on canvas.

Have you ever daydreamed while gazing at the clouds, finding random images in the patterns of light and shadow? Have you ever zoned out, utterly transfixed when confronted by ornate wallpaper patterns, tracing the intricate imagery with your mind's eye and delighting at what emerges from the whorls and swirls of the repeating motifs of those marbled, mottled microcosms? Well, if that's the case, you're sure to be fascinated by the playful allegorical portraits of Giuseppe Arcimboldo (c. 1526–93), bursting with whimsical visual puns and wacky symbolism. Though these fantastically imaginative composites consisting of everything from flocks of birds to harvest salads may appear a bit deranged, they were meticulously thought out and indulged the Renaissance fascination and delight in puzzles, riddles and games.

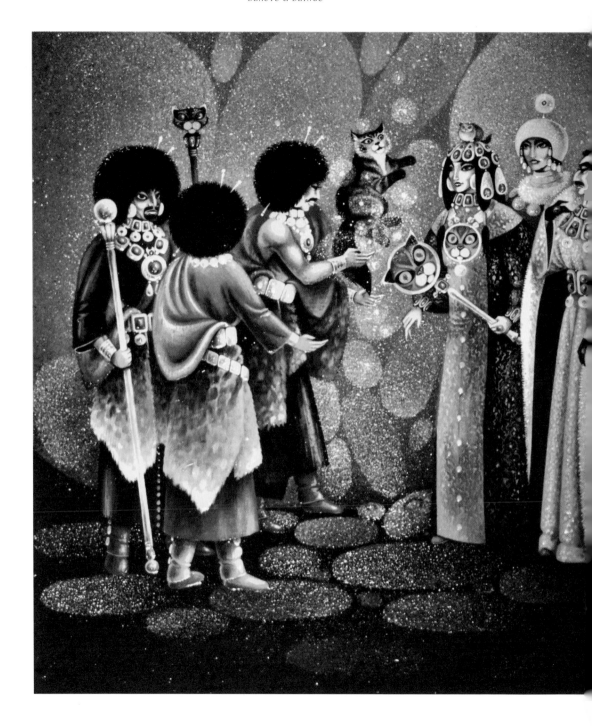

Left: The Presentation, Karen Kuykendall, 1986, acrylic on sand.

I don't know if you had a weird, witchy mother who secreted away tarot decks in every nook and corner of your childhood home, but I sure did. One of these decks absolutely bewitched little me, and to this day I still think it is one of the most mysterious and immersive worlds I have (n)ever visited! Karen Kuykendall (1928–98) drew her inspiration for the 'Cat People from the Outer Regions' featured in that tarot deck of childhood memory from an incredible collection of sources, including Native American folk art, 1960s hippie culture and Ancient Egypt. Like the most memorable fantasy realms, it is complex, rich with detail and highly atmospheric. Today, as I was then, I remain obsessed and ensorcelled with every intricate nuance pertaining to these dazzling people in their elaborate costumes with bespangled Byzantine jewellery and headdresses and fantastical stories that no doubt span generations of fascinating, beautiful Cat People.

III
—

Impossible
Monsters

'Where there is a monster, there is a miracle.'

— OGDEN NASH

C lose your eyes, draw in a deep breath and conjure a monster. Now tell me: what do you see?

Serpentine and slithering with razor-sharp fangs, claws like rusty daggers and leathery wings the length of city blocks? A capering, slavering, eight-legged venomous menace? From Tolkien's fire-breathing Smaug to the gargantuan *kaiju* spawned from the waste of nuclear tests or the distinctly smaller but equally destructive goblin or gremlin, from the gothic horrors of Dracula and Frankenstein to the chimerical creatures traipsing through the pages of medieval bestiaries – monsters can take many forms and appearances. Whether dormant in the lightless dread at the depths of the ocean or menacing us from the skies above, in remote mountain caverns or as close by as just underneath our beds, we have long been tantalized, terrorized and traumatized by the monsters of well-known lore and legend.

Revered, reviled, sinister, sacred – monsters lurk in every corner of the fantastical landscape. Every culture has its own cursed compendium of monsters, and each of these fiends reveals its own story about what torments or frightens us – for these creatures are essentially the manifestations of our biggest fears. The inclusion of monsters in our stories is one tool we have to process and examine these fears. The word 'monster' has origins in the Latin word *monstrum*, which itself derives from *monere* ('to warn'); the word's etymological roots also point to 'that which reveals'. And certainly, much can be revealed about a society in looking to what it is that they deem monstrous; these creatures are a window into our darkest prejudices and phobias. When we examine our monsters, we cast a mirror upon our fears and desires and see the monstrous materialized in the reflection.

When we gaze upon the grim visage of Frankenstein's creation, we grapple with questions about life and death, we try and think critically about the unchecked advancements of technology, and the breakneck societal changes that result. Though Godzilla has come a long way since its genesis in 1954, it originally represented a powerful avatar for the horrors of nuclear weapons and those who wielded them, and Christians in medieval Europe were concerned about temptation and pleasures of the flesh and believed that giving into carnal desires opened the door for the demonic. And certainly everywhere in the world, a tale or two can be found where the monster is calling from within the house! Or, to speak plainly, the monster we fear

in these instances is that which is already within us, generated by our own repressed dark psychology. How did it get there? Where did it come from and what does it want?

Sigmund Freud's early twentieth-century theories about the subconscious mind had a particularly profound impact on the boundary-pushing Surrealists, who embraced the monstrous and produced powerfully disturbing images in their search for the new modern myth. With inspirations taken from their own dreams and nightmares to invoke the horrific vistas of alternate realities, visionaries such as Salvador Dalí, Joan Miró and Pablo Picasso created darkly fantastical menageries of fiends and apparitions that stood in for the all-too-real menaces of racism, nationalism and the violence of fascism.

Below: Polyphemus, Salvador Dalí, undated, gouache, watercolour and Indian ink on paper.

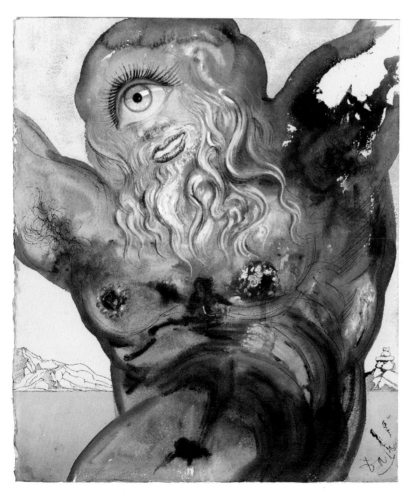

Today this fascination with the wicked, the abominable and the monstrous that has haunted us since the time of our ancestors has not lessened its ghastly grip one iota – we are powerless to resist monsters and their stories! And though most of the creatures from days of yore no longer literally terrify us, we're still inventing monsters to embody the energies of our modern anxieties while we wrestle with the real-world themes that underpin them. Most of our neighbours don't believe the streets will be overtaken by the undead with an appetite for human flesh, but through zombies, we confront our twenty-first-century concerns, often revolving around the fragility of human society. The trolls that once lurked under bridges now prowl social media platforms, mythical monsters in modern disguise to relentlessly provoke and antagonize. And in a strange twist, don't some of the very best monsters foster a sense of empathy in us? In striving to understand their motivations and attribute agency to their actions, we are putting ourselves in their weirdly shaped, enormous shoes and developing a connection and a kinship with that which once frightened us, which we once saw as 'other'. Perhaps this is why throughout our lives, when we close our eyes and conjure our monsters and the emotions that accompany them, those visions continue to change and evolve.

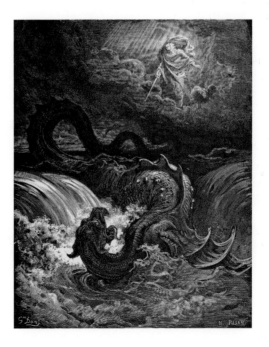

Right: Destruction of Leviathan, Gustave Doré, 1865, engraving.

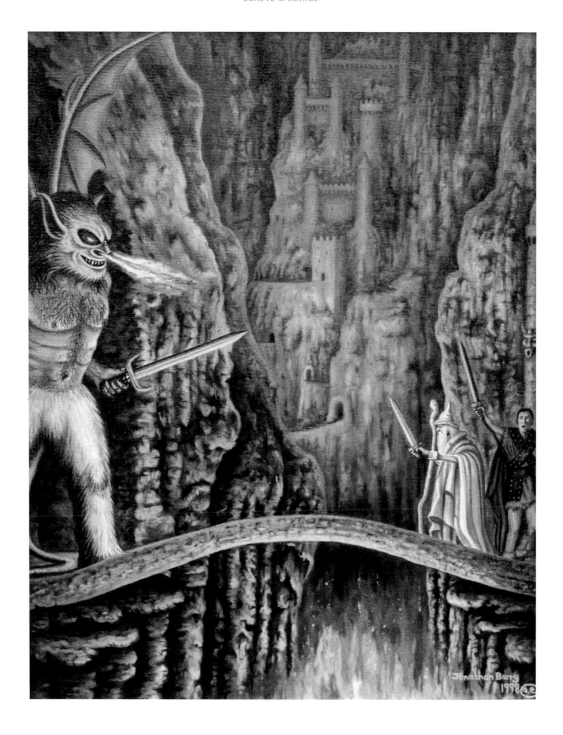

Left: La Tarrasque, Charles Lepec, 1874, oil on canvas.

Following a formal academic education, the artistic career of Charles Lepec (1830–90) began with painting, flourished with the production of elaborate enamels, portrait miniatures and jewellery, and later in life returned to painting, drawing, designing and carving. And architecture! He was, by all accounts, a very busy guy. In Lepec's *La Tarrasque*, the fearsome legendary dragon devastating southern France has been tamed by St Martha, charmed with her hymns and prayers. They are seen here on their way back to the city, but what we don't see, 'off camera', is how the townsfolk, terrified by the monster, just kill the heck out of it. Much like the story *Beauty and the Beast*, the monster is calmed by a feminine influence and then attacked when brought back to civilization. Not entirely apparent from this painting, La Tarrasque was said to have a lion-like head, a body protected by a turtle-like carapace, six feet with bear-like claws and a scaly serpent's tail – but I suppose we can allow Lepec a bit of artistic licence.

Opposite: The Bridge of Khazad-dûm, Jonathan Barry, 1998, oil on canvas.

Contemporary artist Jonathan Barry paints vivid scenes from well-beloved literature and classic stories, such as *Alice's Adventures In Wonderland*, *Peter Pan*, *The Wind In the Willows*, Sherlock Holmes novels and many other classics. In this work, we see wizard Gandalf in The Mines of Moria, when he confronts the Balrog on the bridge of Khazad-dûm. The Balrogs were primordial spirits who took the form of demons cloaked in shadows with hearts of fire and who carried whips of flame in J.R.R. Tolkien's *The Lord of the Rings*.

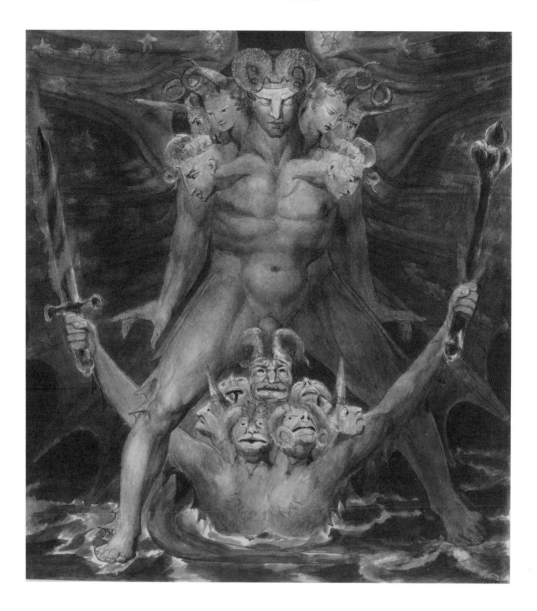

Above: The Great Red Dragon and the Beast from the Sea, William Blake, *c.* 1805, pen and ink with watercolour over paper.

Ambitious, unyielding and utterly original, the dedication of radical visionary poet and painter William Blake (1757-1827) to his craft can be ascertained in even a second's blinking glimpse at a single canvas.

Drawn to grand themes reflecting his deeply held beliefs about humanity's moral and spiritual decline and the pervasiveness of evil and oppressive forces, his works were energized by his comprehensive biblical reading, along with mythology, Milton and other literature, but also echoed his study of art history. *The Great Red Dragon* paintings are a watercolour series painted between 1805 and

1810, depicting 'The Great Red Dragon' in various scenes from the Book of Revelation. In this spectacular sequence, representing Christian faith and the battle between evil and good as predicted in the Bible, Blake depicts the seven-headed and ten-horned dragon as the devil while the creature emerging from the sea also has seven heads, ten horns, a welding sword and a torch.

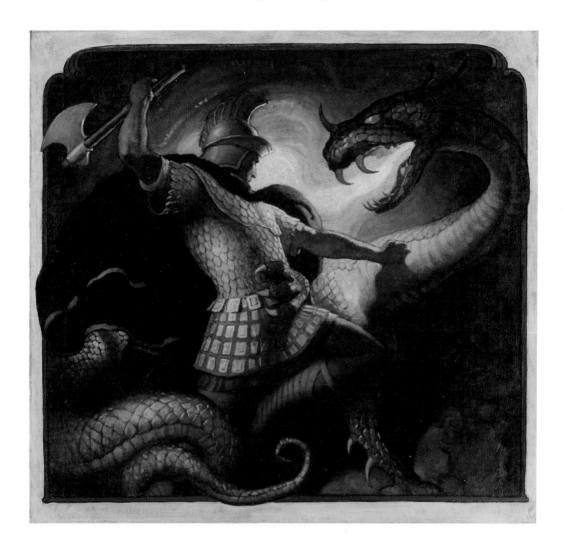

Above: Cover illustration for *Legends of Charlemagne* by Thoas Bulfinch, N.C. Wyeth, 1923/24, oil on canvas.

Newell Convers Wyeth (1882-1945), or N.C. Wyeth, was a star pupil of Howard Pyle who followed the master artist's principles and precepts almost religiously, and went on to spend much of his life and career as one of the best-loved illustrators of his day. Renowned for his illustrations of a long shelf of classic literature,

N.C. Wyeth's vibrant imagery, rich decorative colour and dramatic command of visual narrative brought the pages of *Treasure Island*, *The Last of the Mohicans* and *Robinson Crusoe* to vivid life, along with Thomas Bulfinch's *Legends of Charlemagne*, seen above. Wyeth's valorous characters created prototypes of our American heroes today, and no illustrator of the Golden Age had a wider influence on the world of art than he did.

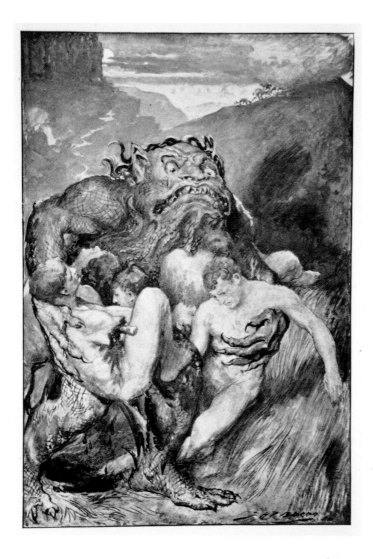

Opposite: Grendel and victims from *Hero-myths & Legends of the British Race* by M.I. Ebbutt, John Henry Frederick Bacon, 1910, lithograph.

Written during the eighth century CE, the English epic poem in the tradition of Germanic heroic legend called *Beowulf* is to Anglo-Saxon civilization what the *Iliad* is to the Greeks. In this work by British painter and illustrator John Henry Frederick Bacon (1865–1914), we are treated

to a rendering of what is likely the poem's most memorable creation, the first and most terrifying monster in English literature, Grendel - one of the monsters that Beowulf battles. Though he has many animal attributes and the grotesque, monstrous appearance of an ogre, Grendel seems to be guided by impulse and sensibilities that almost appear human - envy, resentment, anger. Dwelling in misery among the banished monsters, it's possible

he is not a demon or supernatural entity at all; perhaps Grendel has been vilified as 'the other', a demonic representation of someone outside the tribe. Either way, when you kill and eat your victims, the hero is probably not going to pause in his quest to suss out whether you're a murderous beast or a badly behaved human outsider - he's just going to rip your arm off and vanquish you.

Above: Nemo and Squid, Leo and Diane Dillon, 1999, acrylic on acetate.

It must have been fate, or the stars aligning, or any one of those flowery phrases of magical happenstance that our favourite fantasies contain. Born 11 days apart on opposite coasts of the United States, Leo (1933–2012) and Diane Dillon met, competed artistically and eventually fell in love while attending Parsons School of Design, each aspiring to a life of art.

After their marriage in 1957, the artists initially pursued separate careers in illustration before recognizing their strengths were collaborative in nature. In an effort to work in a particular style that they both could master, they symbiotically and seamlessly melded their personalities and styles into an entity/partnership that they came to refer to as 'the artist'. The resulting effect of strikingly original and sumptuous beauty was a seamless amalgam of both their hands. The

creators of fabulous science fiction and fantasy scenes based on the stories of Ray Bradbury, Harlan Ellison and others, the Dillons have won numerous prestigious awards for their book-jacket illustration in the fields of history, children's fantasy, classic literature, folk tales and contemporary fiction.

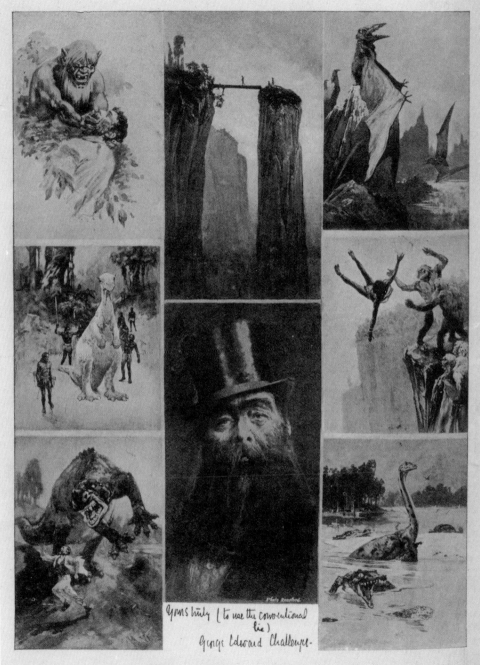

Yours truly (to use the conventional lie)
George Edward Challenger.

Photo Reserved

"THE LOST WORLD."

The Leader of the Explorers, with some of their Adventures.

Opposite: Illustrations from *The Lost World* by Arthur Conan Doyle, Joseph Clement Coll, 1912, pen and ink.

Above: The Serpent, Victor Hugo, 1866, paper, pen and ink wash.

American illustrator Joseph Clement Coll (1881-1921) was renowned as a vividly imaginative master of the pen and ink medium, capable of marvellous delicacy and great boldness in his dramatic, dazzling strokes. Coll's illustrations hail from *The Lost World*, a science fiction fantasy novel by British writer Arthur Conan Doyle, published by Hodder & Stoughton in 1912, centred on an expedition to the Amazon basin of South America where prehistoric creatures continue to survive. Led by Professor Challenger, the explorers confront all manner of peril and dinosaur horrors; particularly striking is the fearsome pterodactyl-type creature cawing into the chasm (top right).

While we may best know French poet, novelist and playwright of the Romantic movement Victor Hugo (1802-85) as the wordsmith responsible for *Les Misérables* and *The Hunchback of Notre-Dame*, you might be surprised to learn that he was a brilliant artist who produced more than 4,000 experimental and enigmatic drawings and paintings during his lifetime. Originally a casual hobby, drawing became his sole creative outlet during the time of his exile ; labeled as a traitor for his outspoken political views during the reign of Napoleon, Hugo was forced to leave his homeland, and did not return to Paris for 15 years. Having transferred to his art the creativity that had until that time found expression in literature, Hugo doodled brooding landscapes and sombre fantasies of castles and medieval towers, alongside grotesque figures from folk tales and legend on a small scale, typically in dark brown or black pen-and-ink wash, sometimes with hints of white, but rarely with colour. Remarkably adept at his 'hobby', the results of Hugo's talent were later remarked upon years later by Van Gogh as 'astonishing things'.

Right: Two Dragons (in Clouds),
Kano Hogai, 1885, ink on paper.

Originally a painter for the shogun,
Japanese painter Kano Hogai
(1828–88) made efforts to innovate
Japanese-style paintings, boldly
pioneering the *nihonga* art style
of painting that reframed existing
ink and calligraphy techniques and
experimented with the depth and
three-dimensional perspective of
Western artistic conventions. His art
eventually evolved into novel, eerie
images meant to satisfy both Japanese
and Western audiences. Hogai is
perhaps best known for his paintings
of dragons, birds and Buddhist gods;
in this scene, we observe two powerful
dragons intertwined and playfully
fighting in the sky.

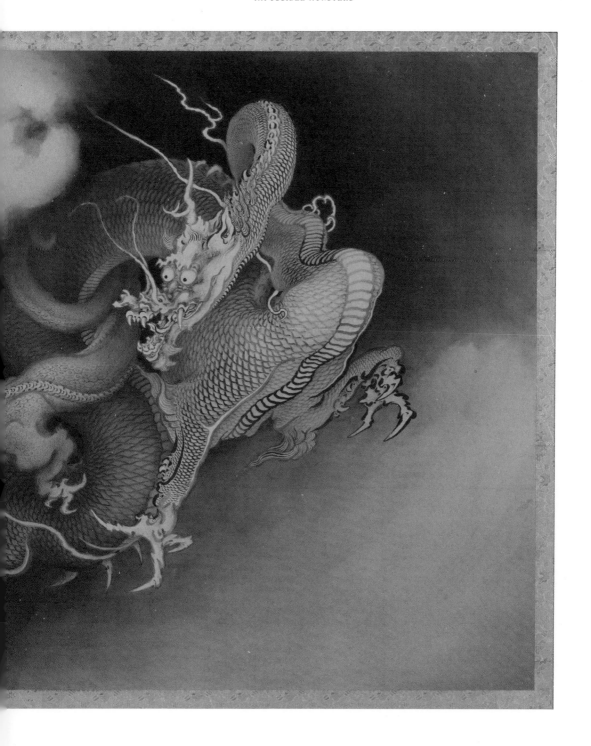

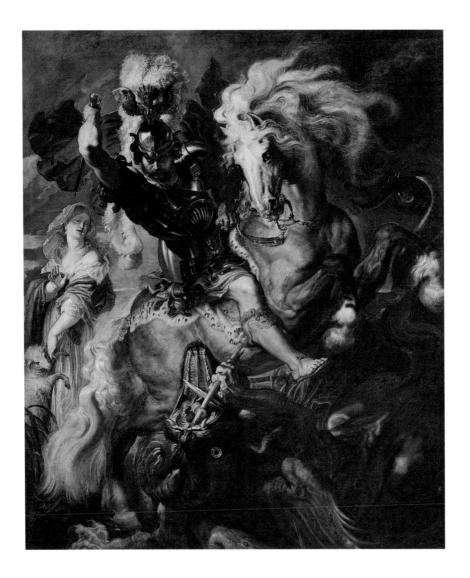

Above: St George and the Dragon, Peter Paul Rubens, *c.* 1606, oil on canvas.

In Jacopo de la Voragine's *The Golden Legend* (compiled *c.* 1259-66), St George slew the dragon that was menacing the people of Silene, saving a princess in peril. The story goes that the dragon originally wrested tribute from the villagers. When there was no longer enough livestock or trinkets to appease the dragon, they began to resort to a human offering once a year. In this dramatic painting by Peter Paul Rubens (1577-1640), St George and his steed symbolize the triumph of good over evil, a Christian hero riding a spirited white stallion and brandishing his sword against the evil foe. Behind the horse and rider, the princess looks on next to a lamb, ostensibly representing innocence and purity and the Church and all that jazz.

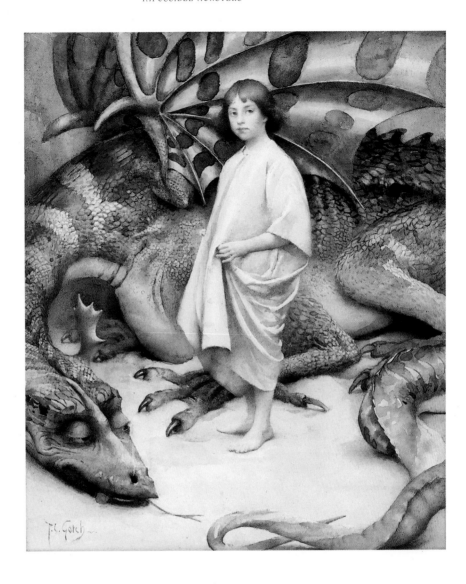

Above: The Child in the World, Thomas Cooper Gotch, *c.* 1900, watercolour on paper.

English painter and book illustrator Thomas Cooper Gotch (1854–1931) initially painted natural, pastoral settings before settling into the Romantic, Pre-Raphaelite style for which he is best known. Gotch explained *The Child in the World* as a young person 'standing alone and unafraid in the innermost, horridest home of the Dragon, called the World, who is powerless against her innocence'. The model for the child was his daughter Phyllis. Apparently, Gotch was fussing with this work quite a bit, as different versions exist in oil, pencil and watercolour. The oil version was exhibited at the New Gallery in 1895, to mixed reviews: some critics thought the dragon sillier than it was scary. I don't think they're wrong, but not all monsters are terrifying to behold, and not even all of them mean to frighten us. And I think that's a good lesson for a human – of any age – to take to heart.

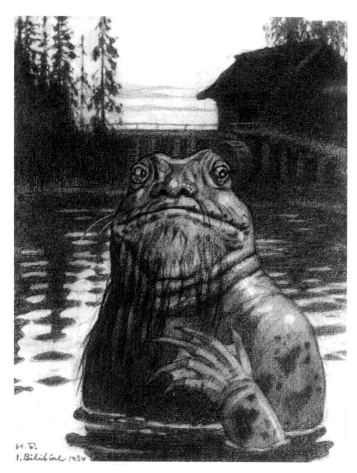

Peerless illustrator of Russian folklore,
Ivan Bilibin (1876–1942) was a
graphic artist and stage/costume
designer who was largely influenced
by Art Nouveau and whose work is
commonly associated with Russian
fairy tales – to the extent that we could
say his work very much defines our
perceptions today of what Russian
folklore art looks like. Seen here
is Bilibin's depiction of a water-
dwelling demonic creature found in
the mythology and lore of Eastern
Europe – the Vodyanoi. A bloated,
cranky frog-faced old water spirit,
who, when angered, breaks dams,
washes down water mills and drowns
people and animals – the surest way
to rile the Vodyanoi is to upset the
natural balance of his watery habitat.
Although according to legend, he can
be appeased with a knob of butter.
That seems fairly relatable.

Opposite: Creature, Vincent Di Fate,
2006, acrylics on hardboard.

A multiple-award-winning artist
specializing in science fiction and
fantasy illustration, the works of
Vincent Di Fate span the remote
frontiers of astronomical art and
aerospace illustration – space chases,
futuristic supermen, machines born
of dreams or nightmares. Astonishing
voyages of the imagination to the
edge of the cosmos and vast worlds
inhabited by incredible beings, light
years away from planet Earth. Some
of these visions, however, live a little
closer to home. Di Fate casts an
eye on one of the 'truly remarkable
character designs of the 1950s
science fiction movie genre', that
infamous gilled man captured by
scientists in the Amazonian jungle.
Thought to be a missing link between
creatures that lived in the water
and those that walked on land, its
appearance is both fantastical and
terrifying, and, in Di Fate's hand,
rendered breathtakingly beautiful,
as well.

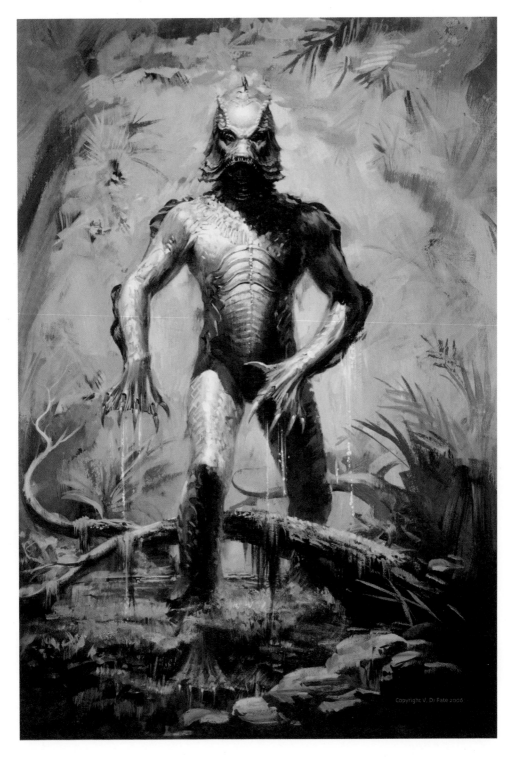

Copyright V. Di Fate 2006

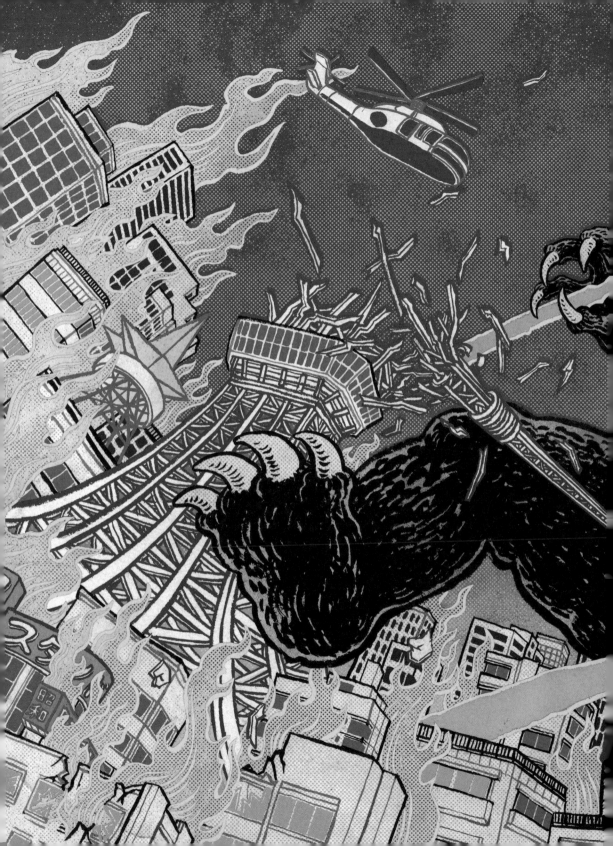

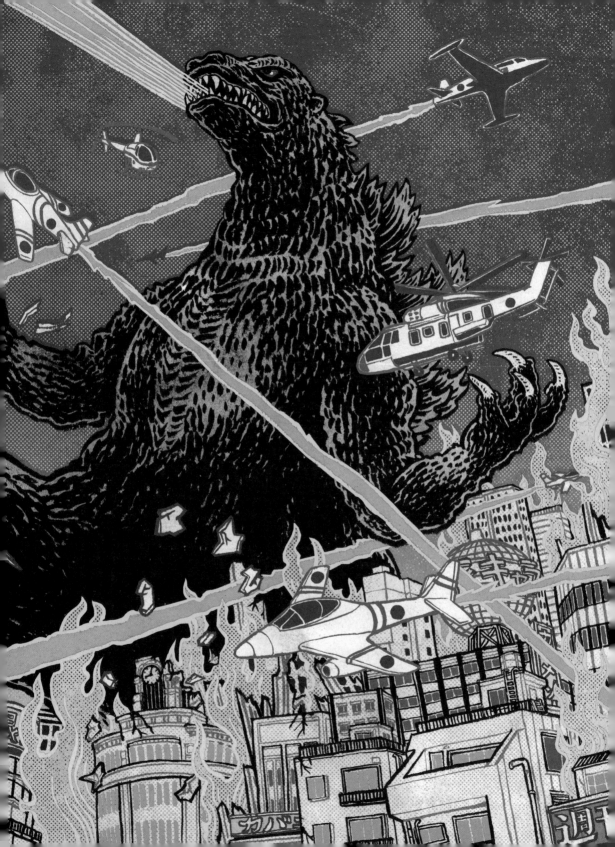

Previous spread: Godzilla, Yuko Shimizu, 2019, ink drawing with digital colour.

Above: Dragon, Witold Pruszkowski, 1896, oil on canvas.

I don't think any monster list is complete without our favourite enormous, destructive king of nuclear waste-spawned monsters, Godzilla. With his gigantic stature, scaly body and atomic breath, Godzilla is basically a dragon from 'traditional' fantasy art, right? Gobbling up citizens and scientists instead of knights and crusaders, devastating vast metropolises towering with glassy skyscrapers as opposed to castles and fiefdoms. Well, I think that Japanese artist Yuko Shimizu might agree, if her fantastical rendering of the king of *kaiju* is any indication. Vividly coloured, boldly realized and with striking details, Godzilla here is a towering sci-fi fantasy dragon viewed through a surreal American pop and Japanese graphics and comic culture lens.

The hazy, dying embers of a setting sun sets up the moody backdrop and contributes to an uncanny sense of romanticism in nineteenth-century Polish painter Witold Pruszkowski's (1846-96) golden hour portrayal of this fearsome beast. Is this dreadful dragon violently twisting towards an armor-clad foe in advance of an incendiary last stand, one which will either end with a barbecued knight or beast with a sword in its heart? Or is this merely a benevolent beast discharging a fiery belch, goggle-eyed with embarrassment? Whether we're quivering with terror or with barely repressed giggles and *Fremdschämen*, the artist's fondness for fantasy and fairy-tale archetypes, combined with a keen eye for weird detail and mystical atmosphere, paints a curiously evocative picture of this mythical monster.

Above: The Sphynx, the Substance, and the Dreamer, Jason Mowry, 2017, watercolour and gouache.

Expressed in the languid dream of a sombre, sumptuous palette and resplendent with atmosphere and emotion, the work of Jason Mowry trembles in a thrillingly familiar way, caught between the border of formal and fantastic. We may not know who these subjects are or what they're up to, but from the monstrous figures to the human characters that look just like us, there is something in their story that we recognize nonetheless. These strange, sentimental visions combine myth and legend, personal narrative and symbolic imagery in a visual language that speaks a timeless spell, that bypasses the modern viewer's analytical safeguards and sings to something ancient and ancestral in their blood.

Above: Fighting a Vampire, Bolesław
Biegas, *c.* 1916, oil on board.

Bolesław Biegas (1877–1954) was a
Polish Surrealist painter and sculptor
best known for his fantastically bizarre
and sometimes scandalous 'vampire-
as-femme fatale' style of art featuring
mythical, monstrous chimeras, which
symbolized a violent battle of the
sexes. One of a large number of
Polish artists working in *fin-de-siècle*
Paris, there he found a more kindred

artistic environment in which to
flourish rather than the conservative
Academy of Fine Arts in Krakow
which had expelled him in 1900.
Despite the academic blemish, with
staunch support from the editor of
the Paris Symbolist literary and artistic
revue, *La Plume*, and membership
in the Salon d'Automne, Biegas
firmly established himself among
the Parisian avant-garde and artistic
community of the time.

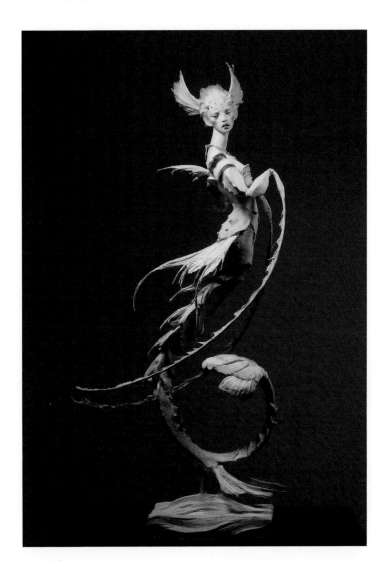

Above: The Beautiful Crustacean, Forest Rogers, 2016, mixed media, Japanese air-dry clay with mulberry paper.

One gets the sense that Forest Rogers is an artist who has experienced first-hand both the joy and despair of mermaids singing, has felt the euphoric, incandescent flutter of angel wings, held the literal hand of the dark night of the soul and maybe even danced a tango with a prehistoric skeleton or a luminous beam of starlight. How else would this artist instinctively know how to sculpt the ineffable, the transcendent, the staggeringly unbelievable into such a graceful and dynamic reality? These creatures, marvels of myth and imagination, monstrously beautiful and tinged with melancholy, seem poised at the verge, a frozen moment of fragile movement - as if they may at any moment take flight and disappear with their secrets into the mist, or skitter close and whisper mysterious revelations. Approach them with care, take only what is offered to you and let the world go on, knowing that you have experienced a bit of the magic that made them.

Quest for Knowledge

'You must let what happens happen. Everything must be equal in your eyes, good and evil, beautiful and ugly, foolish and wise.'

– MICHAEL ENDE, *THE NEVERENDING STORY*

Opposite: Fatality, Jan Toorop,
1893, chalk and pencil on paper.

The forbidden pursuit of arcane knowledge, dangerous voyages into unknown realms or the search to unlock the secrets of immortality – these are the never-ending quests of curiosity that we tend to associate with fantastical tales and the evocative visuals that accompany them.

Seekers and saviours, magic and miracles, revelations, hallucinations and sinister confabulations – art history teems with daring adventures of inquiry and mystery. From the nebbish antiquarian to the faithful seminarian to the unexpectedly philosophical barbarian, we can see these figures in fantasy art the world over, stoking the fires of our imaginations, envisioning their impossible escapades and enterprises.

What is it that draws us to imagery evocative of dreams and magic, faith and philosophy? Gods and demons, magicians and sages, prophets and priests, as outlandish and otherworldly as

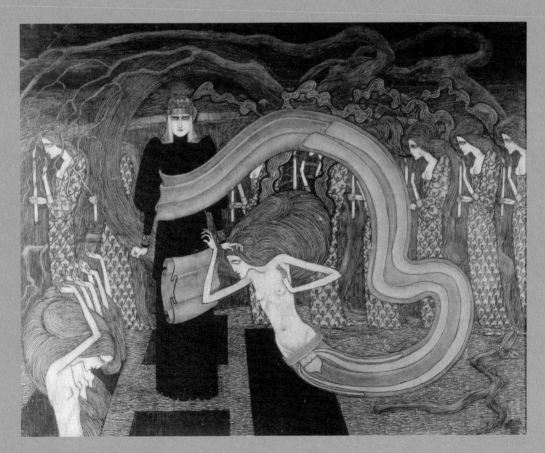

these figures might seem, their stories are a collection of dreams and imagination, observation of reality and a profound study of humanity. Historically rooted in folklore, mythology and religion from all over the globe, these archetypes speak a collective language of the extraordinary through a kaleidoscope of the fantastical. But they are also a reflection of us – both exactly as we are for good or ill – and all that we have the potential to be.

Where do we come from? Where are we going? What even are we anyway? Through art, we discover pieces of ourselves and our fellow humans in the characters we encounter; we become sensitive to hidden marvels and mysteries hitherto unexplored or that perhaps we had previously overlooked; our hearts become softened by beauty and wonder, receptive to new ideas and answers to questions we may not even have realized we were asking. We may contemplate the mysteries of the sacred and divine, as does the shadowy subject of *The Magic Circle*, by John William Waterhouse, ruminate upon the unknowable essence of fate in the gloomy golden swirls of Symbolist Jan Toorop's *Fatality*, or simply wax philosophical on the nature of beauty and horror as we glance between works such as Margaret Macdonald Mackintosh's glowing and gorgeous *The Heart of the Rose* and Aubrey Beardsley's rather horrid and sinister depiction of Virgilius the Sorceror.

Transformation and metamorphosis, evolution and revolution. Art can lead to change, and the capacity for change is at the heart of being human. I believe we are drawn to these seekers and searchers on their perpetual quests to 'level up' because we want the same for ourselves. When we know better, we become better and can do better. When we dream the impossible, hope for the unattainable and imagine the unimaginable, we take that first step on the journey of exploration and enlightenment, and we are creating the most extraordinary magic there is.

Opposite: Virgilius the Sorcerer, Aubrey Beardsley, *c.* 1893, pen and brush and black ink, over traces of graphite, on ivory wove paper, laid down on board.

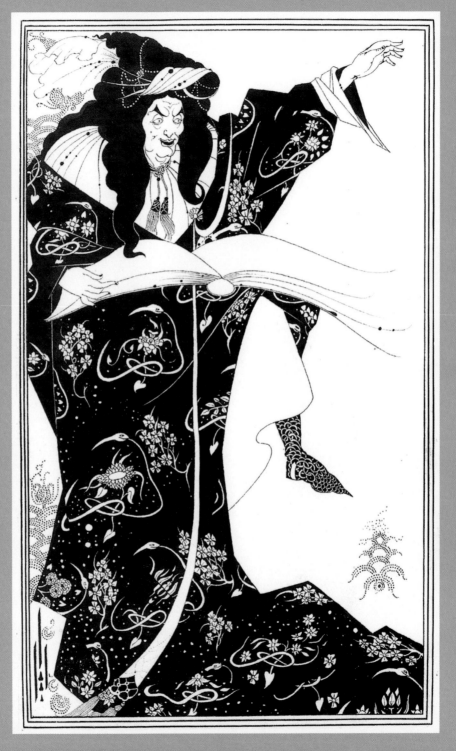

IV

In Our
Dreams

'I've always had access to other worlds. We all do because we dream.'

LEONORA CARRINGTON

Those few seconds upon waking, that disorienting feeling in which reality and fantasy become one – when all of the surreal imagery of the dream, strange sequences of ideas blurring together and lingering in your consciousness just feels *so incredibly real*. Dreams are weird that way. And though a universal phenomenon, they are intensely personal and a confounding combination of hard to remember, difficult to forget and hopelessly complicated to describe. How do you talk about these moments? How do you depict the unreal and utterly indescribable? And do people really even want to hear it, or see it? Many folks are of the belief that there is nothing more tedious than to suffer through the telling of someone else's dreams – and as dreams are really just random flotsam without narratives or structure that we can barely articulate in any meaningful way, can we really blame them?

Yet time and time again, artists and writers have looked into the recesses of the unconscious mind for inspiration, and found myriad ways to record the mysteries of these ephemeral fantasies and inner visions. Through their artful interpretations of dream worlds and illusory realms we begin to see these reveries as anything but dull – rather, a dazzling source of visual brilliance through which our waking world is seen anew.

Dreams are a common theme in art history. Mysterious and elusive, these phantom figments and filaments work at prickling our curiosity, tickling our fancies, disturbing and fascinating us all at once. For the Romantics, dreaming was not only an escape but also a mystical revelation of what was deep in one's soul; dreaming was at the heart of the nineteenth-century Symbolist aesthetic, as evidenced in the works of artist, poet and 'King of dreams' Odilon Redon, considered by many to be the figurehead of Symbolism and the Surrealists (Salvador Dalí, René Magritte, Max Ernst, Leonora Carrington and so on), each painting from the liminal space of the seen and the invisible, revelling in the nonsensical and eerie resonances found there.

The boundless capacity shared by the dream and the artistic imagination can also be found in the much gazed-upon illustrations of our favourite stories, intensely enjoyed as children and again while finding our way towards adulthood: *Sleeping Beauty* ensorcelled us as children, *Alice's Adventures in Wonderland* led us down all sorts of delightful rabbit holes of our own. One of the earliest newspaper comic strips recounts Little

Nemo's adventures in Slumberland. Gothic fantasist Edgar Allan Poe, whose tales were often eerily illustrated by Harry Clarke, enigmatically asks: 'Is all that we see or seem / But a dream within a dream?' Many of H.P. Lovecraft's stories were directly inspired by his own personal dreams and nightmares.

Today, artists who grew up on a steady diet of such visual dream-fuel dazzle and confound us with explorations of their own nocturnal journeys and visions, investigating the twists and delights of midnight fear and desire in a vast array of mediums – paintings, videos, sculptures, costumes and installations. These artistic reveries giving form to the fantastic can be seen as recordings of a personal nature, intimate ephemeral feelings and internal fantasies, or perhaps speak to something much grander, plumbing the depths of the unconscious mind to connect to the unseen forces of the universe. The psychological experience of the self in connection with the world around us is, of course,

Below: The Sleeping Beauty, John Collier, 1921, oil on canvas.

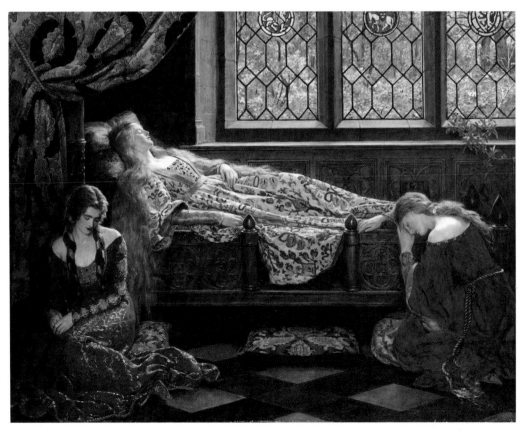

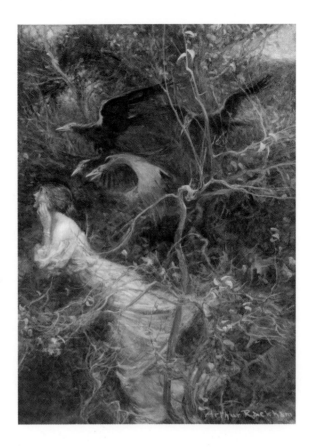

common to artists of every era, and every culture. And the rest of us, too – even if we can't draw a stick figure to illustrate it, we still dream. We understand this urge and connect with it as well.

By the time we've lived out our lives, we will have experienced a lot of dreamy art, whether culled entirely from the sleeping brain of an artist, or via dreamtastic books and films – and spent an estimated 50,000 hours actually dreaming in our beds. That is a goodly amount of time hanging out with the night-time shades and shadows, those troubling, vexing, fascinating companions of the dark. And even if we're not eager to hear our sibling's boring mumbles about whatever nocturnal humdrum thing happened to them last night, we certainly remain captivated by the dreams, those exaltations of the unbridled imagination, the fantastical and nightmarish mysteries and masterpieces wrought on canvas, page and screen by our favourite artists.

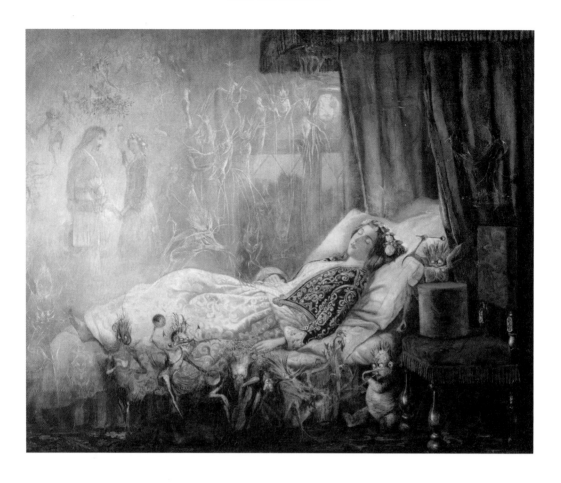

Above: The Stuff That Dreams Are Made Of, John Anster Fitzgerald, 1858, oil on canvas.

Nicknamed 'Fairy Fitzgerald', John Anster Christian Fitzgerald (1819–1906) was a Victorian-era fairy painter and portrait artist. In moods both sinister and mischievous, featuring birds and other tiny creatures, as well as a fabulous array of fairy folk, these works have a hallucinatory atmosphere, as if they were the illusion of drug-induced dreams; his work has often been compared to the hallucinatory weirdness of Hieronymus Bosch and Pieter Brueghel the Elder. When pictured outside the enchanted home of their woods, does it appear as if these diminutive entities are collectively composing the young person's nocturnal reveries? Or, are the fairies but a fantastical detail of the dream?

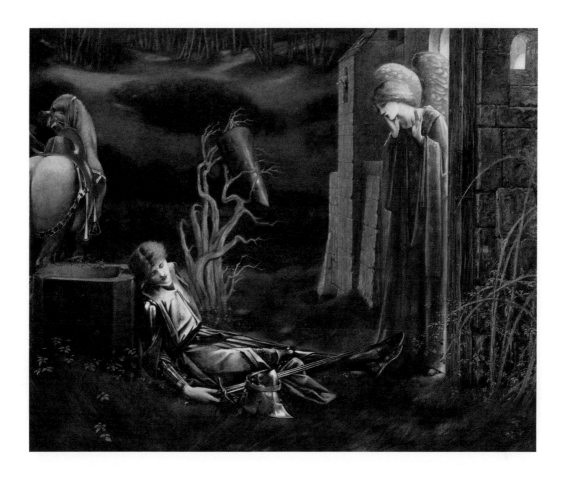

Above: The Dream of Sir Launcelot at the Chapel of the Holy Grail, Edward Burne-Jones, 1896, oil on canvas.

Sir Edward Coley Burne-Jones (1833-98) was a painter associated with the later phase of the Pre-Raphaelite movement. Typical of this artist's work and, in general, that of the Pre-Raphaelite artists, *The Dream of Sir Launcelot* is medievally inspired, with its source being found in the Arthurian legend. On the quest, Sir Launcelot, one of the Knights of the Round Table, encounters the Holy Grail in a half-awake and half-dream state. He tries to lift it but cannot. His failure, he realizes, is because his heart is not pure. The knight is portrayed asleep against the head of a well. His helmet sits by his side, while his sword rests in his hand and his shield hangs from a withered tree.

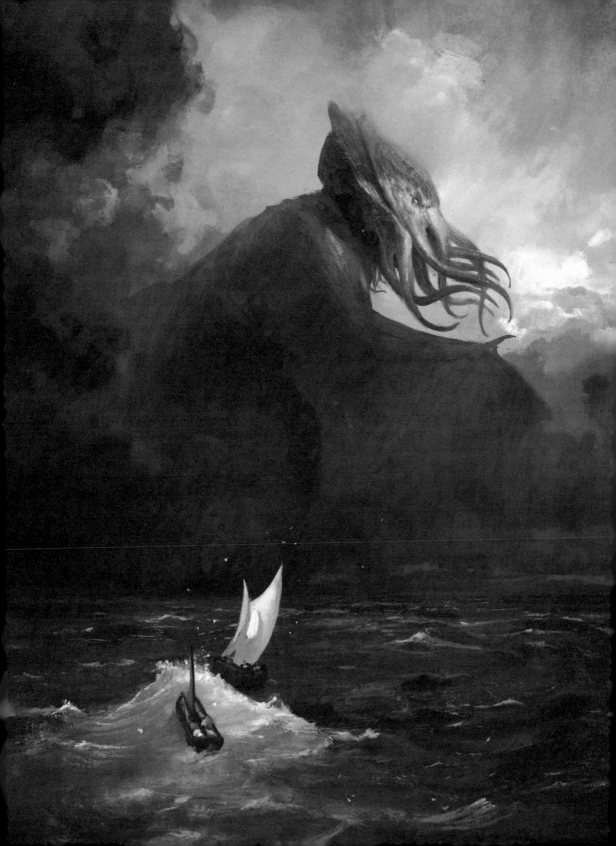

Right: Seeing Things at Night,
Maxfield Parrish, 1904, oil on paper.

Calling himself 'a mechanic who
paints', Maxfield Parrish (1870-1966)
claimed not to understand his own
popularity and once remarked,
'I am hopelessly commonplace, I
don't know what people see in me!'
Nevertheless, Parrish's paintings
of beautiful surroundings and
delightful characters charmed the
public during America's Golden Age
of Illustration (1850-1925) and have
been used for book illustrations,
large murals and magazine covers.
Among the artist's idyllic paintings
of fairy tales and nursery rhymes,
this nocturnal scene of grim goblins
haunting a child's bedtime seems
a little dire. Humans have been
creating art from the shifting ciphers
of their slumbering midnight riddles
since the dawn of time – I wonder
what nightmare of Parrish's might
have inspired this work?

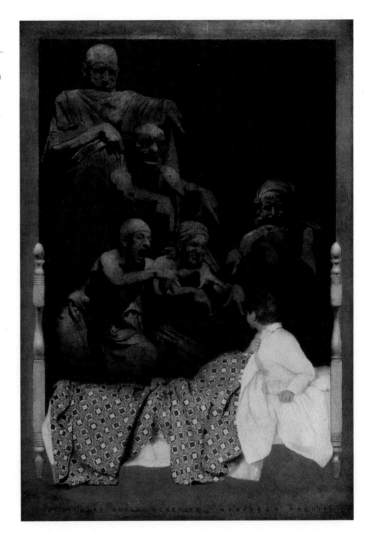

Opposite: Cthulhu Rises, Bram Sels,
2017, digital.

Fiction writer H.P. Lovecraft's most
enduring monster of oppressive
horror, Cthulhu, despite being 'too
abstract to be accurately described by
human perception', as well as possibly
the sanity-destroyer of anyone who
even catches a glimpse of the ancient
creature, sure shows up in a lot of our
fantasy art. A god-like, inconceivable
cosmic entity with a vaguely
anthropoid outline, an octopus-like
head, a pair of rudimentary wings
and a mass of feelers surrounding
his supposed mouth, while the sum
of his parts sounds like it adds up
to something that will render you a
senseless, gibbering mess, artistically,
how could a creator let slip the
challenge to interpret Cthulhu in their
medium of choice and own unique
style? The likeness of the deity-priest
by contemporary artist Bram Sels
casts a vast, mountainous shadow
over a small boat that flounders in its
wake; the sense of scale alone here
is unnerving, especially when you
realize the top of Cthulhu's head is
obscured by the clouds. By the time
one has finished taking in the entirety
of the canvas, one has the doomed
and desperate sense that it's already
too late for them.

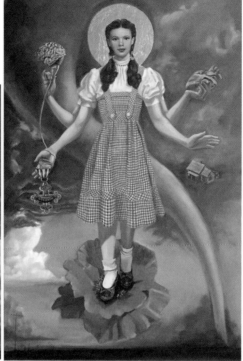

Above: The Oz Altarpiece, Carl Grauer, 2017, oil on panel.

Carl Grauer is a contemporary artist who primarily works in oil, painting contemporary representational portraits and, at times, surrealistic paintings. Having grown up in rural Kansas, the artist notes that he has always had a fascination with *The Wizard of Oz* and Judy Garland, and

that, as a gay man, the attachment is only enhanced by her historical and cultural influence as a gay icon. In the movie, Dorothy gets knocked out by a flying window during the cyclone scene. She eventually lands in Oz, but by the movie's end she wakes up in her bed with her family surrounding her, and reassuring the viewer that the whole ordeal was simply a dream. In L. Frank Baum's original novel,

The Wonderful Wizard of Oz (1900), however, there is no dream. In this dreamlike surrealistic triptych, Grauer, using influences from fifteenth-century religious art and other mythological references, explores the subject matter of *The Wizard of Oz* and its context within celebrity worship.

Above: 'A large pigeon had flown into her face' from *Alice's Adventures in Wonderland* by Lewis Carroll, Charles Robinson, 1907, watercolour.

Lewis Carroll's dreamy tale of a girl named Alice who falls down a rabbit hole into a fantasy world populated by surreal and anthropomorphic creatures showed us a world askew with curiousness and confusion.

Because Carroll structured the story in the form of a dream, he was empowered to make fun of the myriad Victorian didactic maxims in children's literature of the day, with all manner of nonsense and parody peppered throughout. Accompanied by a set of captivating Charles Robinson (1870–1937) illustrations, it was a huge commercial success, and from that time onward Robinson

continued to create visuals for fairy tales and children's books – with his characteristic style of subtle line and delicate watercolours still delighting generations both young and old over a century later.

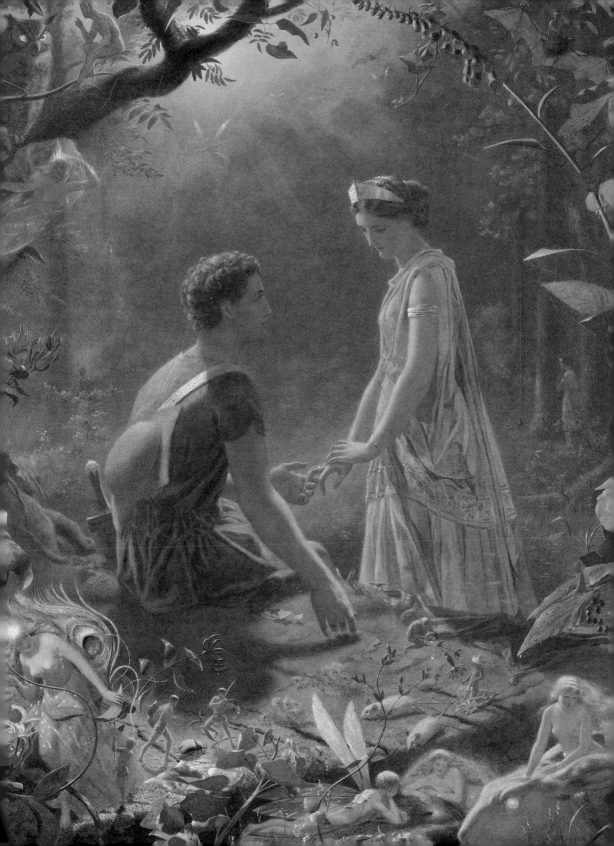

Right: Second Dream: A Promenade Through the Sky, J.J. Grandville, 1847, wood engraving.

J.J. Grandville (1803–47), born Jean Ignace Isidore Gérard, was a caricaturist later recognized as a grandfather of Surrealism; from Gustave Doré to the Walt Disney studios, his anthropomorphic cartoons have numerous successors. In *Second Dream: A Promenade Through the Sky*, there is a sort of nonsensical ruminative but somewhat reasonable progression of the imagery from one object to the next, transfiguring and morphing as if in a dream. In this visual stream of consciousness where one reverie dissolves into another, a mushroom becomes a parasol, which in turn becomes an owl, until it ultimately becomes a horse-drawn chariot sprinkling the night sky with stars.

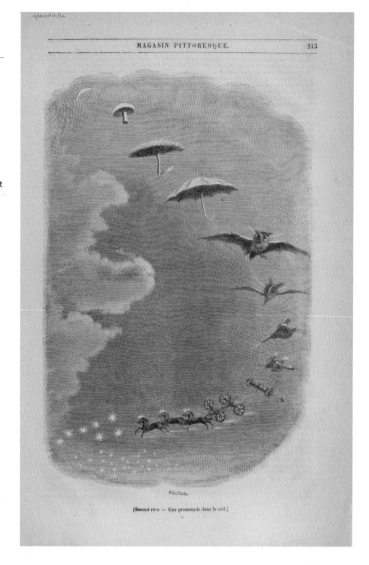

Opposite: Hermia and Lysander. A Midsummer Night's Dream, John Simmons, 1870, watercolour with gouache on paper.

Based on a scene from William Shakespeare's comedy, *A Midsummer Night's Dream, Hermia and Lysander* is a watercolour painting created in 1870 by British artist John Simmons

(1823–76). The couple are tired and disorientated, appearing unaware of the throng of animals and fairies around them. Lysander is seated and touching Hermia's fingers with one hand while indicating the soft forest moss with his other hand. It is the point in the tale of *A Midsummer Night's Dream* when he invites her to rest, saying: 'One turf shall serve

as pillow for us both; One heart, one bed, two bosoms and one troth.' Paintings of fairies had a resurgence of popularity in the nineteenth century with many based on scenes from *A Midsummer Night's Dream*, and Simmons produced several luminous pieces in this genre.

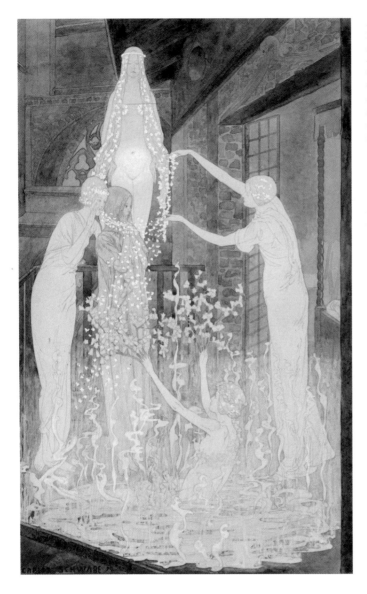

Left: Illustration from *Le Rêve* (The Dream) by Émile Zola, Carlos Schwabe, *c.* 1888, watercolour on paper.

German-Swiss painter and printmaker Carlos Schwabe (1866-1926) was an artist of mysticism and esoteric strangeness, generally considered a Symbolist - although some of his style characteristics, such as the floral motifs and rich ornamentation, have much in common with Art Nouveau. His works were largely mythical or allegorical and, more often than not, steeped in arcane despair. Schwabe was in high demand as an illustrator for books, and, as it happened, French novelist of the time Émile Zola encouraged publishers to partner his novels with etchings and lithographs by the best illustrators. This mysterious, emotive work is for Zola's *Le Rêve*: a fairy tale, of sorts, that reveals the story of a strange young orphan, who grows up enthralled by the tales of the saints, and whose dream is to marry a rich and handsome young prince.

Opposite: The Day Dream, Dante Gabriel Rossetti, 1880, oil on canvas.

A founding member of the Pre-Raphaelite Brotherhood, painter and poet Dante Gabriel Rossetti (1828-82) created a distinctive body of work inspired by a romanticized version of the medieval past and mythic beings of classical antiquity, portraits characterized by languid, melancholy women and luminous, luxuriant colours. *The Day Dream* depicts a subject attired in lustrous green silk (Jane Morris, with whom the artist was having a secret affair) in the shaded embrace of a sycamore tree, a small stem of honeysuckle is in her hand. Enclosed in her lush bower, she is lost in reverie, her gaze turned inward to something that only she can see.

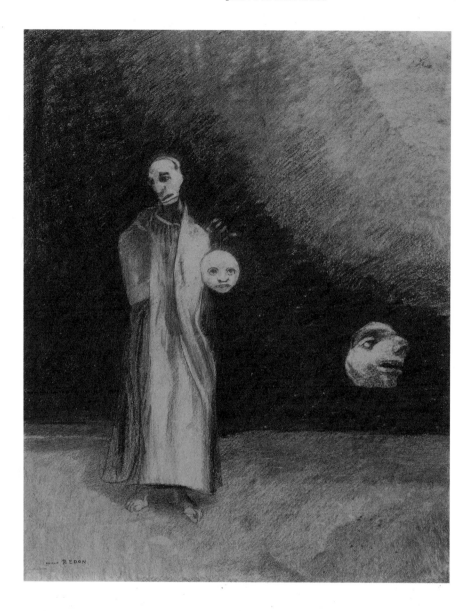

Above: The Nightmare, Odilon Redon, 1881, charcoal on paper.

If there is any artist who appears to be sequestered in the misty obscurity of those otherworlds between dream and nightmare, it is the French luminary of ambiguous metaphor and insatiable imagination Odilon Redon (1840-1916). In this particular nightmare, part of the artist's *Noirs* series rendered in the velvety black of charcoal and chalk, we are confronted with the vague vision of a disturbingly unreal scenario. A lone figure, in either daydream or hallucination, looks aside, distressed, as two disembodied faces dance before him. Are these haunting visages masks of himself he has discarded? Pieces of former selves or past lives? Some nightmares are simply too personal to parse.

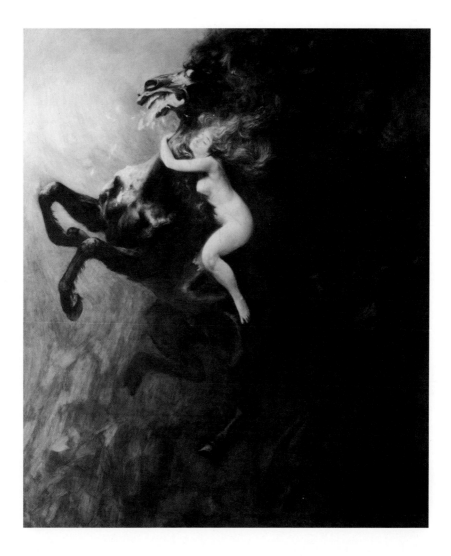

Above: Frenzy of Exultations or *Frenzy of Dreams*, Władysław Podkowiński, 1894, oil on canvas.

The Impressionistic works by Polish painter and illustrator Władysław Podkowiński (1866–95) did not exactly wow contemporary critics when presented to the Warsaw public in the autumn of 1890. So what did the young artist do? He drastically transformed his art, turning to the dark side of Symbolism to paint mysterious compositions in gloomy, tenebrous shades. In the delirium of Podkowiński's nightmarish *Frenzy of Exultations*, or *Frenzy of Dreams*, we thrill at a chaotic scene in which a nude woman sits astride a demonic steed; she appears rapturous, the beast seems agitated; the horse's mane and rider's tresses tangle in a maddening mass of shadowy vapours, which surround the subject and look to drift right off the canvas. An atmosphere of scandal surrounded the painting's exhibition, virtually ensuring its success, and yet a buyer for it could not be found.

Right: Illustration from *Tales of Mystery and Imagination*, Harry Clarke, 1919, engraving.

Was there ever a more gorgeously gruesome artistic pairing than that of the fantastically morbid *Tales of Mystery and Imagination* penned by Edgar Allan Poe (1809–49) alongside the feverish, writhing decadence of the illustrations by Harry Clarke (1889–1931)? Clarke's eerie, intricate imagery swirled throughout the stories of some of history's greatest fantasy writers, visions fuelled by his own appetite for the weird and wondrous drawn from fable, folklore and literature. This 'fascination with the terrors of damnation' (in the words of his concerned family) produced page after page of the provocative nightmares which still haunt us today.

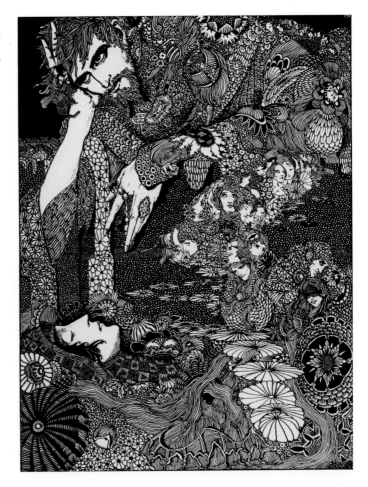

Opposite: The Dreamers, Jana Heidersdorf, 2020, painted in acrylics with digital colour.

Fantasy and horror illustrator of fierce, feral beasts, the secrets and darkness of nature, and at least 100 mermaids, Jana Heidersdorf knows a thing or two about traversing the surreal world of dreams. But though the imaginative realms of her work are often inspired by the mystery and unpredictability of wild things and the natural world, it's not all monstrous fairy tales and fantastical nightmares. Sometimes an artist dreams the peaceful romance of soft midnight magic and swanky castles in the clouds, too.

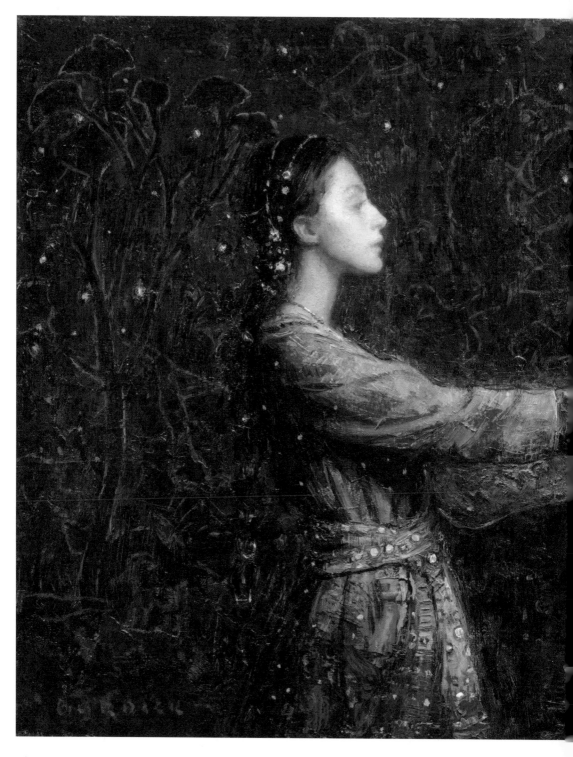

Left: The Hand of Creation,
Scott Burdick, 2022, oil.

Oh, there is such a volatile beauty and fraught magic in the art of creation, is there not? In never knowing for certain if your hand is capable of properly conjuring forth and doing justice to all of the wonders and fantasies that you've dreamed up in your mind? What strange and heady power it is to plunge ahead into that uncertainty regardless, to trust that those figments and fancies will find a way to the canvas or the page! In contemporary painter Scott Burdick's lush, moody vision, *The Hand of Creation,* we observe the fabulously sanguine energies of that decisive moment when an artist takes that leap and begins to coax those dreams forth into reality.

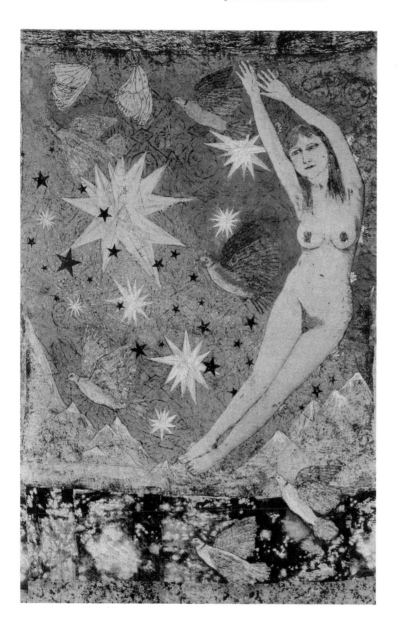

Above: Sky, Kiki Smith, 2012, cotton Jacquard tapestry.

Known for her layered, lyrical multidisciplinary work that explores embodiment, female identity and the natural world, artist Kiki Smith's artistic pursuits evolve and unfold like a mythical cabinet of curiosities overflowing with darksome fairy tales, in a body of work that includes sculpture, printmaking, photography, drawing and textiles. Finding inspiration in the pageantry and spectacle of 1920s Hollywood and the Middle Ages, this tapestry blooms with beguiling textures, celestial elements and cosmic symbology, and Smith's fantastically dreamy vision of a harmonious universe. A spirit of both the sacred and the sophisticated infuses the creation, which combines the construction of a massive collage, converted to a digital weave file, and completed with the techno-magic of computerized looms.

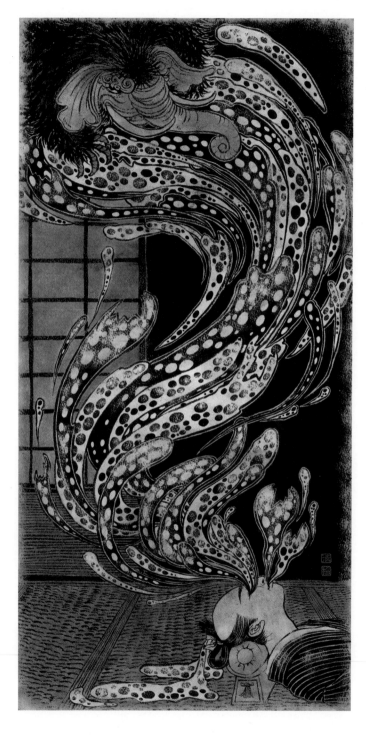

Left: Baku, Yuko Shimizu, 2008, pen and ink.

Baku are Japanese supernatural beings that are said to devour nightmares. Legend has it that when children in Japan wake shivering from a nightmare, they know what to do: whisper three times: 'Baku-san, come eat my dream.' If the child's request is granted, the monstrous Baku will come into their room and suck the bad dream away. Summoning a Baku must be done sparingly, however, because if it remains hungry after eating a single nightmare, it may also devour their hopes and ambitions as well, leaving them to live an empty life. Yuko Shimizu's eerie Baku, despite its monstrous appearance, appears to voraciously hoover up those bad dreams, true to form as a revered and powerful force of good, and as a holy protector of mankind.

V

Magic
is Real

'You've got to know [magic is] still here, all around us,
or it just stays invisible for you.'

– CHARLES DE LINT

In sweeping tales of legendary and epic fantasy, characters adventure through worlds of unsolvable riddles and magical metamorphoses where the impossible is possible, reality is fluid and magic is real.

Magic is a fundamental building block of fantasy worlds, and artists drawn to the fantastical are well acquainted with the enchantments to be found in these spaces. Canvases awash with cryptic immortals, mystical portals, fabulous creatures, extraordinary beasts, chimerical monsters and anthropomorphic objects, uncharted lands, vast kingdoms, beings of great power and ambition, mythical quests, legendary heroes! Illusory and surreal, bizarre and terrifying, or beautiful and breathtaking, magic in every brushstroke, at every richly rendered fingertip.

Many artists have plumbed the depths of myth and legend for their creations, but just as many have borne these astonishing fancies from within the magics of their own dreams and imagination. Beardy wizards arm waving, babbling arcane incantations, battling in a crumbling old keep, with wands of oak and ash directing spells that defy the laws of space and time as we know them. Why, that could be Merlin from Arthurian legend or Middle-earth's Gandalf, or a wholly new wizarding wonder conjured forth from the artist's own subconscious. These magical archetypes transcend medium, whether it be the page, the screen, the easel, or on the stage of one's midnight brainwaves.

Whether born with it, or it was bestowed as a divine favour, whether it was learned the hard way or stolen the easy way, there's nothing more thrilling than seeing our favourite artists portraying our favourite magic-wielders in action and the spectacular conjurations and enchantments that they dazzle us with – no matter how those powers came to be. Alchemists brewing and stewing in the doodles of illuminated medieval manuscripts; wizened astrologers reading the mystical maps of the stars or colourful, cavorting depictions of the zodiac in Renaissance art. Witchly enchanters charming Pre-Raphaelites, such as John William Waterhouse or Frederick Sandys; Symbolist sorcerers, such as Odilon Redon, summoning the lush and morbid; or Surrealist artists Max Ernst or Remedios Varo blurring the boundaries of the mundane and the magical, through dreams and explorations of the unconscious mind. The glimmering magic of Golden Age illustrators' fairy-tale enchantments and the lurid glamour and dynamism of pulpy

mid-century sword and sorcery art. Through every era and movement, through every artist's distinctive style, these powerful works of myth and magic, of divine interventions and supernatural forces, are transportive, immersive – and, to veer off in a slightly different direction, an intriguing gauge of the times in which we live, as well.

Take our fantastical witches, for example. Historically, we think of witches as fictional figments, such as the Weird Sisters in William Shakespeare's *Macbeth*, immortalized by the hand of many an artist. A gruesome and evocative witchly trio, as many depictions of witches of the time were. As the centuries passed, portrayals of witches and witchcraft didn't carry quite the same frightening imagery: though still shadowy, dangerous creatures, they became mysterious, prophetic, oracular femmes fatales through the Pre-Raphaelites and the Symbolists; forces of sacred, transformative magic via the Surrealists; and in contemporary times, artists channel the witch as a celebratory, emboldened and empowered symbol. Witches, wizards, any of our fantastical magic-wielding characters and archetypes are subject to shifting attitudes and beliefs of the time, and it's an interesting exercise to gauge how magic was perceived in culture by the darkness and fear with which it was depicted in its visual records and art.

In every world, be it a story between the pages of the book, a quest in your weekly *Dungeons & Dragons* game, the epic drama unfolding on the big screen of the cinema or the vast, never-ending and always dreaming realm of the artist's imagination, the inclusion of magic adds that wondrous, vital spark of the fabulous and fantastical. We crave the impossibility and wonder of the magical – and the art we love, whatever form it may take, simply wouldn't be the same without it.

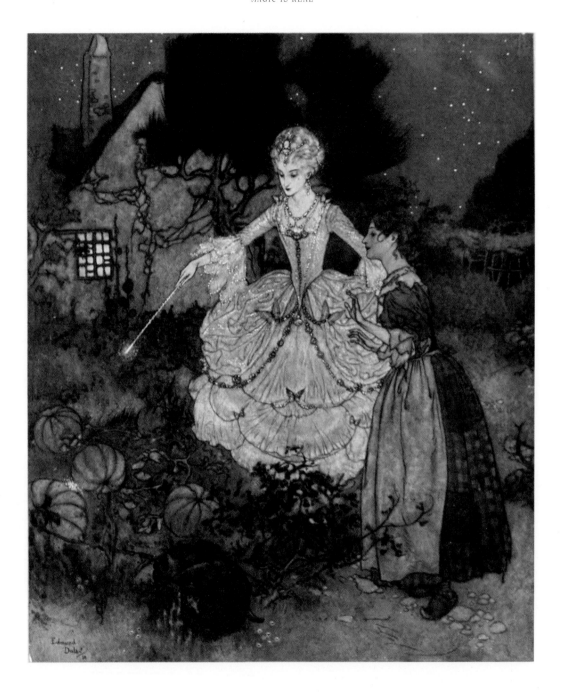

Above: Cinderella and her Fairy Godmother, Edmund Dulac, 1910, watercolour, gouache and ink.

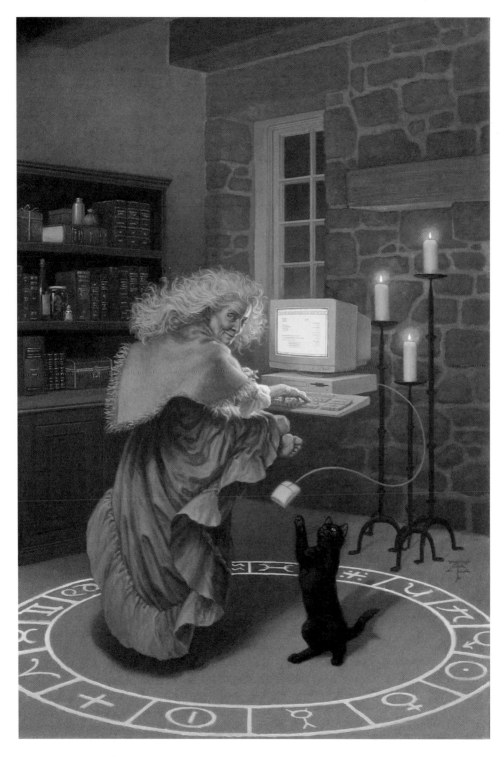

Right: The Wizard, Edward Burne-Jones, 1898, oil on canvas.

From Merlin to Gandalf to Schmendrick, to that strange old hermit Ben Kenobi who lives out past the Dune Sea, wizards are a classic staple of the fantasy genre. Wizards seem to have a rather wizardly aesthetic – more often than not, they're terribly old, rather beardy and won't be caught dead without their dusty robes. Modern interpretations may vary, but you usually know a wizard when you see one! Which makes the wizard in this canvas by Edward Coley Burne-Jones (1833–98) fairly easy to spot. Within a panelled chamber, a wizard stands beside a young maiden revealing to her a shipwreck within a magic mirror, possibly referencing Shakespeare's *The Tempest*. Art historians believed that this looming magus is the artist in his younger years, while the young maiden is said to have been modelled on the daughter of his primary patron, William Graham.

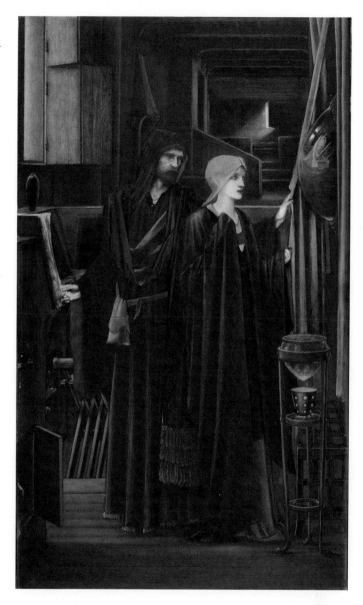

Opposite: Curses, Inc., Tristan Elwell, 1997, oil on board.

In this evocative scene by Tristan Elwell, we spy a levitating witch-like character, slyly peeking over her shoulder to spy us spying her! A cat cleverly bats at a 'mouse' and in a circle of symbols on the floor, an on/off button in the foreground gives us a cheeky wink. Though it resembles a somewhat archaic ad for witchy helpdesk support in *PC Plus* magazine (OK, we understand your illusion spell fizzled but did you try turning it off and on again?), this is a book cover for *Curses, Inc. and Other Stories* (1996), a book of short stories by Vivian Vande Velde where one can learn first-hand 'just what magic spells, enchantments, and curses really can do'.

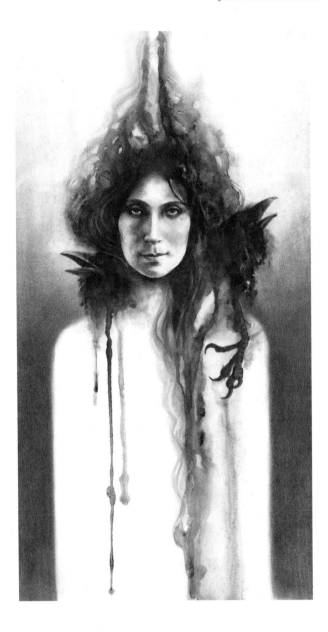

Left: Morrigan, Iris Compiet, 2015, graphite pencil.

Drawing inspiration from European folklore, dark fairy tales and ghost stories, contemporary artist Iris Compiet is renowned for her painterly explorations of unknown realms brimming with fantastical creatures and beings. Fearless Celtic goddess of war, death and fate, the Morrigan is rendered with sober brilliance by Compiet, with a grim but wry expression on the deity's face, and a shadowy crow-like nod to her shapeshifter nature.

Opposite: Visionary, Carrie Ann Baade, 2018, oil on canvas.

Carrie Ann Baade is an artist who considers herself a 'radical hybrid of curator and axewoman'. Snipping the threads of ancient myth and slicing through the archaic pages of art history, she returns to these haunting moments to reclaim them for contemporary sensibilities, building original collages that become fierce feminist parables which then serve as still-life models for her fantastical oil paintings, such as this far-seeing, many-eyed visionary. Visionaries, seers and oracles can see things hidden from others, veiled paths and possibilities where others see solid walls. They also have the ability to peer into the future, or some even speak for the gods. These individuals often act as guides along a journey, although whether for good or ill depends on who they are advising . . . and, of course, their own ambiguous agenda.

Opposite: The Inspiration, Gustave Moreau, *c.* 1893, watercolour on paper.

Ask anyone who pursues the creative arts, there is nothing quite so marvellously magical as the glorious spark of inspiration. Whether it strikes you with a lightning bolt-sized revelation or softly whispers the gentle beginnings of an idea, having the muse on your side feels nothing short of miraculous. And who better to demonstrate those divine 'aha!' moments via the paintbrush than visionary artist of allegory and fable Gustave Moreau (1826-98)? In

this work, saturated with the artist's distinctive jewel tones, reminiscent of crushed rubies and sapphires, a winged cherub-like being murmurs enigmatically in our subject's ear, their pensive gaze slowly dawning with profound awareness. Inspiration, it seems, has struck.

Above: Wizard, Bénigne Gagnereaux, 1790–95, oil on canvas.

Well, this certainly looks like a situation of 'be careful what you wish for'! Artist Bénigne Gagnereaux (1756-95) was a French painter most favoured by contemporary Roman patrons of the arts during that time, and whose works drew inspiration from historical and mythological subject matter. As to the matter at hand in this scene, it appears as if this wizard may have been attempting to conjure a lone familiar and instead raised forth an entire snarling, slithering menagerie!

Above: The Fairies, Madeleine-Jeanne Lemaire, 1908, watercolour.

This impossibly splendid twosome bedecked in the glittering and exquisite finery of the fairy court was envisioned by Madeleine-Jeanne Lemaire (1845–1928), an exceptionally successful French painter in watercolour, whose focus honed in on elegant portraits, genre works and flowers. In fact, it is believed that during her lifetime she created hundreds, quite possibly thousands, of paintings of flowers and other plants; Alexandre Dumas *fils* is noted to have said that 'only God had created more roses than Madeleine Lemaire'. One must imagine, then, that the subjects in this painting hail from the most extraordinary of faerie floral kingdoms!

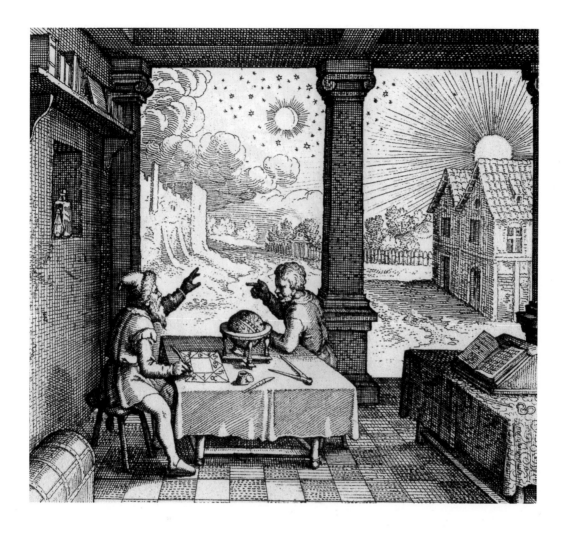

Above: An Astrologer Casting a Horoscope, from *Utriusque Cosmi Historia* by Robert Fludd, 1617, engraving.

Between 1617 and 1621, one of the great minds of the early modern period, the prominent English physician Robert Fludd (1574-1637) published his most famous work, *Utriusque Cosmi Historia*. Split into several volumes and lavishly packed with over 60 intricate engravings, the tome delved into Fludd's thoughts on cosmic harmonies, various divinatory practices, the kabbalah, alchemy and everything from occult science to medicine and music; the symbolic illustrations were designed by Fludd but engraved by the artisans employed at his publishers. What extraordinary events or fantastical claims could this astrologer above have foreseen? Is their client impressed or demanding a refund? If nothing else, the space where the psyche and cosmos meet provides limitless possibilities for the imagination.

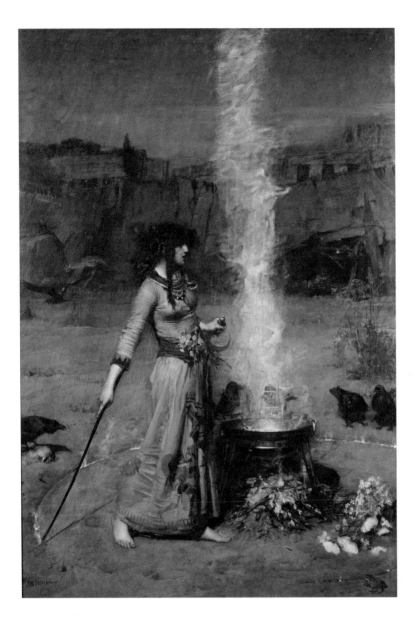

Above: The Magic Circle, John William Waterhouse, 1886, oil on canvas.

In *The Magic Circle* by John William Waterhouse (1849-1917), a lone figure gazes steadily into the vaporous pillar of smoke rising skyward from the glowing depths of a cauldron while resolutely tracing closed a faintly glimmering circle in the earth behind them with a wooden wand. A conspiracy of ravens looks on with menacing curiosity from the ground just beyond the symbolic ring, and even the landscape glowers claustrophobically with ominous intent. Within the confines of the circle, the witch grasps a crescent-shaped sickle, surrounded by flowers, both belted at her waist and a posy of wild blooms beside the crackling flames. We don't know if the circle guarantees the safety of the subject, but regardless, it is a scene heavy with magic and power. Magic and miracles, sorcery and enchantments were themes that Waterhouse returned to time and again in his vivid, romantic canvases.

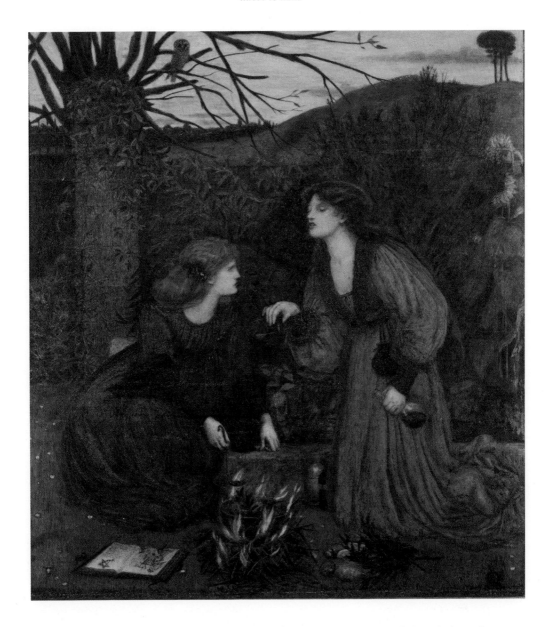

Above: Pharmakeutria (Brewing the Love Philtre), Marie Spartali Stillman, 1870, watercolour, body colour and gum arabic on paper laid down on panel.

The women of the Pre-Raphaelite movement are generally thought of as models and muses; it is sadly overlooked that many of them were gifted and accomplished painters in their own right and essential to the success of the movement. Both a talented artist and muse of Pre-Raphaelite painters, Marie Spartali Stillman (1844-1927) established an art career for herself with works awash in harmonious colours and evocative atmospheres. Drawing inspiration from medieval and mythological subjects, her style brims with thoughtful details and a keen eye for the charms of nature, elements which combine to coalesce on this canvas wherein two sumptuously attired figures conjure up a love potion in the rich, dappled sunlight of an autumn afternoon.

Right: The Seer, Simeon Solomon, 1881, pencil and watercolour.

Simeon Solomon (1840–1905) until relatively recently remained a little-known Victorian artist of interest only to those immersed in Pre-Raphaelite studies. Over the past 30 years, increased interest in the Pre-Raphaelites and Aesthetes, Jewish studies and gender/gay/ queer studies have generated a resurgence of information on one of the dreamiest Victorian artists you've most likely never heard of. Solomon was an artistic wunderkind in a family of prominent artists. A child prodigy who showed at the Royal Academy in London aged 18, he continued on as an influential young painter to become a vital associate of the Pre-Raphaelite movement. His career cut short in scandal, outed and ostracized by society, he worked in isolation and obscurity, turning to alcoholism and eventually dying in poverty in a workhouse – but unapologetic about who he was and creating his art until the very end. In *The Seer*, we observe the sombre mysticism and sensitive contemplation so frequently seen in this remarkable artist's visionary works.

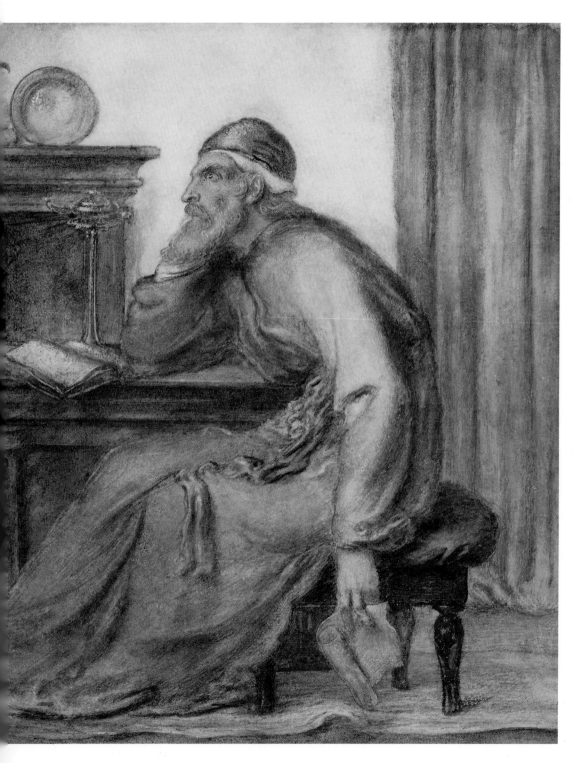

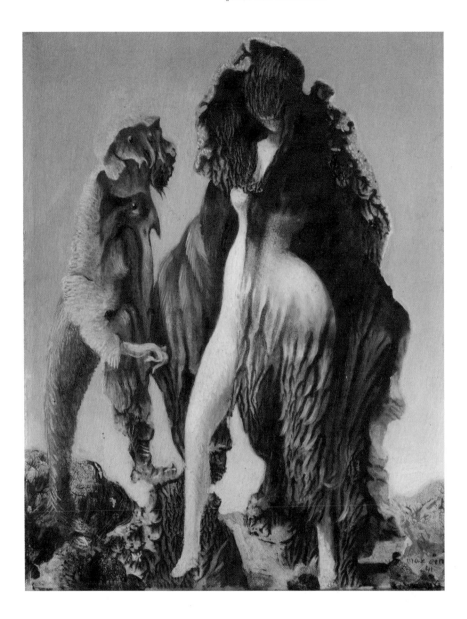

Above: The Witch, Max Ernst, 1941, oil on canvas.

A pioneer of both the Dada and Surrealist movements and a key figure in the twentieth-century avant-garde, Max Ernst (1891–1976), like many innovative artists of his generation, was influenced by Sigmund Freud's writings on the unconscious and the uncanny. Investigating his psyche as a means of exploring the source of his own creativity, he channelled these primal emotions and personal traumas into his collages and paintings. Seeking safe haven from the Nazis, Ernst painted *The Witch* the same year he departed Europe for New York. Noted as one of the artist's favourite subjects, this fantastical figure wrought in eclectic, organic imagery, inspires both fascination and foreboding in equal measure. By portraying their artful analogues as beings with powers of metamorphosis and transformation, the Surrealists alchemized a response to a world devastated by the horrors of the two world wars.

Right: Astro Errante, Remedios Varo, 1961, oil on masonite.

Mystical and mystifying, enigmatic and oracular, the art of Remedios Varo (1908-63) was absolutely thronging with esoteric energies. Steeped in the symbolism and personal visual language of her own surreal dream world, her paintings were often the dwellings of strange beings engaged in psychic or alchemic explorations and experiences of exquisite cosmic transcendence. In *Astro Errante* (The Wandering Star) a radiant celestial figure swathed in a frayed blue cloak emerges from a nebulous landscape with tiny glittering stars underfoot, suggesting both the voyages of mythic immortals as well as the real-life physical and spiritual journeys of the artist.

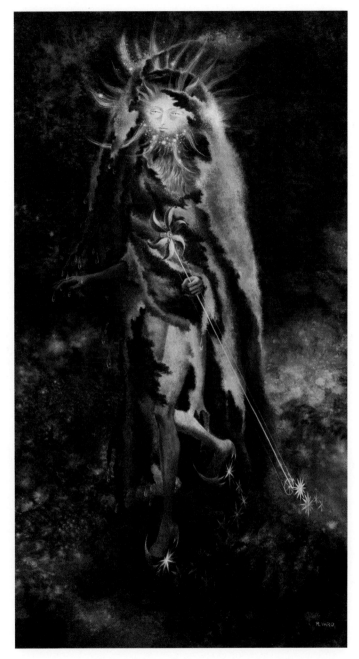

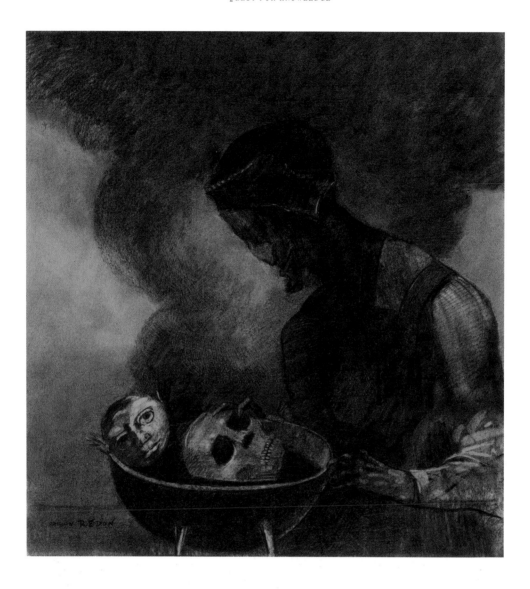

Above: Cauldron of the Sorceress, Odilon Redon, 1879, charcoal on paper.

Perhaps best known for his avant-garde Symbolist drawings and lithographs in the late nineteenth century, the artist Odilon Redon (1840–1916) was adept at giving expression to the obscured and imperceptible, whose visions were concerned with the supernatural and the extraordinary. Cloaked in soft shadows and steeped in poetry, Redon conjured forth all manner of disquieting enigmas in the first half of his career, although later his work took a dramatic turn to colour. In this penumbral work of various charcoals to smouldering, smoky effect, we spy on the workings of a sorceress peering into their cauldron, fondling the eye socket of a skull, while a disembodied demon head looks on dispassionately from the coals.

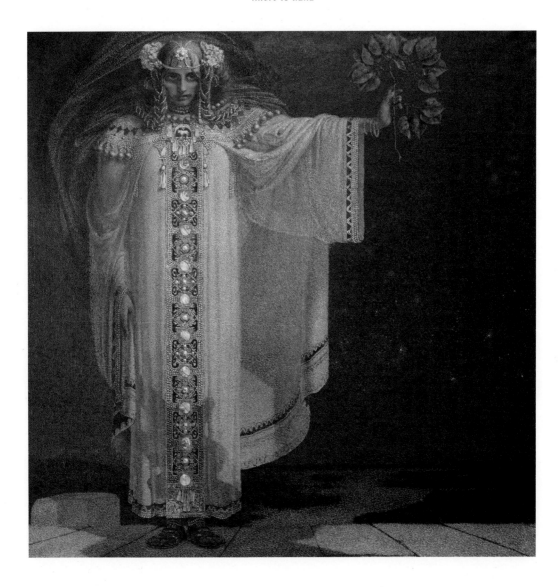

Above: *La Prophétesse Libuse*,
Karel Mašek, 1893, oil on canvas.

A phantasmal figure awash in eerie
moonlight, bedecked in flowing
robes and glittering headdress, and
offering a sacred branch, Libuse is a
mystical figure from Czech mythology.

One of three magical sisters, she
was blessed with wisdom and the
power of prophecy, and foretold and
founded the city of Prague in the
eighth century. She is depicted here
in a moment of dramatic majesty by
Karel Vítězslav Mašek (1865–1927),
a Czech painter, architect, illustrator

and art professor active during the Art
Nouveau movement in Europe, and
had a significant influence on later
artists such as Gustav Klimt.

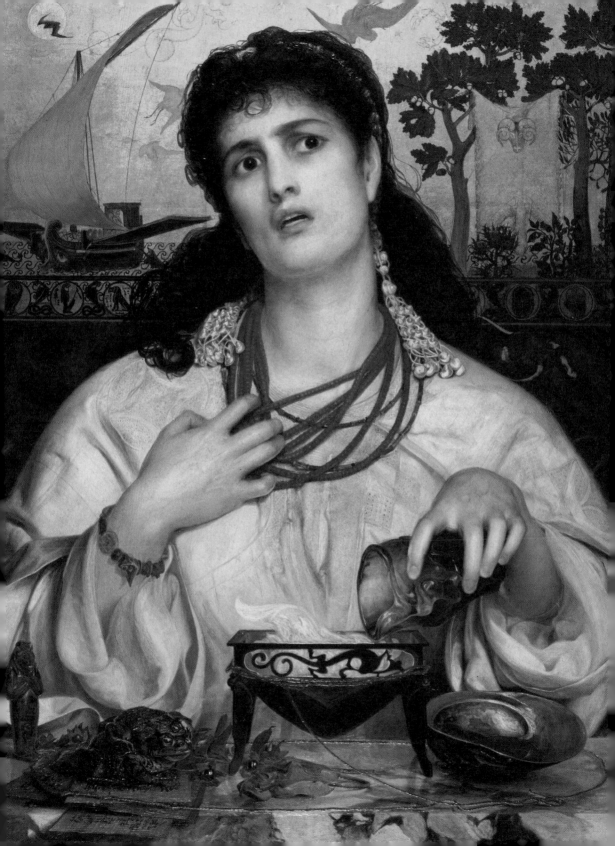

Right: Cover art for *Snow, Glass, Apple*s by Neil Gaiman, Dark Horse Comics, Colleen Doran, 2019, pen and ink.

A blood-curdling and darkly twisty re-lensing of the *Snow White* fairy-tale rivalry between a princess and her stepmother, Neil Gaiman, in *Snow, Glass, Apples,* writes of an actually-not-all-that-evil queen who is terrified of her vampiric stepdaughter and is desperate to save her kingdom from this monstrous creature. Award-winning illustrator Colleen Doran has, for much of her career, collaborated with writers on a wide variety of comics, graphic novels and digital comics, and for this beautifully grotesque narrative, she contributes the thrillingly exquisite, highly decorative art that lends an overall hallucinatory and fractured feeling of a stained-glass fever dream to the story.

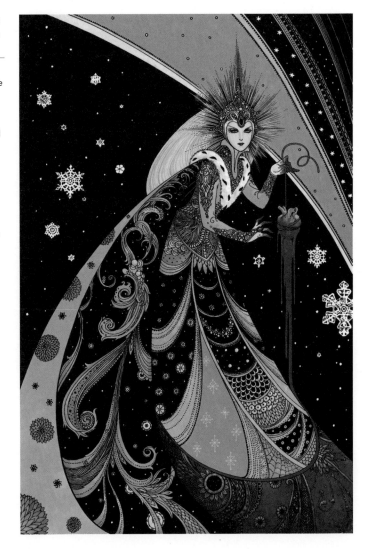

Opposite: Medea, Frederick Sandys, 1868, oil on canvas.

Sorceress, seductress, mother, murderess. When you peel away the layers and the labels, the mythological Medea – though a descendant of the sun god, possessing magic powers and more than mortal – was also a woman scorned and betrayed, seeking revenge when there was nothing else left for her. English Pre-Raphaelite painter and disciple of Rossetti, Frederick Sandys (1829–1904) depicts an intense scene wherein the enchantress, surrounded with symbolic elements in a magical mise en place, gathers her powers while preparing a potion.

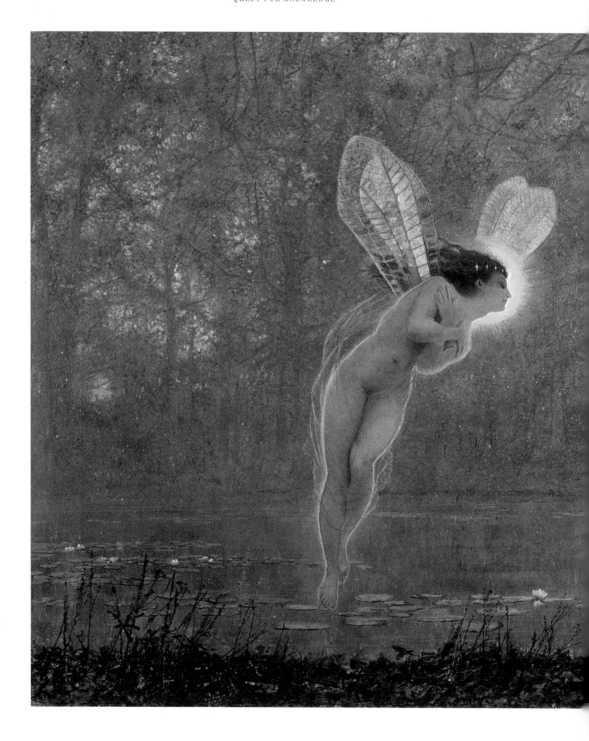

Left: Iris, John Atkinson Grimshaw, 1886, oil on canvas.

In the burnished autumn twilight of *Iris* by English painter John Atkinson Grimshaw (1836–93), we happen upon a scene of rare enchantment, wonder and beauty. A diminutive figure haloed in light, this fairy-like messenger flits among the soft mists and river reeds, a backdrop of skeletal-limbed trees in the distance. Her crystalline wings are filigreed with a kaleidoscopic opalescence reminiscent of a rainbow's aura, recalling another Iris, goddess of multicoloured prismatic spectrums of colour, from Greek mythology.

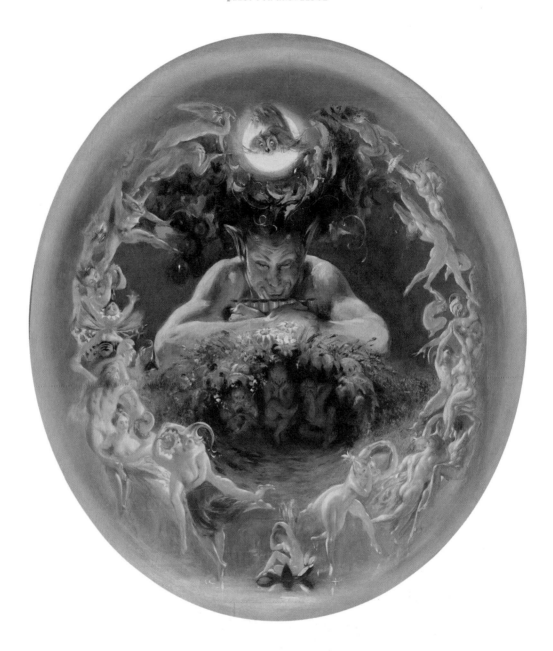

Above: The Faun and the Fairies,
Daniel Maclise, *c.* 1834, oil on board.

Lit by the shimmering glow of a bright butter-yellow moon, encircled by the faint luminescence of a rainbow and observed by no one but a dazed and dumbfounded midnight owl, this amorous extravagance by Daniel Maclise (1806-70) depicts nocturnal fairy revelries presided over by the melodious musical stylings of a syrinx-playing satyr, and is thought to be one of Maclise's most magical paintings.

Fairy paintings were an avid fascination for the Victorians, offering escape from the changes of industrial society, and an indulgence for their preoccupation with the romance of the paranormal and supernatural.

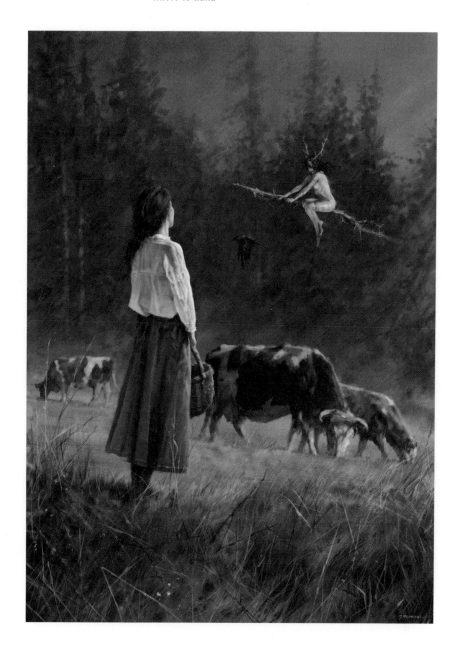

Above: If I Only Could . . .,
Mr. Werewolf, 2018, mixed
techniques/media.

The contemporary Polish artist known
as Mr. Werewolf brings to life bucolic
pastoral landscapes with a twist.
Inspired by history, folk tales and
myths, and the wildness of nature,
these imaginings take the form of
idyllic Eastern European countrysides,
with a dash of fantastical darkness,
monsters and menace, and often
beset by futuristic anachronism, to
either playful or horrifying effect.
Though the visual story above would
appear firmly rooted in some version
of the past, the young woman gazing
wistfully skyward past a grazing herd
of carefree cows definitely has her
sights set on a witchier future – and
might just be mapping out her next
career move!

VI
—

Faith &
Philosophy

'The beginning of knowledge is the discovery of something
we do not understand.'

— FRANK HERBERT, *GOD EMPEROR OF DUNE*

Serious philosophical questions need not only be examined in dry journal articles or in university lecture halls; we can glean insight into these inquiries and discover a world of hidden significance in the art we explore and surround ourselves with and in the illustrated stories we cosy up to in the comfort of our armchairs. These fantastical artworks intrigue us for reasons that might not always be readily apparent. Although they offer thrilling tales in worlds beyond our own – some rendered with subtlety, others with spectacular disregard for understatement – they are often still founded on the profound philosophical and metaphysical questions that fascinate humanity, and something deep within us always connects with these contemplations. That something, I suspect, is the imagination.

While we are breathlessly inspecting ornately surreal images of saints or florid visual sagas of warriors or wise men in search of a holy object or perhaps an avant-garde, abstract visual rendering of some philosophical notion quite beyond our ken, we may, without even consciously realizing it, be pondering the relationship between body and spirit, the existence of divine power, moral and ethical quandaries, free will versus fate, even the very nature of existence. Artists who reflect these questions about our place in the world – why we suffer and how to live fulfilling lives – excite our imagination. The artists of these fantasy spaces, the denizens of these fantasy worlds, create a richer, more rounded and relatable experience – for us, the reader or viewer, at any rate.

Philosophers tend towards both despair and delight regarding our relationship with the imagination. Some seem to have little use for it, such as René Descartes, who criticized it as 'more of a hindrance than a help'. Artists don't care about that! They're going to sketch portraits of those dour logic-mongers in the most imaginative ways possible anyhow and probably include a chaos of chubby, naked cherubs, just for fun. The Scottish philosopher David Hume was just as conflicted, but also praises the freedom of engaging in imagination; that imagination can go beyond our perception of 'actual' to the realm of the maybe, the what-if and if-only. If you need a further example of how 'nothing we imagine is absolutely impossible', just think of how Leonardo da Vinci's fantastical ornithopter flying machines paved the way for the Wright brothers. Of course,

in mythological tales, Icarus didn't have great luck with *his* constructed wings, but – as important as those lessons of risk, ambition and hubris that we take from that doomed venture are – when we see a painting of Icarus and his glorious wingspan, as in Sergey Solomko's *Dream of Icarus*, it also speaks to the power of hope, and dreaming big, and just *going for it*.

Religion and fantasy are somewhat strange bedfellows . . . or are they? A collection of beliefs, systems and cultural views, religion was born as a way for humans to explain their biggest questions, and there are certainly common patterns and parallels in and between religion and fantastical art: the dichotomy of good and evil, salvation and redemption, sin, sacrifice and the concept of resurrection are recurring painterly themes, and artists through every age often harness them to comment on society and religion and the sacred versus the profane. In the sprawling and fevered visions of spiritual ecstasy, the terrifying likenesses of angels of divine retribution, or sketches focusing on the hushed shadows of stillness and sanctity in sacred places

Below: The Circle of the Lustful, or *The Lovers' Whirlwind*, *Francesca da Rimini and Paolo Malatesta*, illustration from *The Divine Comedy*, *Inferno*, Canto V by Dante Alighieri, William Blake, *c.* 1825–27, pen and ink and watercolour.

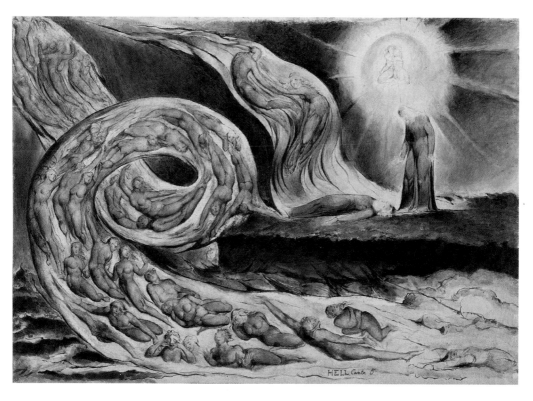

Above right: St Michael Fighting the Dragon, Antonio del Pollaiuolo, *c.* 1460–70, oil on canvas.

of worship, artists across centuries have wrestled with and wrought creations questioning, condemning and celebrating the fantastical spectacle of religious beliefs.

As human beings, we have a powerful drive for intellectual exploration, and we often satiate this insistent need through the art and stories we consume. Through these artful works that enthrall viewers young and old alike, we ponder the poetic preoccupations of time, death and eternity. We meditate on the limits of both human nature and divine, cosmic creation and destruction, the horror of annihilation and the yearning for transcendence. We gain a sense of wonder and awe and marvel at a connection to something greater than ourselves. And no matter what those pesky philosophers claim – all of these introspective journeys are possible only via the pathways of our vast, voracious imaginations.

Above: The Alchemist, Edmund Dulac, 1911, lithograph.

In *The Wind's Tale*, by celebrated Danish author Hans Christian Andersen (1805–75) and illustrated by the renowned Edmund Dulac (1882–1953), we see greedy alchemist Valdemar Daae hard at work amid his beakers and glowing potions. Valdemar is of royal blood and already possesses great wealth, but he is nonetheless stubbornly seeking the recipe for red gold. Surely this avarice will not be the instrument of his utter downfall and ruination! Before the advent of modern science, alchemy was regarded as an earnest scientific and philosophical pursuit. And though sometimes alchemists' practices were closer to magic than modern scientific methods, their contribution to the emergence of modern chemistry cannot be denied. The language and iconography of alchemical philosophy have both captivated and confused us for centuries. But, of course, in that curious perplexity is found great inspiration for writers and artists!

Above: Faust and Mephistopheles, Charles Ricketts, *c.* 1930, oil on canvas.

Sinister cults, mysterious rituals, secret knowledge and unseen supernatural forces – when immersed in these eerie elements, you definitely know you have found yourself in the midst of some sort of occult or horror fantasy. Literary forms of

English-language occult fiction arose from the supernatural and heroic in folklore, and was galvanized by a modern and non-religious take on the ancient mythology of gods, devils and heroes. During the Elizabethan Age, we might have read of sorcerers, ghosts and monsters – with a crowd favourite being that of the cautionary tale of the sorcerer Dr Faustus and his pact with the devil.

Charles Ricketts (1866–1931) based this painting on a scene from the 1859 opera *Faust* by Charles-François Gounod. Faust sits in his study surrounded by symbols of learning, including books, a globe and an astronomical chart. Weary of life and despairing, he calls on the devil (Mephistopheles), who materializes and offers him youth and fortune in exchange for his soul.

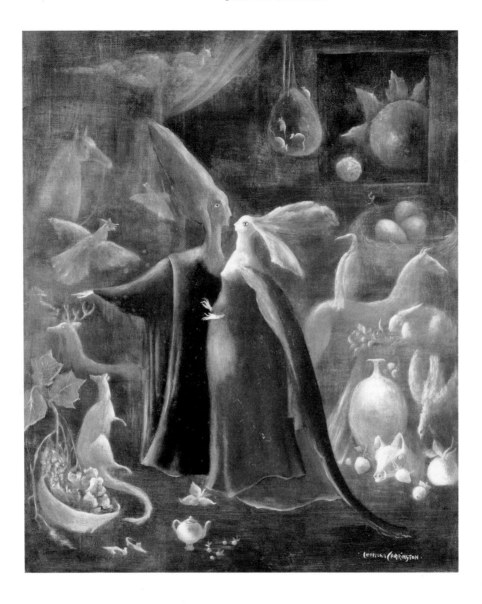

Above: Clean Up At Once, Said the Archbishop, Leonora Carrington, 1951, oil and tempera on plywood.

Clean Up At Once, Said the Archbishop was among the 28 works that Leonora Carrington (1917–2011) exhibited with Pierre Loeb in her first one-woman show in Paris in 1952. The painting conjures a scene from Carrington's childhood regarding her aunt Leonora, the sister of her mother after whom she was named. Leonora the younger apparently not only inherited her aunt's name but also her aunt's interest in the mystical and an utterly uncompromising personality. A Catholic nun who devoted her life to doing hard work, Aunt Leonora was also remembered by her memorable quarrels with the archbishop. In *Clean Up At Once*, the archbishop and the nun stand in the midst of a power struggle in an eerily lit dark cellar. Their eyes lock as he shouts at her, attempting to show who rules. But Aunt Leonora, staring back, is not moving, 'you're not the boss of me', she seems to say.

Above: Storm Warning, Jody A. Lee, 1993, oil and gold ink on board.

A freelance artist in the publishing industry for over 40 years, Jody A. Lee's fantasy illustrations have graced the covers of authors Mercedes Lackey, Michelle West, Kate Elliott, Mickey Zucker Reichert, Katherine Kerr and many others. Her style at times recalls a medieval tapestry, with evocative figures intricately rendered with a high level of detail and attention to visual texture, which can make an effective contrast against the more graphic decorative elements. In Mercedes Lackey's *Storm Warning* (1994), we see the devotion of a variety of different people to their different faiths and that none of those faiths is wrong. Notes Ambassador Ulrich of Karse: 'I have always felt . . . that before I passed judgment on any man because of the god he swore by, I would see how he comported himself with his fellows – what he did, and how he treated them. If he acted with honor and compassion, the Name he called upon was irrelevant.'

Above: The Sacred Place, Petar Meseldžija, 2016–17, oil on canvas.

Widely acknowledged as one of the greatest artists in the field of contemporary fantastic art, Petar Meseldžija paints in a style that resembles timeless masters of the ilk of Rembrandt, Rubens and Frank Frazetta - figures both mortal and god-like that fairly leap from the page or canvas with their astonishing sense of breathing, pulsing life. And when your favourite characters desire interaction with their gods, where do they go? Down the street to the familiar local temple? To a warm corner of their kitchen, warmed by the hearth and redolent with the scent of freshly baked bread? To the blustery top of a windswept mountain? Many traditions revere certain natural places as being sacred in themselves, and while some cultures mark sacred places with temples or shrines, others leave them in their natural state or mark them only with the simplest of structures like a cairn or standing stone. Such spaces, as seen in *The Sacred Place,* are often held to be the homes of natural spirits or gods.

Above: The Temptation of Sir Percival, Arthur Hacker, *c.* 1894, oil on canvas.

Arthur Hacker (1858–1919) was an English painter of the late Victorian era whose canvas beheld a spectrum of subjects from society portraiture through classical, religious and mythological works to scenes of peasant life and landscape. An open-minded artist who embraced a variety of styles (making his own style a bit ambiguous and hard to pin down), in *The Temptation of Sir Percival*, a Pre-Raphaelite influence is easy to see. The medieval story is painted in jewelled colours with meticulous attention to minute details, such as the knight's costume and the naturalism of the outdoor setting. In many of the medieval versions of the story, Sir Percival (or Parsifal) is very simple and almost foolish, but even in these versions of the story, he is pure enough of heart to ultimately become the keeper of the Grail.

Right: Frontispiece for *Acajou et Zirphile* by Charles Pinot Duclos, designed by François Boucher (and engraved by Pierre-Quentin Chedel), 1744, etching and engraving.

This bizarre jumble of daydreams and fancies in an engraving by François Boucher (1703-70), a celebrated eighteenth-century artist known for his Rococo style and his idyllic, allegorical paintings, has a bizarre backstory as well. French author, linguist and historian Charles Pinot Duclos (1704-72) wrote his parodic fairy tale *Acajou et Zirphile* as the result of a bet; the wager involved seeing who could write the best fairy tale based on some engravings by Boucher (which were originally intended for another story but the book's printer had multiple unused copies of the illustrated plates, and thus the challenge came about). Charles Duclos came to the rescue, rearranging the illustrations to fit his fairy tale of love and reason, wherein we see Prince Acajou travelling to the Moon to retrieve the severed head of Princess Zirphile. No wonder the fellow in the engraving looks so lost in thought! It's a lot to take in.

Opposite: Red Lady, Gerald Brom, 2015, oil.

In *Lost Gods* (2016), talented storyteller and gothic fantasy illustrator Gerald Brom brings us on a haunting, harrowing journey diving deep into the underworld and a pantheon of gods and goddesses, angels and demons. Murdered by an arcane horror, Chet undertakes an epic quest through the lands of Purgatory, risking eternal damnation to save his family and befriending and antagonizing lost souls, dead gods and unruly spirits. This artwork, used on the cover of Brom's novel *Lost Gods*, features the stunning Sekhmet, also known as the Red Lady, a winged sphinx who, though divine, is mortal and whose heart pumps live blood.

Previous spread: Details from the
Stoclet Frieze, Gustav Klimt,
1905–11, tempera on cardboard.

The whimsical gilt garden of the
Stoclet Frieze is a series of three
mosaics created by Austrian Symbolist
artist Gustav Klimt (1862-1918) for
a 1905-11 commission for the Palais
Stoclet in Brussels, depicting the
swirling Tree of Life, a standing female
figure and an embracing couple.
Here, embellished with ceramic,
gilded tiles, pearls and marble, and
radiant with meaning, the Tree of Life
is a theological, philosophical and
mythological concept dating back
thousands of years, symbolizing the
interconnectedness of all things,
above and below. How splendid to
lose oneself within the fantasy of the
magical worlds within these golden,
billowing spirals while contemplating
all the possible meanings of the work!

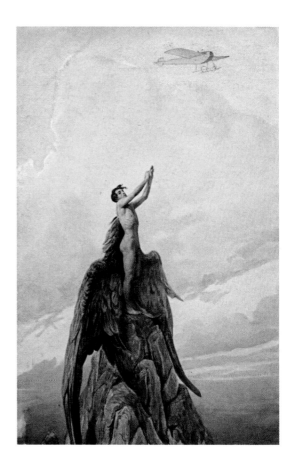

Above: The Dream of Icarus, Sergey
Solomko, *c.* 1916, watercolour.

Sergey Sergeyevich Solomko (1867-
1928) was an artist constantly keeping
busy - from his masterful watercolour
paintings of historical and allegorical
subjects to illustrations for Russian
fairy tales, his work with journals,
magazines and publishing houses.
He also designed theatrical posters,
created costumes for balls and
performances, and collaborated with
the lavish jewellery company Fabergé.
In this work of aerial fantasy, Solomko
muses on myth and modernity,
wherein Icarus' wings hang heavy and
low, but his heart leaps skyward with
hope from a lone peak, his gaze taking
in an early aircraft soaring through
clouds, the scene softly lit, as massive
clouds tumble by in the distance.

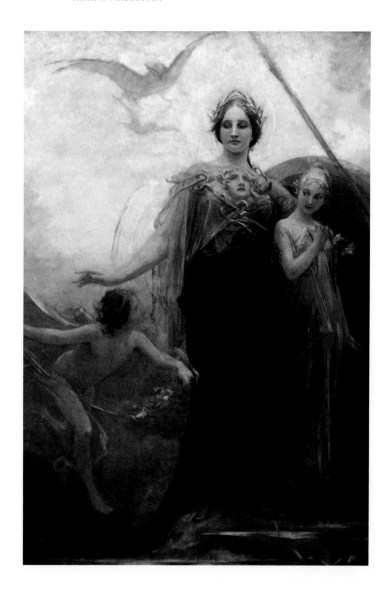

Above: Love, Thought and Life,
Maximilian Pirner, 1886–93,
oil on canvas.

Czech painter Maximilian Pirner
(1853-1924) is known for his
Neo-Romantic style and fairy-tale
visions, drawing on themes of classical
mythology and a dramatic penchant
for the mordantly macabre and the
sinuously mystical. In this allegorical
scene of philosophical fantasy, we are
treated to uncharacteristically hopeful
musings from this painter in the form
of this charming trio of sentiments,
Love, Thought, and Life, personified.

163

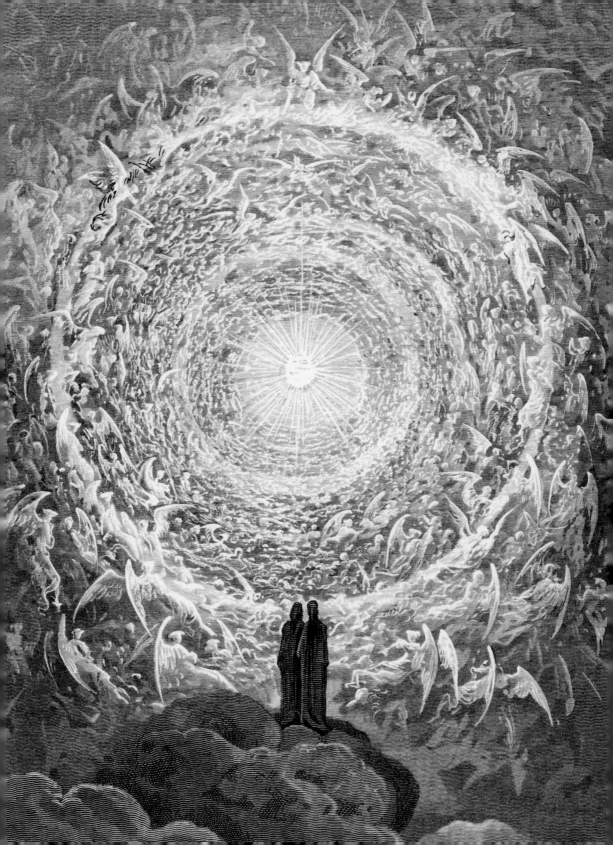

Opposite: The Saintly Throng Form a Rose in the Empyrean (Rosa Celeste), Gustave Doré, 1885, digitally coloured engraving.

The vivid illustrations of Gustave Doré (1832–83) and Dante Alighieri's imaginative vision of the afterlife have become so intertwined that even today, both aspects of the poet's travels through Hell, Purgatory and Paradise are spiritual experiences intrinsically connected in our imaginations. These allegorical representations of the soul's journey towards God take the form of nudes, landscapes and elements of popular culture and are characterized by both astonishing technical skill and awe-inspiring grandeur. In this illustration from *Paradiso*, Canto XXXI in *The Divine Comedy*, Dante beholds the dwelling place of God, revealed in the form of a cosmic holy rose, thronged by angels, the petals of which house the souls of the saintly.

Above: Six-winged Seraph (Azrael), Mikhail Aleksandrovich Vrubel, 1904, oil on canvas.

Referred to in terms of Art Nouveau as well as Symbolist art, Mikhail Aleksandrovich Vrubel (1856-1910) was a Russian artist who broke from academic traditions to express his artistic outlook in idiosyncratic visions that utterly defy categorization. Combining decorative forms and saturated colour with dramatic subjects, mystical themes and murky, melancholic moods in his paintings and drawings, Vrubel experimented to the point of mania with the expressive potential of colour and line. In his later years, the artist's fixation with religious subject matter came to influence his output, resulting in the intriguing cycle of biblical and apocryphal paintings made at the end of his life.

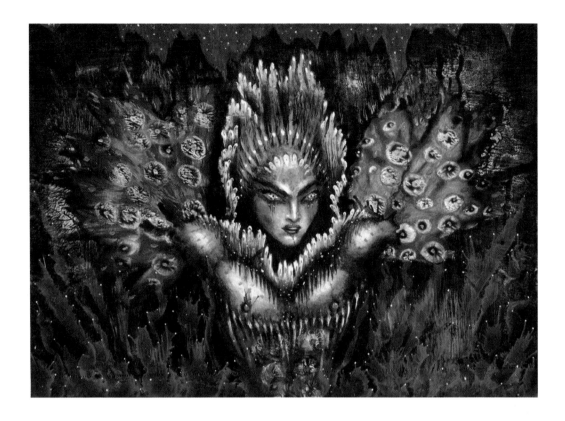

Above: Enlightenment, Virgo Paraiso, 2003, oil on wood.

'Let the beauty we love be what we do' – contemporary artist Virgo Paraiso creates complex, exuberant visions of paradise, enlightenment and transformation embodied in the flowers, birds and butterflies of his mystical hybrid creatures and fantastic dreamscapes – a celebration of beauty free from human destruction. The artist incorporates the beliefs of his ancestors, the Nahua people from ancient Mexico, into these extraordinary manifestations – they believed that an individual's fate was determined by their 'nagual' or animal twin spirit, into which some had the power to transform themselves. In addition, he incorporates the Nahua's belief that we are born with a physical heart and face, yet we must create a deified heart to shine through our face before our features become reliable reflections of ourselves.

Above: The Heart of the Rose, Margaret Macdonald Mackintosh, 1902, painted gesso over hessian.

The British answer to Art Nouveau rooted itself in the past through folk legends and beliefs, was characterized by abstract, elongated bodies, a dreamy colour palette, striking geometric dashes of symmetry and modernity – and was pioneered by a group known as 'The Glasgow Four'. Among this Glasgow Art School circle of creatives was Margaret Macdonald Mackintosh (1864–1933), while her sister numbered among the collective, as well as their eventual husbands, all stunning artists in their own right. Margaret's work was full of whimsical Symbolist drama, ethereal and fairy-like. *The Heart of the Rose* was the final panel in a series produced for the exhibition space known as 'The Rose Boudoir'. Encircled by briars and embellished with roses, the two serene figures lovingly embrace, enfolding between them a newborn; scholars suggest this is the conclusion of a story about artistic union.

Right: The Wave, Pamela Colman Smith, 1903, watercolour, brush and ink, and graphite pencil on paper.

Often called 'Pixie' for her irrepressible spirit, Pamela Colman Smith (1878-1951) was an artist, poet, folklorist, editor, publisher, costume and stage designer – and, if none of that immediately rings a bell, then perhaps you know her from her work in that 78-card divinatory deck of cards that's been around for ages? It was this gifted artist's bold and brilliant illustrations and allegorical imagery for the iconic Rider-Waite Tarot that, even today, we still associate with the mystical secrets of the tarot – and yet, outrageously, it's only been in recent years that Colman has been credited for it. The artist's interest in mysticism and her personal brand of spirituality is evident in the otherworldly melancholy of *The Wave*, in which sorrowing figures arise from the depths of the oceans, spilling their tears back into a vast pool of grief as the tides ebb and flow.

Right: Illustration from *Le Pater*, Alphonse Mucha, 1899, lithograph.

An intensely meaningful and ambitious work created by celebrated artist Alphonse Mucha (1860–1939) in 1899 at the close of the century, *Le Pater* was an illustrated exploration representing the artist's spiritual revelations. Considered a masterpiece by the artist himself, in this work brimming with mysticism and occult themes and haunting imagery, Mucha created an image for every line of the Lord's Prayer, representing his own interpretations of religion and philosophy – a belief that Beauty, Truth and Love were the three cornerstones of humanity.

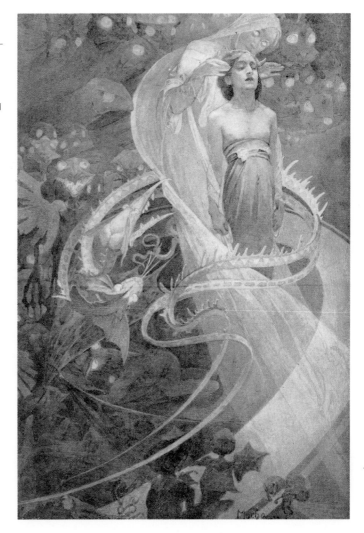

Opposite: 320 Megahertz, Susan Jamison, 2021, egg tempera on panel.

Best known for the glimmering, numinous spirit of her intricate egg tempera paintings, the delicate iconography of contemporary artist Susan Jamison spans several media, including painting, drawing, textile-based sculpture and installation. Abundant with ritualistic and mythological associations and frequently channelling a sense of sacred or enchanted ideals, Susan's works are inspired by metaphysical and spiritual practices, as well as the answers that nature and natural cycles provide. *320 Megahertz* is part of her body of work, *The Frequency of Roses*, centred on the holy, healing energies of the flower and the practice of raising one's vibration to 'encompass more love'.

Worlds Apart

'The universe is exactly the size that your soul can encompass. Some people live in extremely small worlds, and some live in a world of infinite possibility.'

– KEVIN HEARNE, *HOUNDED (THE IRON DRUID CHRONICLES)*

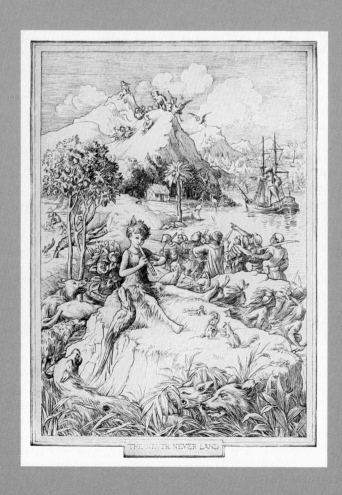

THE NEVER NEVER LAND

A realm of night, illuminated by the gentle grin of the Man in the Moon and the sentient starlight of twinkling fairy wings; a portal through a mirror to a mind-bending realm of the surreal and absurd; epic worlds full of chimerical creatures and tempestuous battles between good and evil; myriad populations, each with a vivid and diverse history, peopled with immortal elves and powerful wizards and chatty forest animals – and, of course, we can't forget the megalomaniacal, villainous overlord who aspires to rule them all.

From vast oceanic realms submerged fathoms deep to sky-borne kingdoms floating among the clouds, underworlds, otherworlds and every paradise, dystopia or abyssal void in between, the human imagination has devised an extravagance of places and spaces for us to dream of. Some of these environments are parallel worlds connected to our Earth via magical portals or even an imaginary universe hidden within our own; they could be a fictitious Earth set in the distant past or future, an alternative version of our known history, an entirely independent world set in another galaxy, far, far away.

From antiquity to the present, artists have been racking up the frequent-flyer miles with visits to these fantastical worlds and bringing to life on canvas what they've seen in their travels. From medieval parchment renderings of star maps, exuberant processions of celestial luminaries believed to represent figures of divine importance, to murky paintings of the mysterious lost world of Atlantis or the geometric fantasies of fabulous visionary architecture – visually, many fantasy worlds may appear to draw heavily on real-world history, geography, sociology and mythology. But the marvellous thing about our vast, wondrous human minds full of brash, bold flights of fancy is that, not limited by our standard rules of Earth-bound reality, artists can let their creativity run wild in the playgrounds of their own mythical worlds and Neverlands and somewhere-over-the-rainbow realms. Logic and physics, pish posh! Who needs that stuff? Creating and constructing something wholly new and never seen before, these visionaries conjure captivating scenes that immerse the viewer in a world entirely alien and strange but which feels stunningly please-pinch-me real.

Rare is the world, imaginary or otherwise, that is devoid of conflict. No matter how pristine the lands and peaceful the society, someone's always out there looking to shake things up

Opposite: 'The Never Never Land' from *Peter & Wendy* by J.M. Barrie, Francis Donkin Bedford, 1911, engraving.

and cause trouble. Perhaps it's a spot of localized misfortune, contained to a quaint cursed hamlet, or kingdom under siege – or a disturbance as expansive as the fate of the entire universe! The point is – these worlds, they often need saving, and frequently from the very folks populating them. And that's where heroes come in. From the splendidly chivalrous knights of legend to the marvels of mythological warriors, from the small and unassuming saviours to the superstars of bravery and courage, artists have long showcased these champions, mortal and immortal, human and otherwise, in their masterpieces.

Given a chance, would you peer through that portal, mosey on through that mystical doorway? There are amazing adventures to be had, uncharted lands to explore, fantastical characters and mythical creatures to befriend and band together and embark on world-saving quests with. All you have to do is gaze into that vibrant canvas, take a deep, calming breath and equip the most powerful weapon you will ever have at your disposal: your most excellent, highly trained imagination.

Opposite: Illustration from *Around the Moon* by Jules Verne, Émile-Antoine Bayard, 1870, engraving.

VII

Forgotten Realms
& Wonderlands

'There is nothing new under the sun, but there are new suns.'

OCTAVIA E. BUTLER

Whether you tumbled down a rabbit hole or travelled via a traumatic tornado or magic train ride, or perhaps even found yourself caught up in the machinations of an artist's daydream of strange terrains, opulent palaces and enchanted forests, the very idea of wonderlands where adventure dwells sends the imagination soaring and sets the scene for unforgettably dramatic visuals.

'Imagination,' science luminary Carl Sagan assured us, 'will often carry us to worlds that never were.' 'Some things have to be believed to be seen,' declared beloved fantasy author Madeleine L'Engle. I believe they're both right, even though one might suppose that science and fantasy don't often agree with one another. And who better to make us see what they already believe, to sit us right smack in the middle of those realms and wonderlands, than artists who are inspired to illustrate the fiction and fables of imagined worlds.

Artists construct worlds and invite us to enter. Glittering underwater kingdoms, misty fairy fields, heaven and hell, and everywhere in between – and beyond. In space, way out past the bounds of the known and knowable, artists are conceiving of and conjuring forth in every possible medium, all of those frontiers where no person has gone before. They know, just as Carl Sagan did, that 'somewhere, something incredible is waiting to be known'. (Carl Sagan was brilliantly quotable!) Anyway, you don't have to tell us twice – we as exhausted human people want to escape our real-world concerns and humdrum existences and hang out somewhere else for a while.

A painterly brushstroke is a door left ajar, a peek behind the rustle of a curtain or in the mirror's depths, through which we catch a glimpse of another world. Glimpses immortalized by artists such as Maxfield Parrish, a major figure in the Golden Age of Illustration (1850–1925), whose ethereal compositions were immersive portals into lush, imaginary places, his subjects imbued with mystery and wonder. Gustave Doré, Charles Robinson and Richard Dadd brought the glimmering, supernatural, sometimes mischievous, sometimes malicious land of the fairies to life in their wildly different, though equally enchanting and entrancing, individual styles. The Surrealists tapped into the subconscious mind for their abstract, uncanny hallucinatory landscapes, and the fabulous otherworlds of mid-century to present-day artists, such as Bruce Pennington

and John Harris, guide us breathlessly through eye-poppingly spectacular alien landscapes and gleaming futuristic metropolises.

Whether looking to the stars to inspire visions of vast cosmic regions beyond our lonely planet, gazing inwardly at the psyche for the complex explorations of our internal realms, or mining the annals of history to construct a distant but extraordinary eventuality – experiencing the strange new worlds of these artworks helps us rethink our tired, old perspectives. Sometimes we need to be turned on our heads, encouraged to shed our reason and logic and reach into the deep, hidden parts of ourselves to access novel and unconventional ideas and rediscover our sense of wonder. These dark, secret spaces are where we've locked away our sense of childish delight, hidden away our hopes and our wildest dreams, our longings for the sublime, the splendid, even the silly! And artful immersion in these forgotten realms and wonderlands is at least one of the

Below: Detail from *The Rainbow Factory*, Charles Robinson, 1926, medium unknown.

Opposite: Land of Make Believe, Maxfield Parrish, *c.* 1905, oil on canvas on board.

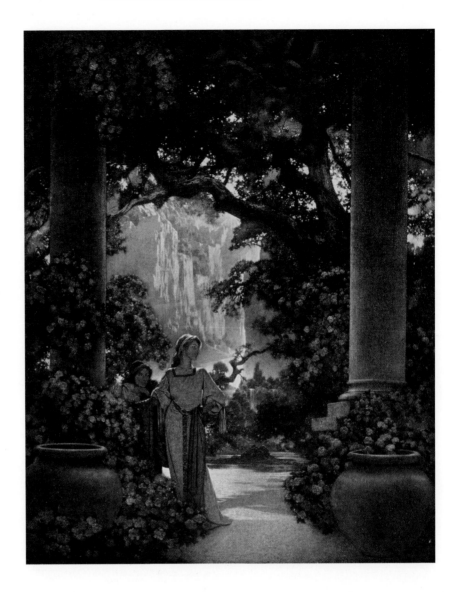

keys to setting those pieces of ourselves free. Our inner child has *always* known these places exist. In observing and absorbing the other suns and moons and magic and marvels of these unknown, unexplored worlds, either via oil on canvas in a museum display case, or through the illustrations of a tattered and much-loved storybook, or even in the digital dreamland of an artist's portfolio on the internet, we allow that divine spark within, the inner child, our little-us, a chance to come out and play for a while.

Above: The Fairy Feller's Master-Stroke,
Richard Dadd, 1855–64, oil on canvas.

In 1843, Richard Dadd (1817–86),
a charming, young rising star in the
Victorian art world, murdered his
father. Dadd had returned in a much
disturbed state from a tour of the
Middle East and was experiencing
violent delusions. Soon after, in travels
with his father, the artist suffered
what we might now consider to be a
psychotic break-down, cut his father's
throat, and fled. Apprehended and
incarcerated by court order as a
'criminal lunatic', Dadd was sent to
the Bethlem Royal Hospital, better
known now by its infamous nickname
of Bedlam - where he was to live out
his remaining 43 years. During his
confinement, he was encouraged to
continue his painting and it was during
this time Dadd painted the complex
and intriguing *The Fairy Feller's*
Master-Stroke, a verdant, murky
cacophony of characters that took him
nine years to paint, and which remains
unfinished. The bizarre world in this
canvas, wrought by an artist trapped
in the frightening world of their illness,
was an inspiration to many, including
contemporary fantasy author Neil
Gaiman, and the late singer of grand
fabulosity Freddie Mercury.

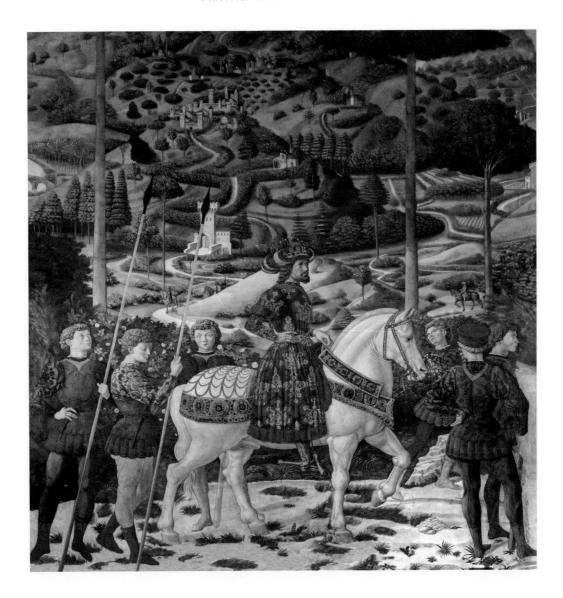

Above: Fantastical landscape detail from the *Journey of the Magi* cycle, Benozzo Gozzoli, *c.* 1460, fresco.

Italian Renaissance painter Benozzo Gozzoli (*c.* 1421-97) is best known for his series of murals depicting festive, vibrant processions with wonderful attention to detail and brought to life with glorious colours. In these works, like this aristocratic fantasy unfolding in the rich Tuscan landscape, many art enthusiasts revere the superb observation of detail, but some critics note that Gozzoli was not really known much for his attention to detail and, in fact, many pieces of his work can be found with errors. Is this procession of untroubled, opulently dressed travellers riding through the vegetation of the countryside meant to be visiting a huge, welcoming city - or a small village with a stable, as we might expect from the familiar narrative? Maybe historians and theologians got it all wrong - or, more likely, these dynamic details originated in the painter's own fantasy.

Above: Battle of Fishes, André Masson, 1926, sand, gesso, oil, pencil and charcoal on canvas.

An image depicting a savage underwater battle between sharp-toothed fish, *Battle of Fishes* was created by Surrealist artist André Masson (1896–1987), by liberally applying gesso to areas of the canvas, tossing sand on it, then brushing away the excess. The emerging contours hinted at vague forms – 'although almost always irrational ones', observed the artist – around which he sketched and applied. Masson, who lived with physical and spiritual wounds from the First World War, joined the Surrealist group in 1924. He felt that, if left to chance, pictorial compositions would reveal the sadism of all living creatures.

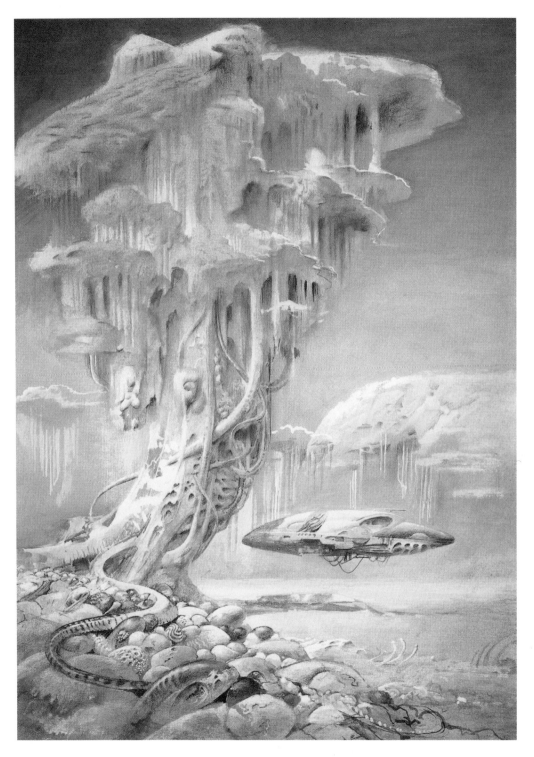

Right: The Ship of Yoharneth,
illustration for *The Gods of Pegāna*
by Lord Dunsany, Sidney H. Sime,
1911, medium unknown.

Symbolist, Golden Age illustrator
and painter Sidney Herbert Sime
(1865-1941) was an English artist
in the late Victorian period. Sime is
largely remembered for his fantastic
and satirical artwork brimming with
fin-de-siècle elegance, delicate
linework and its manifestation of the
uncanny – and for his illustrations of
Irish author and poet Lord Dunsany's
stories in particular. Indeed, it is
remarked that one can scarcely
imagine a Dunsany story without the
visionary drawings of Sidney H. Sime.
In Dunsany's 1905 story collection *The
Gods of Pegāna,* Sime illustrates the
remote dream worlds and myths from
a lost culture, the invented pantheon
of deities who dwell in Pegāna.

Opposite: Fungus Gigantica,
Bruce Pennington, 1990,
gouache, acrylic paints and
Indian Ink.

A fixture in the fantasy and science
fiction section in your favourite
bookstore in the 1970s and
1980s, Bruce Pennington's style is
immediately unmistakable. Richly
imaginative landscapes ranging from
apocalyptic desolation to biomorphic
extravagance, ruined cities smouldering
in the distance under the haze of an
alien sun. In interviews, Pennington
references painters such as Hieronymus
Bosch, John Martin, Henry Fuseli
and Richard Dadd among the artists
that have influenced his work, and
it's always a delightful exercise to
pore over his atmospheric far-flung
worlds and catch glimpses of these
fantastical inspirations, while never
once forgetting that Pennington is a
luminary in his own right with his own
unique and fabulous vision for futures
that might have been or never were.

Above: Sadko in the Underwater Kingdom, Ilya Répine, 1876, oil on canvas.

In Paris, in 1873, Ilya Efimovich Répine (1844-1930) began this work inspired by a traditional Russian poem. It depicts the story of Sadko, a wealthy Novgorod merchant, who falls into the underwater kingdom of the sea tsar; invited to choose between several fiancées, he elects Chernavushka, the Russian girl. Répine worked on this painting for three years, without being satisfied with it. He felt that this fantastic theme, treated with precious details and refined colours, would not be in line with his ambition as a realistic painter. Nevertheless, the artist presented *Sadko* to the Academy of Fine Arts in St Petersburg on his return in 1876 and received, thanks to this work so foreign to the rest of his production, the title of academician.

Above: Riverside, Danny Flynn,
date and medium unknown.

Contemporary artist Danny Flynn
carries with him a lifelong interest in
science fiction and fantasy, as well as
a deep appreciation for wildlife and
the beauty of the natural world. Add
to that a dash of artistic influences:
a sprinkle of Surrealists Dalí and
Magritte, a smidgen of master of light
Maxfield Parrish, and a healthy dollop
of ethereal, mystical electronic music

from Vangelis or Tangerine Dream,
and you have a recipe for Flynn's
landscapes from another dimension.
Magical worlds and secret places
brimming with eye-popping colours,
extraterrestrial flora and fauna, and
powerfully strange architecture are
but a few of the details you will find
in this artist's extraordinary body
of work, splashed across massive
paintings and several scores of vivid
book jackets.

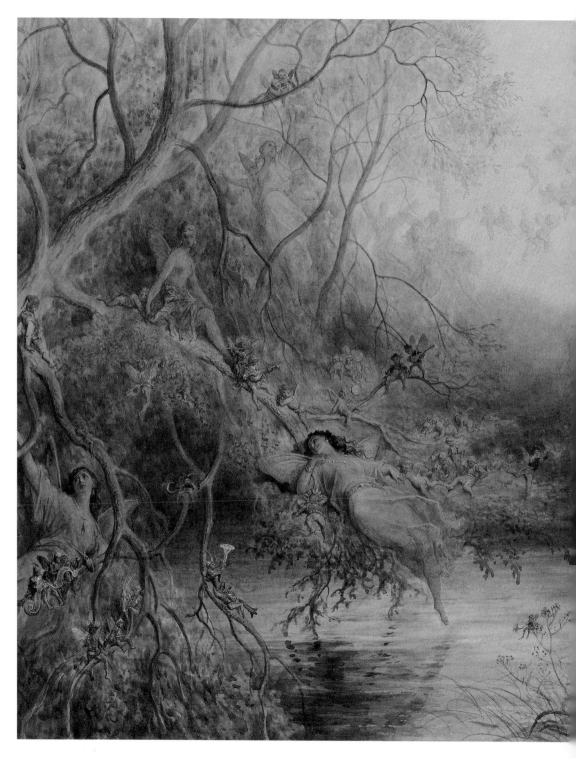

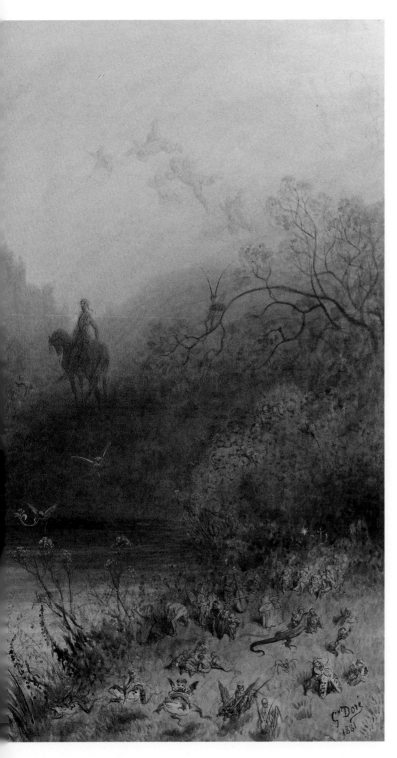

Left: Fairy Land, Gustave Doré, 1881, watercolour with gouache over graphite on cream wove paper.

Best known as one of the finest book illustrators of the nineteenth century, Gustave Doré (1832–83) was a gifted and wildly popular artist in his own lifetime, whose spectacular visions laid many of the foundations of the fantasy art we enjoy today. This remarkably inventive artist was guided by his own imagination and produced extraordinary scenes of dreamlike intensity where fantasy and reality overlap in large-scale canvases and sculptures, as well as insightful ink drawings and detailed engravings.

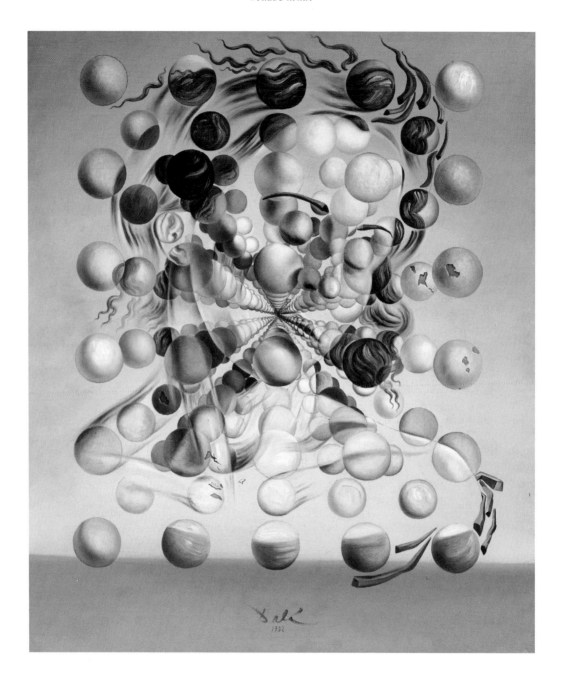

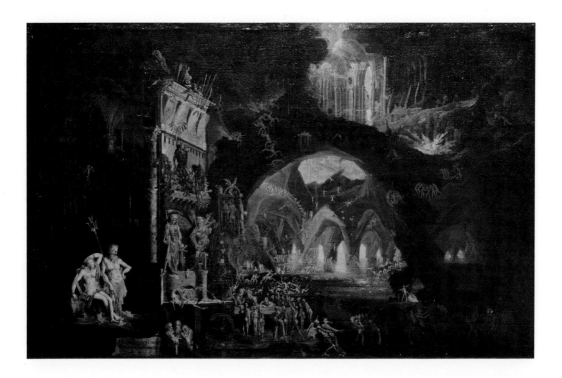

Opposite: Galatea of the Spheres,
Salvador Dalí, 1952, oil on canvas.

Above: Hell, François de Nomé (Monsù
Desiderio), 1622, oil on canvas.

From those iconic melting clocks to imaginative visual illusions and avant-garde symbols, it's safe to say that we instantly recognize the unparalleled weirdness and fantastical hand of celebrated Surrealist artist Salvador Dalí (1904–89) when we see it. In Dalí's marvellous 1952 portrait of his wife Gala, the artist harmoniously portrays her face in a graceful matrix of fragmented spheres, suspended in space. The structure of DNA fascinated Dalí and this work, a Gala-universe consisting of many Gala-worlds continually merging, is the result of a Dalí impassioned by science and the theories of the disintegration of the atom in the period of nuclear mysticism.

In the mid-twentieth century, art historians identified the works previously attributed to 'Monsù Desiderio' as being by at least three different painters: François de Nomé (c. 1593–after 1630) and Didier Barra (1590–1656), both originally from Metz, and a third artist, whose name is unknown. These works comprised ghostly architectural scenes, crumbling and bizarre and fantastic . . . and throughout the ages, are there really any worlds so ghastly and fantastical to contemplate as hell? A soft glow illuminates the theatrical chiaroscuro of Nomé's Baroque version of 'The Bad Place', wherein there is an absolute extravagance of tormented souls plummeting, pitching and plunging from every great height and veritably stuffed into every nook and cranny. Yet, chaos does not reign eternally. They are tidily queued up for judgement as well.

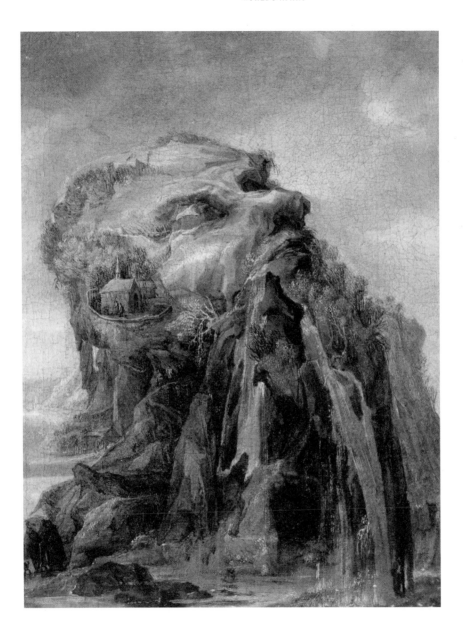

Above: Allegory of Winter, Joos de Momper the Younger, *c.* 1600–35, oil on panel.

Flemish painter Joos de Momper the Younger (1564-1635) specialized in craggy, mountainous landscapes, both the topographically accurate sort as well as the fantastically imagined, and with these striking, picturesque works, achieved great success during his lifetime. In fact, he was thought to be one of the greatest landscape painters of his period. His allegorical portrayal of the seasons took form as a series of sombre anthropomorphic landscapes, carefully composed with a variety of seasonal details: trees and their changing foliage, animals, birds and humans. Early modern Europe delighted in this kind of allegorical imagery, with pictures not merely pleasing to the eye, but inspiring curiosity of the mind as well. Meanwhile, the mind resting within this wintry mountain's head seems to be having a nice snooze.

Above: The Garden, Martina Hoffman, 2021, oil on canvas.

Offering lush, complex glimpses into the inner journeys of expanded states of consciousness, contemporary visionary artist Martina Hoffman paints portals into parallel worlds steeped in mystical atmosphere and profound biological energies, such as this verdant moonlit Elysium, where even the shadows are glossy and glowing. Dazzling and dreamlike as these vistas may be, they are more than mere surreal canvases of psychedelic brushstrokes – these works are ecstatic experiences and spiritual awakenings, introspective meditations on the infinite power of imagination and the vast potential of human transformation.

Right: The Most Sacred (Treasure of the Mountains), Nicholas Roerich, 1933, tempera on canvas.

Visionary and idealist Nicholas Roerich (1874–1947) kept himself very, very busy. His pursuits were many and varied: he was an artist, scholar, archaeologist, adventurer, editor, writer; he promoted peace, the protection of the world's cultural heritage, and the notion that the creative people of the world bear the responsibility to save the world; and he was also a great seeker of hidden mysteries, the pursuit of which are reflected in his art and his writings. Roerich's *The Most Sacred (Treasure of the Mountains)* explores the idea of questing for riches, but not the glittering, bankable sort; the painting's beautifully fantastical gemstone-encrusted caverns are not indicative of material wealth but rather the spiritual 'treasure' that's available to all who are willing to reach inside themselves for it.

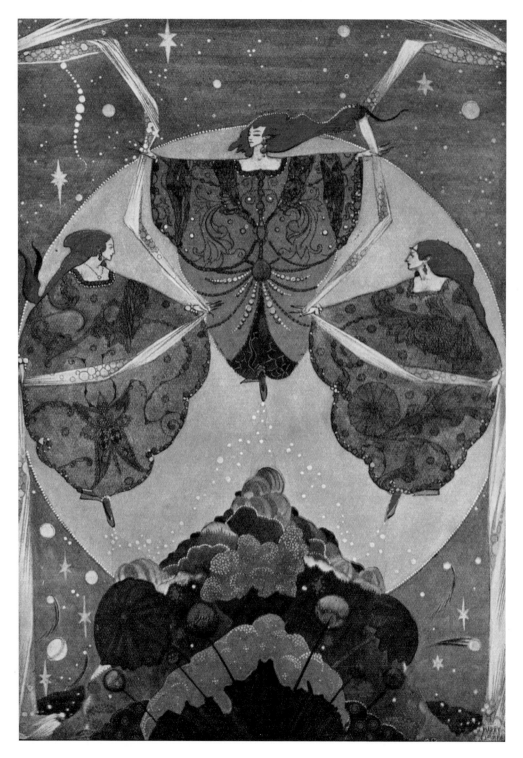

Right: The Land of Dreams,
Otto Lendecke, 1918,
medium unknown.

The enduring mysteries of our
dreams have long captivated
artists - but where do we go when
we dream? And how do we get
there? Austrian Impressionist Otto
Friedrich Carl Lendecke (1886-1918)
offers us insight in this snapshot of a
slumbering soul blissfully transported
by the delirious acrobatics of a flock
of cherubim to The Land of Dreams.
Much of this painter, sculptor and
illustrator's body of work consists of
watercolour illustrations for fashion
journals, but even in those pieces,
in the soft, shadowy fold of fabric,
the fantastical patterns embellishing
a lady's cape, it's apparent this
fellow was a pro-daydreamer well
acquainted with the otherworlds of
a vast imagination.

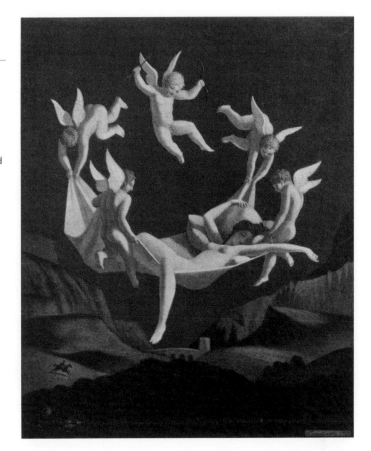

Opposite:The Elf-hill, Harry Clarke,
1919, ink, graphite, watercolour
gouache and glazes with body colour
highlights on paper.

'Hark, what a buzzing and humming
there is!' Such are the festivities
and fun attended by mermaids and
ghosts, hobgoblins and imps at the
feast of the Elf-hill in Hans Christian
Andersen's 1845 fairy tale. For this
evening of merriment the Elf King has
invited the Goblin King of Norway
and his unruly sons to a feast where
his daughters, potential brides for
the goblin suitors, will display their
talents. These are not entirely useful
or desirable talents, as it happens,
and the goblin boys are unimpressed.
Here in this strikingly vivid illustration
by Harry Clarke (1889-1931), the elf
maidens perform a frenzied, flying
feverish dance with swirling shawls
'woven of mist and moonlight'.

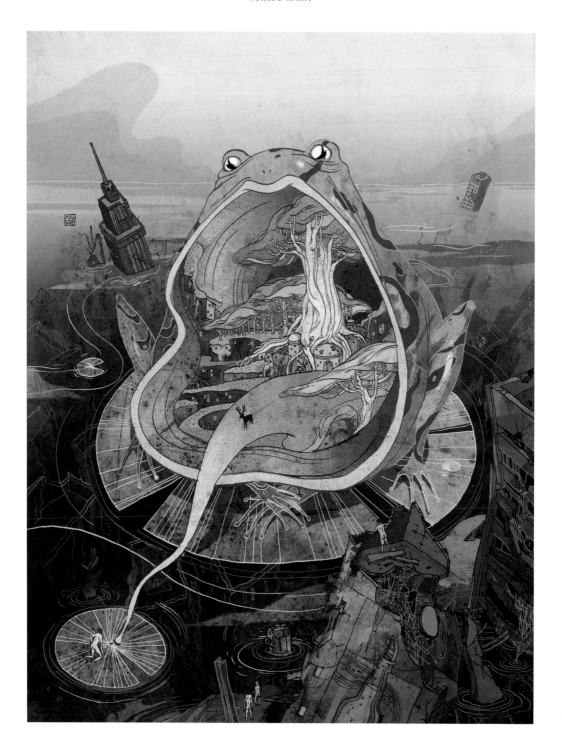

Opposite: Frogfolio Utopia, Victo Ngai, 2012, mixed media with digital.

Contemporary illustrator and storyboard artist Victo Ngai reveals elaborate worlds filled with intricate narratives and brimming with curious details, where the mundane morphs into the magical, yet the otherworldly and outlandish rings somehow familiar. In this visual storyteller's utopia, a massive bullfrog gawps majestically on a lily pad at the centre of a drowned and ruined metropolis - giving the viewer an astonishing view down its gullet, where a serene expanse of nature flourishes, untroubled by the horror of the world just outside its amphibious sanctuary.

Above: *The Garden of Earthly Delights* (detail), Hieronymus Bosch, 1503–04, oil on panel.

Let's hear it for artists who have created imaginary worlds so exceptionally distinctive that their names have entered our daily lexicon as wonderfully, singularly descriptive adjectives! If someone were to construct a sentence referencing a 'Boschian hellscape', we can - from that economy of words - immediately conjure the scene. Intensely, even shockingly, fantastical - the works of medieval Dutch painter Hieronymus Bosch (c. 1450–1516) range from the bizarrely bucolic to cataclysmic chaos - sometimes even in the same painting! And, of course, the

infamous *The Garden of Earthly Delights*, a nightmarish triptych encompassing humanity's eternal battle between wickedness and morality, interwoven with all of the horror and grandeur of the cosmos, is the most memorable of all.

VIII

—

Time Travel, Alternate Histories & Parallel Universes

'If you think this world is bad, you should see some of the others.'

— PHILIP K. DICK

If you had a time machine, where would you go? Would you program in a destination back to prehistoric times and spend a few moments taking in the triceratops and pterodactyls and hopefully make your exit before you got gobbled up by a T-rex? Would you zoom back to yesterday around noon to reframe that joke you told that fell flat in front of your co-workers and you felt amazingly embarrassed and wanted to crawl into a hole and die? Or, perhaps, do you imagine another 'you' out there, a you whose jokes never fail to elicit genuine hilarity, someone suave and charismatic and never awkward or cringey. And maybe in that alternate reality, you're also the person who invented that time machine!

Are we alone in the universe? Are there multiple realities, other dimensions and planes of existence? And how do we access these worlds that transcend reality, these glimpses into things that never occurred, or which could only occur in a theoretical future, possibly somewhere else entirely? Scientists and physicists have all sorts of theories regarding these fascinating questions, and I do too.

If a painting is a portal to another dimension, then artists are conductors of the magic carpets that whoosh us to and from these imaginative realms and rifts in reality, guiding us and granting us access to exalted spaces brimming with the unreal, the unseen and the unknown. What are these artists' inspirations? Space, nature, industry; dreams, ancient cultures, mythologies; time, energy and matter. Personal cosmologies that speak to the impossible and the fantastical dreams in all of us. Some through evoking the anxieties of our modern age and creating strange realms between our hopes for utopia and our fears of oblivion, others through an interplay between loneliness and isolation, our concerns regarding overpopulation, but also our deep need for connection.

What do these irresistibly thought-provoking expeditions and their astonishing destinations look like? In Albert Robida's and William Heath Robinson's sketches, we thrill to imaginative and fanciful (though sometimes ridiculously over-complicated) inventions that were envisioned as practical augmentations to everyday life, as well as the societal advancements that arose from them. In Robert Venosa's crystalline works we observe serene, sublime visions of glowing alien flora – unlike anything seen in our terrestrial handbooks of botanical illustrations.

It's a shame that these works of speculative wonder are still considered 'lowbrow' and not appreciated in the same way as 'high art' in museums and galleries, valued by those with 'cultivated tastes'. Perhaps because fantastic art is such a broad and loosely defined art genre, or due to its association with commercial illustrative use as opposed to fine art, it is not taken very seriously or considered valid by art historians. Bah to that, I say! In terms of exposing oneself to as much beautifully imaginative art as possible, this is a limiting distinction and hierarchy that harms more than it helps.

These artists are explorers and by taking us with them on their journeys, by extension we, too, are voyagers traversing the strange superhighways of the unknown. Alternate planes of existence, parallel dimensions, travelling back and forth in time – artists remind us time and time again (and show us proof!) that what we believe to be reality is but one scenario out of an infinite number of possibilities. And whether or not that astonishing work is appreciated by art scholars or consumed by the masses – highbrow, lowbrow – where we're headed, these things don't matter.

Opposite: Martian tripods standing over a flooded city, illustration from *War of the Worlds* by H.G. Wells, Henrique Alvim Corrêa, 1906, pencil on paper laid on cardstock.

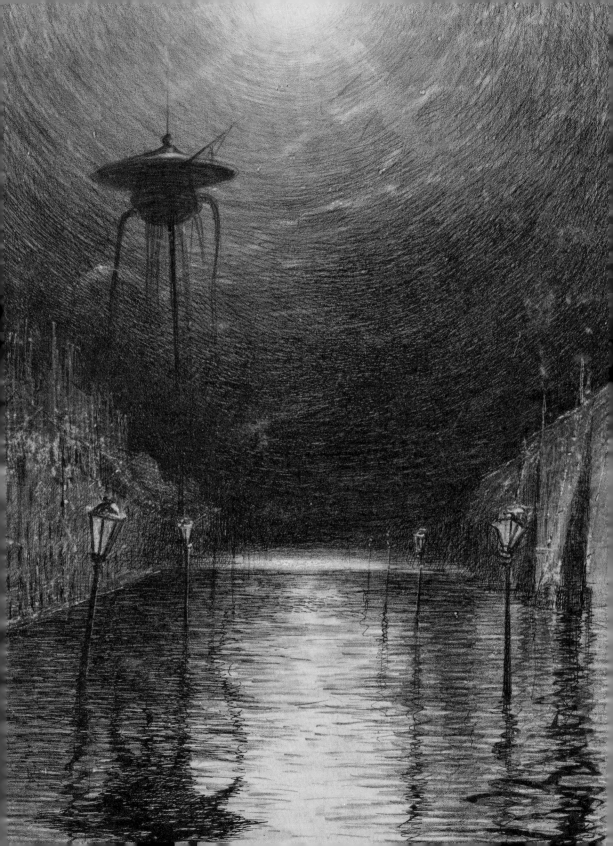

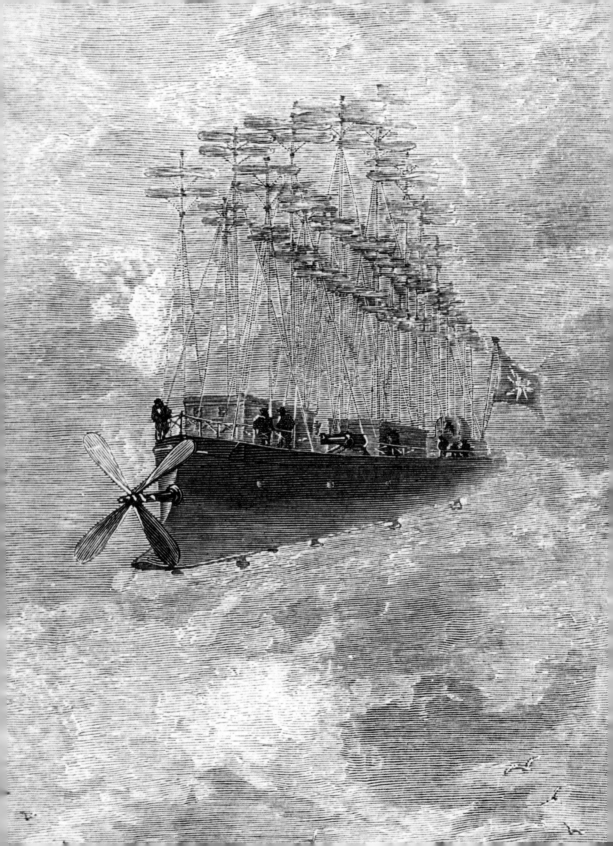

Right: Central Aircraft Station at Notre-Dame (Paris), illustration from *Le Vingtième Siècle. La Vie Électrique*, Albert Robida, *c.* 1890, colour engraving.

Jauntily sailing past an elevated restaurant and opera house, there are flying cars, buses and airborne means of transportation. The sky is swarming with these cloud-adjacent conveyances, tootling Victorian-garbed folks to and from their destinations. Fabulous visionary Albert Robida (1848–1926) was a French illustrator, lithographer and novelist, who began drawing at a young age and later drew cartoons and illustrations for various journals, but he is best known for his futuristic work of revelatory visions and startling predictions of the mechanized society of the twentieth century. This masterpiece is a trilogy of anticipatory novels in which he shows his creative insights about the technical wonders of our future creature comforts and includes the novels *Le Vingtième Siècle* (1883), *La Guerre au Vingtième Siècle* (1887) and *Le Vingtième Siècle. La Vie Électrique* (1890).

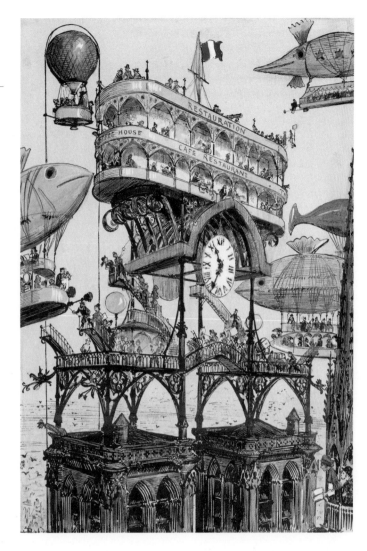

Opposite: The Albatross, Léon Benett, 1886, engraving.

In a world where the skies are ablaze with music and flashing lights, where sightings of an unidentified flying object are causing mass confusion, and atop many of the most recognizable monuments and landmarks, mysterious black and gold flags have appeared – what the heck is happening and who is responsible? In *Robur the Conqueror* (1886), science fiction master Jules Verne imagines two warring factions of brilliant inventors that have each developed the flight technology they believe will usher humanity into the future. These adventures and intrigues were visually depicted by French illustrator and painter Léon Benett (1839–1916), who illustrated 25 novels from Jules Verne's *Voyages Extraordinaires* series.

Left: Voyage to the Moon,
Gustave Doré, *c.* 1868,
engraving (colourized version).

Gather round and hear of the
outrageous exploits and outstanding
adventures of Baron Munchausen,
whose feats included riding
cannonballs, pulling himself out of
a bog by his own hair and travelling
to the Moon! A fictional character
created in the late eighteenth century
who has been everywhere, seen
everything, done it all - and given
any chance, he'll tell you all about
it, whether you want him to or not.
*Baron Munchausen's Narrative of his
Marvellous Travels and Campaigns
in Russia* (1785) by Rudolf Erich
Raspe would also inspire a film and a
number of stage productions. Various
artists have illustrated the Baron's
preposterous tales, most notably
Gustave Doré (1832-83), responsible
for the quintessential image of the
Baron as we know him today, and
who created this image of a dreadful
hurricane that propelled his ship
above the clouds to a shining island
that turned out to be the Moon.

Opposite: De gouden stad (The Golden
City), Johfra Bosschart, 1963,
medium unknown.

Twisting and beautiful, otherworldly
spires tower impossibly skyward
to disappear in the distant mists, a
vision of gilded utopia beckons. In
the foreground, a tangled profusion

of labyrinthine archways squats in
the rubble, spectral smoke hangs
heavy on the ground and there
is nary a soul about - hinting that
perhaps much was lost to this golden
city's rise to magnificence. What is
the story here? Dutch artist Johfra
Bosschart (1919-98) described his
works as 'Surrealism based on studies

of psychology, religion, the bible,
astrology, antiquity, magic, witchcraft,
mythology and occultism' – a mystical
and fabulous word soup that, when
taken into consideration alongside
this enigmatic imagery, one can say
with absolute confidence, 'Ah . . . it all
makes sense, now.'

Above: Tres Flores, Robert Venosa,
2010, oil on canvas.

Robert Venosa (1936–2011) was a
master of the numinous, a painter of
cosmic realms and crystalline worlds
whose dazzling paintings kindled
the imaginations of many and greatly
impacted the world of visionary art
during his long and varied career.
A creator of mythical mindscapes and
timeless vistas of wondrous realities,
his fantastic visions reflected a great
spiritual curiosity, emblematic of
the vast creative universe that he
tapped into. What grows in dazzlingly
fertile lands such as these? If we go
by the looks of these three ethereal,
shimmering specimens of flora we can
only imagine the millions of botanical
delights Venosa was growing in the
celestial greenhouse of his soul.

Above: Arrival on Ganymede, Paul Lewin, 2021, acrylic on wood.

The work of contemporary artist Paul Lewin explores ancestral elements – ancient ancestors, futuristic ancestors, inter-dimensional ancestors – in riveting narratives charged with meaning, history, mystery and mysticism. Inspired by nature, Afro-Caribbean culture, folklore and science fiction, Lewin's swirling, jewel-toned hypnotic figures transport the viewer forwards and backwards simultaneously to alternate worlds where visions of the past and the future are reimagined, reconstructed and reformed.

From his well-known humorous
drawings to his fanciful illustrations
for Kipling, Shakespeare or children's
stories, William Heath Robinson
(1872-1944) was a prolific artist
whose quirky, inventive body of
work is considered integral to British
cultural heritage. Heath Robinson
revelled in fussy gadgetry and
elaborate contraptions, and found that
absurdly over-complicated machinery
would serve as a metaphor for the
bureaucracy and arcane processes
that people tend to invent. This
charming combination of whimsicality
and weirdness is found in such works
as *Aerial Life*, an excellent example of
Heath Robinson's droll utopian vision.

František Kupka (1871-1957) was
a Czech painter and graphic artist
interested in cosmic forces and the
occult, concepts he incorporated
into his early creations - though he
gradually evolved a very abstract
style. This 'colour symphonist' sought
to express his beliefs regarding
religion, geometry and music through
the harmonies produced via colour
and line, rather than recognizable
imagery. 'The creative ability of
an artist is manifested only if he
succeeds in transforming the natural
phenomena into "another reality",'
Kupka once reflected. The reality
for this lonely pilgrim travelling a
silent sphynx-lined pathway is that
with his head perpetually bowed in
contemplation, he may never see the
way out through the starry horizon
that lies just before him.

Above: Cover art for *Kindred* by Octavia E. Butler, Laurence Schwinger, 1979, graphite and whiteout on board.

From phantasmal spectres to mythic beings to epic adventures, the intriguing portfolio of Laurence Schwinger includes fantastical fodder across many genres, and his book cover roster is a masterful Who's Who of beloved contemporary fantasy authors. Many of the artist's visions have a multi-layered, hazy atmosphere and a gorgeously subdued colour palette, and his cover art for pre-eminent twentieth-century science fiction and fantasy writer Octavia E. Butler takes that a step further. In this earth- and flesh-toned moody, evocative conjuration of the author's most popular and enduring work, our eyes are drawn to the two figures – each drawn to the other through time – with the negative space between them cleverly forming the top half of an hourglass.

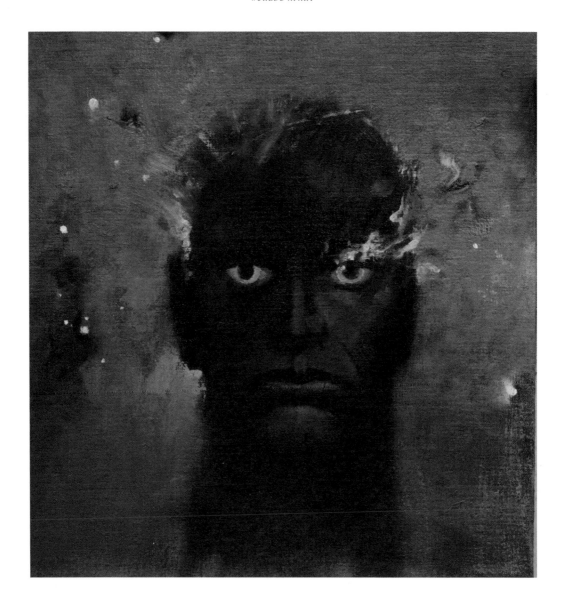

Above: Gully Foyle Isn't Angry Anymore, John Harris, 2019, oil on canvas on board.

In the realm of imaginary explorations, there is perhaps none so iconic as world-renowned visionary artist John Harris, whose spectacular paintings are a window to the immensities of the universe, glimpses of hazy, vibrantly coloured vistas and shattered moons, the impossible grandeur and inevitable decay of towering cities, and a strange melancholy, an ominous impression of the impending end of all things. His paintings have been used on book covers for many authors, including Arthur C. Clarke, Isaac Azimov and John Scalzi; this portrait, brimming with deep space secrets and incendiary, vengeful rage, has not been used on a book cover, but is noted as very much belonging to *The Stars My Destination* by Alfred Bester.

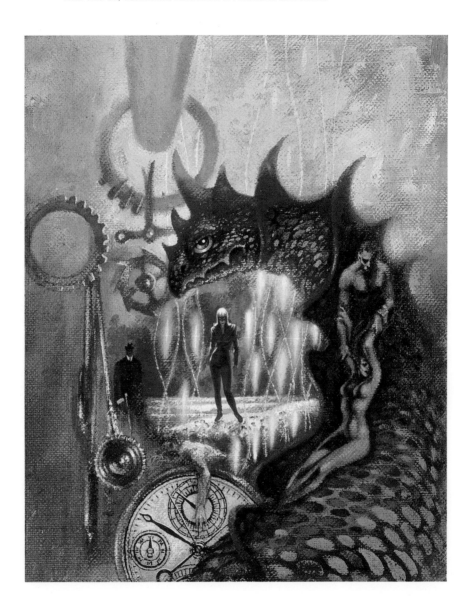

Above: Dinosaur Beach, Frank Kelly Freas, 1977, acrylics.

Frank Kelly Freas (1922-2005) is considered one of the most popular science fiction artists of the twentieth century, with luminous, whimsical illustrations in a staggering number of magazines and books, such as the cover art for *Dinosaur Beach*, above, which is not a travel brochure for prehistoric monsters, but rather a sci-fi adventure-thriller detailing the terrifying odyssey of a hard-boiled time cop, pitted against a time-tampering team from the future! Characterized by expressive figures, mischievous creativity and always with an element of storytelling, Freas' images ranged from pop to pulp art, from fantastical to gritty to humorous. After his picture of a moonlit, flute-playing satyr on the cover of the November 1950 *Weird Tales* began 50 years of professional illustrating, he helped refine the satirical smirk of *Mad* magazine's Alfred E. Newman and, apparently, a werewolf drawing by Freas can even be glimpsed in a classroom scene in the movie *Harry Potter and the Prisoner of Azkaban*.

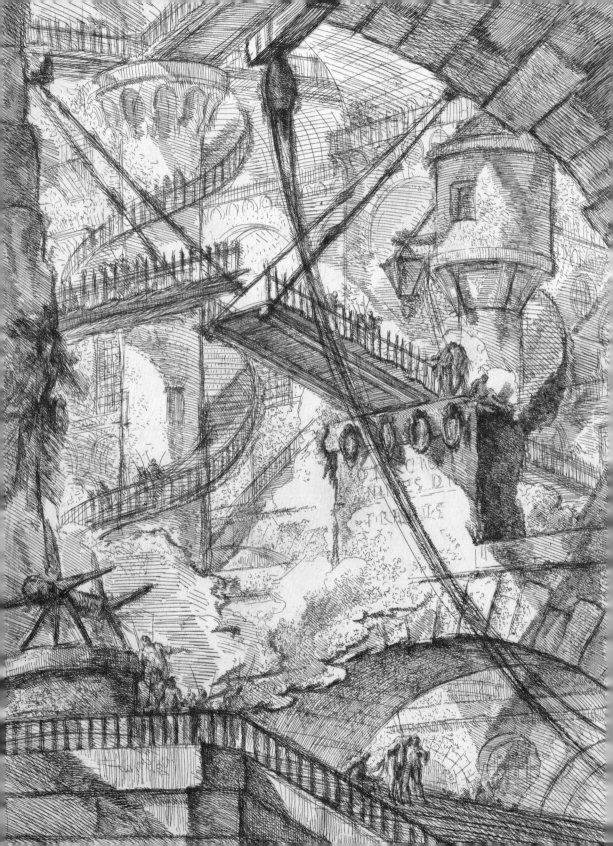

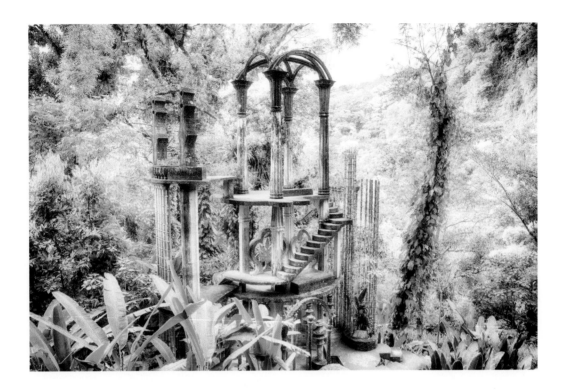

Opposite: The Drawbridge, Giovanni Battista Piranesi, *c.* 1749–50, etching, engraving, scratching.

An enthusiast of Roman, Greek and Egyptian architecture, Italian artist, architect and antiquarian Giovanni Battista Piranesi (1720–78) employed his fantastical genius to create imaginings of ancient buildings and mysterious ruins – complex, dizzying spaces that defied rules of logic and reality. These impossible geographies also included ominous, prison-like structures and confines – immense buildings observed from extreme perspectives, with endless gloomy staircases, bridges, vaults and labyrinths. This *Carceri* (meaning prison or dungeon) series was not conceived of for commercial work, but merely a private, experimental outlet for the artist's incredible imagination.

Above: The Staircase to Heaven, Edward James, 1949–84, concrete.

A Surrealist architectural dreamscape in the remote jungles of Mexico, in the sprawling gardens of Las Pozas, one can find fantastically imaginative structures with names like *The House on Three Floors Which Will in Fact Have Five or Four or Six, The House with a Roof like a Whale* and *The Staircase to Heaven*. An avant-garde menagerie of concrete archways, sculptures and columns amid the lush flora, this vision of paradise – which began as a simple orchid garden – was envisioned by Edward James (1907–84), a wealthy English aristocrat, poet and artist described by Salvador Dalí as 'crazier than all the Surrealists together'.

IX

How to Save the World

'Being a hero means ignoring how silly you feel.'

—DIANA WYNNE JONES, *FIRE AND HEMLOCK*

'I need a hero!' passionately declares power ballad diva Bonnie Tyler in her epic song from the 1980s – and in listening, we cannot help but be swept along with the drama and fantasy, too.

How do you visualize your heroes? When you close your eyes, do you conjure a white knight upon a fiery steed, a strapping Herculean type fearlessly labouring away at their legendary tasks, an everyman removing their spectacles, ripping off their shirt and leaping off a tall building in a single bound (wow, they look like an entirely different person! No one will ever guess their secret identity, thank goodness for those glasses!). Or maybe you imagine a morally-grey roguish type who eventually overcomes their own self-interests to fight the good fight, or the unassuming fellow who just steps out their door one morning and is swept up in an adventure and becomes a warrior and saviour despite themselves? Or the unsung heroes, quietly doing the work sans the accolades, making the world a better place?

Heroes come in all packages, and they're not a one-size-fits-all phenomenon – we need only look to artists' works across the centuries and observe these paragons and protectors of humanity as they carry out their dynamic deeds, immortalized the world over. From realms at risk from a wicked usurper to a world overrun by extraterrestrial aliens, ancient prophecies, evil plots, uncommon quests, vaguely defined cataclysms or very-specifically-spelt-out calamities poised to befall a people or a community – it's do or die against overwhelming odds. And artists in every culture have been capturing the essence of these idealized humans performing extraordinary feats. Why are artists drawn to the heroic? Why are any of us? The fact that practically every culture has stories of heroes is very telling about the collective mindset of us humans as a whole – that the hope for and existence of a hero satisfies something deeply held within us. The emergence of these champions, how they evolve and grow and inspire us along the way, the completion of their story – and the belief that it could be our story too, we could be heroes! – fulfills an emotional need that every one of us clings to.

The grandiose deeds of heroes, preserved in myth, literature and legend were the primary narratives from which artists – from Renaissance painters like Raphael to Symbolists such as Gustave Moreau – drew their inspiration. These powerful characters and

their exceptional undertakings and accomplishments starred in larger-than-life stories through which artists shared moral lessons. Heroes, of course, generally reflect the values and ideals of their society – but these traits and qualities change over time in response to history's hallmarks and dramatic upheavals. Over time, after the French Revolution, for example, artists responded, dismissing mythical subjects in favour of everyday people as artistic subjects worthy of attention, imagined in monumental, heroic terms – when push comes to shove, aren't we all capable of courage and conviction, selflessness and sacrifice?

For all that, we must be careful with paying homage to our heroes. They are far from perfect, sometimes tragically flawed even, and there is a fine line between good and evil, heroism and villainy. After all, don't some of the most diabolical villains believe they're acting for the greater good? Fantasy is flush with stories of heroes and their battles against 'the bad guy', and we are meant to view the hero and the villain on opposite ends of the spectrum of ethics and morality – but are they really so

Left: Hercules and the Nemean Lion, Niccolò Vicentino, 1540–50, chiaroscuro woodcut from two blocks in black and lime.

Right: A Man in Armour, Rembrandt van Rijn, *c.* 1655, oil on canvas.

different? Sometimes the good guys are ruthless and brutal, and sometimes we sympathize with the villains for their relatability or compelling stories, which makes the villain a deliciously tempting subject for the artist's imagination as well!

Admiring our fantastical heroes, whether via the gravitas of a work of classical art, a fate fixed immovably in the sculpt of a stone or in the contemporary mythology of the pages of a comic book, we identify with characters and archetypes that strive for greatness, we grow as they grow, and through them we see the potential for change in ourselves and the world around us. Heroes continue to delight us and excite us for reasons both inspirational and aspirational, and because, well, they just look really damn cool.

Above: Les Amazones, Marie Laurencin, 1921, oil on canvas.

A celebrated figure in the bohemian world of Paris, Marie Laurencin (1883-1956) painted soft, pastel women - figures influenced by both Cubism and Fauvism, but in gentle, flowing lines and a delicate colour palette, indicative of a style utterly and intrinsically her own. 'Why should I paint dead fish, onions and beer glasses? Girls are so much prettier,' Laurencin is said to have exuberantly remarked, a sentiment evident in her preferred subject matter but which can also be applied to her feminine, dreamy aesthetic. The artist was an attendee of the unconventional salons hosted by writer Natalie Clifford Barney, where queer and bisexual women artists and writers mingled and expressed their creativity, a setting Barney visualized being the alternate realm of a Sapphic utopia. Certainly, Laurencin's stylized paintings of the Amazons, those mythic warriors and legendary exemplars of archetypal female strength, were inspired by these provocative gatherings.

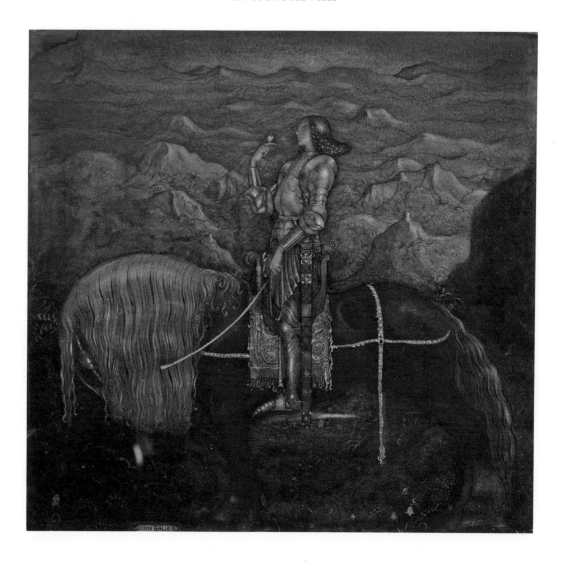

Above: A Knight Rode Forth, John Bauer, 1915, watercolour.

A beloved Swedish folklore annual and children's fairy-tale anthology first published in 1907 and which continues to this day, *Among Gnomes and Trolls* notes John Bauer (1882–1918) as one of its earliest – and best-known – illustrators. Bauer's atmospheres of mossy melancholia and gentle foreboding abound with the artist's boulder-shaped troll folk, but in this scene we have a handsome knight in all his finery, sitting ramrod straight on horseback. In this strange, sad tale by Jeanna Oterdahl, a knight lost in the forest encounters a simple farm girl, who helps him find the way back. Our perception of the typical knight is one encompassing values of chivalry and courage of heart; perhaps this fellow possessed all of these things. And yet, it was a farm girl who got him out of his trouble (spoiler: he eventually dies anyway). The lesson? Heroes come in many packages and not all of them look like this guy here. And not everyone survives the story.

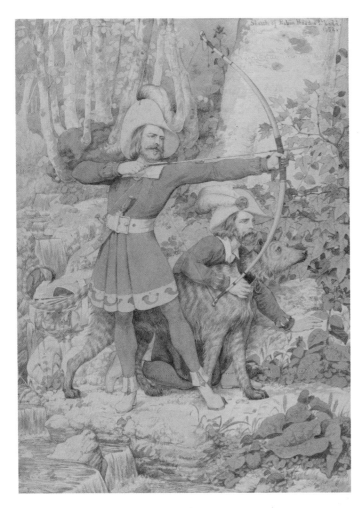

Left: Sketch of Robin Hood, Richard Dadd, 1852, watercolour over graphite on paper.

An enduring legend in the pantheon of heroes, capturing the imaginations of both scholars of history and the general public, Robin Hood is a cultural icon with timeless appeal. Whether or not he was a real person who once existed remains a robust debate, but whatever the age, and imaginary or not, we always need the hope of someone who will stand up for the oppressed and those without a voice - the chivalric bandits and anti-heroes who challenge the arrogance of those in power in pursuit of justice for all. Richard Dadd (1817–86) sketched this outlaw archer in 1852 - 170 years ago at the time of this writing - while living in the enforced seclusion of his stay at Bethlem Hospital, but this charismatic champion of the people will no doubt be reincarnated and adapted for the future, indefinitely.

Opposite: CHARACTER III, Atsuko Goto, 2022, pigments, gum arabic, Japanese ink, gold powder, silver powder, silver leaf, gold mica, natural mineral pigments, lapis lazuli on glued cotton cloth.

There's a pervasive sense of melancholy shrouding the subjects of the paintings by Atsuko Goto inspired by traditional Japanese visual culture

and techniques; an otherworldly gloom infusing every expression, every texture, every shadow of movement or stillness. As if the spectral figures conjured to the canvas are only there for a short while and then whisked back to the invisible land of spirits and shades after they have done the artist's bidding, as prescribed by the intricate rituals woven, unseen but psychically resonating throughout those delicate

watercolour brushstrokes. As if this skilled and decorated warrior, in ceremonial finery embellished with glittering tassels and charms and sophisticated spells of protection, has appeared only long enough to vanquish a villainous foe, to slay a bloodthirsty monster, to defy the gods themselves as humanity's solitary champion - and then is cast once again back into the mists.

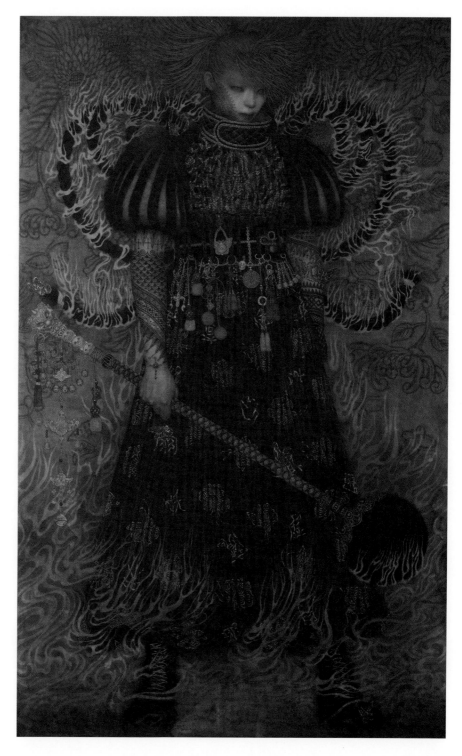

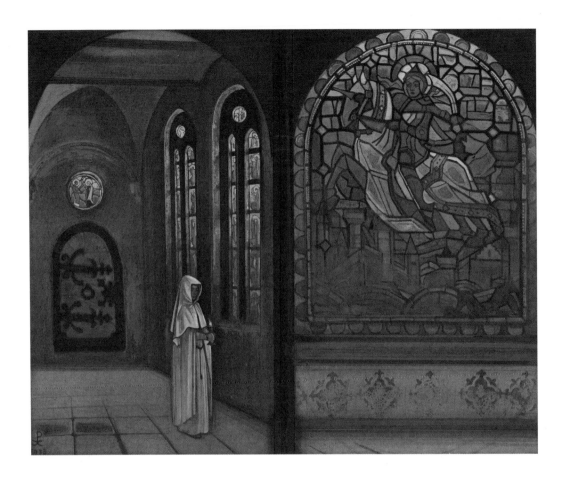

Above: Glory to the Hero, Nicholas Roerich, 1933, tempera on canvas.

In the diptych *Glory to the Hero* by Nicholas Roerich (1874–1947), we observe on one side a contemplative nun experiencing a quiet, spiritual moment in the solitude and stillness of a sombre corridor, and the other side reveals a luminous, almost animated, stained-glass woman soaring above a sleeping city on horseback, a figure reminiscent of Joan of Arc. This painting is reflective of Roerich's interest in the art of the medieval and Byzantine periods (although, technically, traditional medieval diptychs consisted of two independent panels joined together, whereas Roerich paints the division as a single column, but details, details). We can infer that Roerich had an interest in Joan of Arc, having completed a triptych titled in her name in 1931, but overall, Roerich, a bit of a mystic himself, was fascinated with mystic saints in general.

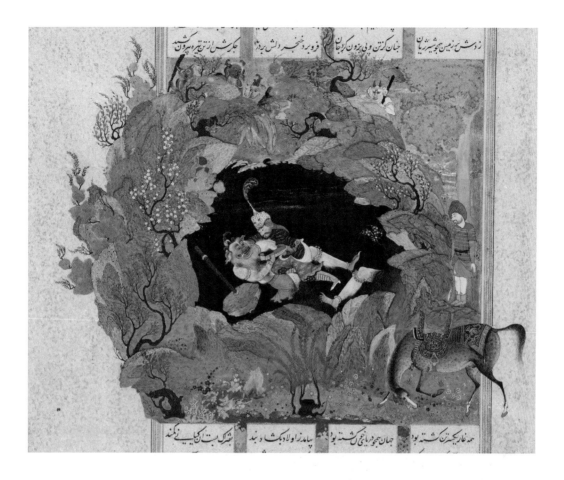

Above: Rustam's Seventh Course: He Kills the White Div, attributed to Mir Musavvir, sixteenth century, opaque watercolour, ink, gold and silver on paper.

The *Shahnama* (Book of Kings, composed 977–1010), with its 50,000 rhyming couplets, is a massive epic of world literature, acclaimed even in its own time for its incredible imagery. An interplay of lore and history, this capacious poem by Abu'l Qasim Firdausi narrates the history of the ancient kings of Iran from the mythical origins to the Arab conquest in CE 651. A tome of fabulous tales that examine the nature of good versus evil, with kings and heroes engaged in battles against monstrous enemies and supernatural creatures, it is also a meditation on the human experience and our internal struggles – as well as an example of a 'mirror for princes', intended to offer models of conduct and rulership for the edification of rulers. This fierce painting illustrates the last of the legendary hero Rustam's various trials – his defeat of the chief of demons, the White Div.

Above: Brunhilde, Arthur Rackham, 1910, colour lithograph.

The valkyrie Brunhilde's story is a bit of a soap opera, the sort of titillating drama of betrayal and vengeance one imagines that Asgardians might sit around and gossip about over golden apples and mead. A valkyrie and shield-maiden in Norse mythology, one who chooses among the slain in battlefields those who are worthy of glorious Valhalla (and who also had the power of causing death to those they did not favour), Brunhilde's is one among many tales of these valorous women seen as transformative agents, both arbiters of fate and psychopomps – though her saga of rebellion and revenge remains among the most popular. Richard Wagner's *Der Ring des Nibelungen* (completed in 1874), four epic operas based on these mythological intrigues, are accompanied by a series of illustrations by Arthur Rackham (1867–1939), one of the most celebrated painters of the Golden Age of Illustration.

Above: African Warrior, Andrea Rushing, *c.* 2014, oil on canvas.

The work of contemporary artist Andrea Rushing is driven by a profound interest in the human condition. Rendered with strength, beauty and compassion, Rushing's rich insights into human nature come alive on the canvas in the form of vibrant portraiture that speaks to destiny, history and one's place in the world. Recognized as a 'Keeper of Culture' by the San Diego African American Museum of Fine Art in 2018 for artistic and cultural work uplifting the region's Black community, Rushing notes that he desires for his work to be a 'place of departure', where, in looking out at the world, people may work to understand themselves a bit better. *African Warrior* is the cover art for *Griots: Sisters of the Spear* (2014), a Sword and Soul fantasy anthology of the Africa that was, as well as the Africas that never were, the legends and sagas sung in celebration to the spirit and bravery of women of colour.

Right: *And the padding feet of many gnomes a-coming!*, Warwick Goble, 1920, watercolour.

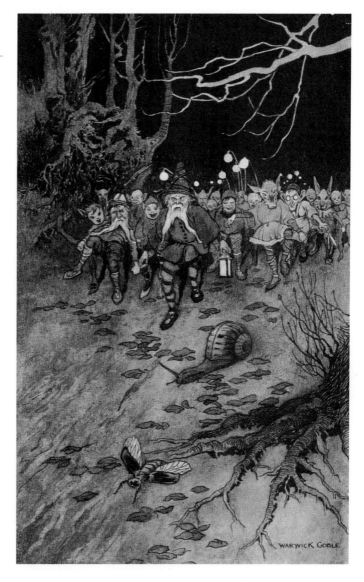

The delightful watercolour paintings by Warwick Goble (1862-1943) charmed fans of fairy tales at the turn of the twentieth century, and his books of vivid illustration remain favourites of readers even today. *And the padding feet of many gnomes a-coming!* appeared in *The Book of Fairy Poetry* (1920), an anthology filled with fantastical writings from beloved authors and poets, such as J.R.R. Tolkien, William Shakespeare, Robert Louis Stevenson and W.B. Yeats. The poem for which these gnomes marched was penned by Tolkien before he went away to fight in the bloody Battle of the Somme and witnessed atrocities and brutality that he would never forget, imagery which eventually made its way into his later writings. But when we read of the gaiety and enchantment of these tiny dancing feet, our hearts feel that old, thrilling crackle of magic, an electrifying, exhilarating shiver that, while it won't go very far to resolve our planet's various warring factions, reminds us of the things that heal our hearts and transcend the horrors of humanity.

Opposite: A Conan pin-up, first published in *Conan the Cimmerian* #25, Dark Horse Comics, Jim & Ruth Keegan, 2010, ink on paper with digital colour.

Two individuals who work together as a single award-winning artist, Jim and Ruth Keegan work in a variety of styles and media, including oils, watercolour, ink wash and digital art. Well known as the creators of *The Adventures of Two-Gun Bob*, which appears in every issue of *Conan*, *Solomon Kane* or *Kull* from Dark Horse Comics, here they have created a dynamic pin-up of the brawny barbarian Conan, in all his pulpy glory, contending with some sort of flying Hyborian-Age horror.

Above: The Wounded Healer's Blood Nourishes the Earth That Gives Birth to Radiant Flowers, Tino Rodriguez, 2017, oil on wood.

Inspired by mythology and music, dreams and childhood stories, the works of Tino Rodriguez are jubilant celebrations of ecstatic divinity, colourful butterfly-fluttered paradises and brilliant floral explosions – sanctuaries for explorations of creative consciousness that transcend borders and language. Personal transformation and universal connectedness are themes that tumble throughout Tino's work, like so many spring blossoms on a sweet, laughing breeze: reminders that a hero's work – this whole business of saving the world – often starts small, internally even, one precious human petal at a time. The humble work of healing one's self is quiet and invisible, and it frequently doesn't look – or feel – very good. Sometimes it feels like ripping an arrow right out of your heart and fertilizing the ground with your blood. But you know what we call that? It's an origin story. And it's a great place to start.

Above: Together Through the Shifting Tides, Andy Kehoe, 2022, digital painting.

If you ever doubt, even for a minute, that the existence of magic is real, you need only look to the infinite grandeur of the perpetual technicolour sunsets suffusing the landscapes of Andy Kehoe's awe-inspiring otherworlds. These feverish horizons ignite the imagination and fill our hearts with wonder and possibility; when we survey these vibrant vistas and the celestial melodrama unfolding on the horizon – when we envision ourselves slipping into the souls of the shadowy denizens of these worlds, taking in that spellbinding view, breathing, even if just for the sacred span of mere seconds, the air of this extraordinary place – what a holy moment, what a miracle! To allow ourselves to see through another's eyes and behold a world worth saving. To not only appreciate, but actively embrace that connection with the beings in these unreal and unimaginable places, and practice that compassion and empathy for your own home world and its myriad inhabitants as well.

Further reading

If your imagination was tickled by a fantastical tidbit mentioned or alluded to within these pages, the following is a list of books that you may enjoy for further reading. There are also titles included in this list that I myself enjoyed while scribbling *The Art of Fantasy*, and while perhaps you will not find a specific reference to them in this book, I feel I would be remiss in not mentioning them – as their various spirits infused, if not the writing itself, then at the very least the atmosphere, frames of mind, and states of being in which the book was researched and written.

Afrofuturism: The World of Black Sci-Fi and Fantasy Culture, Ytasha L. Womack, 2013

Appendix N: The Eldritch Roots of Dungeons & Dragons, edited by Peter Bebergal, 2021

The Art of Aubrey Beardsley, Catherine Slessor, 1989

The Art of John Harris: Beyond the Horizon, John Harris, 2014

The Art of Leo and Diane Dillon, Byron Preiss, 1981

The Art of the Pre-Raphaelites, Elizabeth Prettejohn, 2001

Arthur Rackham: A Life with Illustration, James Hamilton, 2010

Beyond Horatio's Philosophy: The Fantasy of Peter S. Beagle, David Stevens, 2011

The Book of Fairy Poetry, Dora Owen, 2019

By a Woman's Hand: Illustrators of the Golden Age, Mary Carolyn Waldrep, 2012

Carrie Ann Baade: Scissors & Tears, Carrie Ann Baade, 2022

Contraptions: A Timely New Edition by a Legend of Inventive Illustrations and Cartoon Wizardry, William Heath Robinson, 2021

Cosmicats: The Feline Fantasy Art of Karen Kuykendall, Karen Kuykendall, 1989

Dark Crystal Bestiary, Adam Cesare and Iris Compiet, 2020

The Dictionary of Imaginary Places: The Newly Updated and Expanded Classic, Alberto Manguel, 2003

Dinotopia: A Land Apart from Time, James Gurney, 1992

Dulac's Fairy Tale Illustrations in Full Color, Edmund Dulac, 2004

Dungeons & Dragons Art & Arcana: A Visual History, Michael Witwer and Kyle Newman, 2018

East of the Sun and West of the Moon, Noel Daniel and Kay Nielsen, 2022

Fairies and Elves (The Enchanted World), Colin Thubron, 1984

Fairies in Victorian Painting, Christopher Wood, 1999

Fantasies of Time and Death: Dunsany, Eddison, Tolkien, Anna Vaninskaya, 2020

The Fantasy of the Middle Ages: An Epic Journey through Imaginary Medieval Worlds, Larisa Grollemond and Bryan C. Keene, 2022

Fantasy: The Golden Age of Fantastic Illustration, Brigid Peppin, 1975

Fantasy: The Liberation of Imagination, Richard Mathews, 2016

Fantasy, The Literature of Subversion, Dr Rosemary Jackson, 2008

From Fantasy to Faith: Morality, Religion and Twentieth Century Literature, D.Z. Phillips, 2006

From Tolkien To Oz: The Art of Greg Hildebrandt, William McGuire, 1985

From Utopia to Apocalypse Science Fiction and the Politics of Catastrophe, Peter Y. Paik, 2010

The Forgotten Language: An Introduction to the Understanding of Dreams, Fairy Tales, and Myths, Erich Fromm, 1951

Good Faeries . . . Bad Faeries, Brian Froud, 2000

Harry Clarke: The Life & Work, Nicola Gordon Bowe, 1989

HR Giger, Andreas J. Hirsch, 2022

Imaginary Animals: The Monstrous, the Wondrous and the Human, Boria Sax, 2013

Imaginary Worlds, Lin Carter, 1973

Infinite Worlds: The Fantastic Visions of Science Fiction Art, Vincent Di Fate, 1997

Lord of the Elves and Eldils: Fantasy and Philosophy in C.S. Lewis and J.R.R. Tolkien, Richard L. Purtill, 1974

Lost Transmissions: The Secret History of Science Fiction and Fantasy, Desirina Boskovich, 2019

Masterpieces of the Imaginative Mind: Literature's Most Fantastic Works, Eric Rabkin, 2007

The Monster Theory Reader, Jeffrey Andrew Weinstock, 2019

The Monsters and the Critics, and Other Essays, J.R.R. Tolkien, 2007

Offerings: The Art of Brom, Brom, 2001

One Foot In the Green, Brett Manning, 2022

Pamela Colman Smith: The Untold Story, Stuart R. Kaplan and Mary K. Greer, 2018

The Rhetorics of Fantasy, Farah Mendlesohn, 2008

Skin Shows: Gothic Horror and the Technology of Monsters, Jack Halberstam, 1995

Tales of Mystery & Imagination, Edgar Allan Poe and Harry Clarke, 1987

Visions of Beauty, Kinuko Y. Craft, 2022

The Waking Dream: Fantasy and the Surreal in Graphic Art, 1450–1900, Edward Lucie-Smith and Aline Jacquiot, 1975

Wizards and Witches (The Enchanted World Series), Brendan Lehane, 1984

Index

Page numbers in *italics* indicate
illustration captions.

Picture credits

The publishers would like to thank the institutions, picture libraries, artists, galleries and photographers for their kind permission to reproduce the works featured in this book. Every effort has been made to trace all copyright holders but if any have been inadvertently overlooked, the publishers would be pleased to make the necessary arrangements at the first opportunity.

Acknowledgements

To all the artists of wildly fantastical fanciful visions who have sparked my imagination and set my heart aflame – but particularly the kindly ones who have permitted me to include their works in this book – thank you.